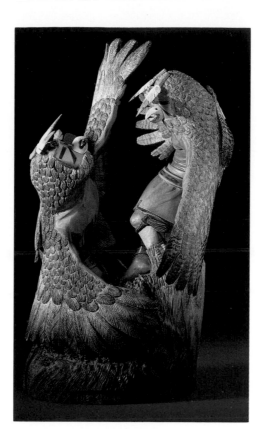

IN THE BEGINNING...

A new day was dawning—

Bathed in the golden glow
of the early morning sunrise,
an eagle soared high into a cloudless sky;
for one breath-stopping moment,
a stag stood motionless,
antlered head held high,
then, bounding effortlessly up the hillside, was gone.

A silent watcher stirred...
awakening emotions became a wordless cry.

From a piquant restlessness,
the first quiet stirrings of a dream began—
a petroglyph was pecked in stone,
a simple figure was formed from twigs,
an animal fetish was carved from turquoise.
A soul cried out with silent fervor.

A new day had dawned—
An artist was born.

On eagle's wings they fly,
gliding, swooping, soaring higher,
and ever higher,
relentless, restless souls,
silently crying to be heard.

There is no sunset on their horizon,
only a spirit that beckons,
and they will fly ever onward,
in search of that distant dream.

LJ

Beyond Tradition

Contemporary Indian Art and Its Evolution

Photographs by Jerry Jacka
Text by Lois Essary Jacka
Introduction by Clara Lee Tanner

 Northland Publishing Company

HALF TITLE: *The Rivals,* two kachinas carved from one piece of cottonwood root by Hopi Loren Phillips. Eagle (*left*), Red Tailed Hawk (*right*).

TITLE: *Messenger,* bronze, 27″ tall, Rollie Grandbois (Turtle Mountain Chippewa). This piece was cast from an original stone sculpture.

FIRST EDITION 1988
SECOND PRINTING 1989
ISBN 0-87358-471-6
Library of Congress Catalog Card Number 88-60922
Composed in the United States of America
Printed in Japan
by Dai Nippon Printing Company

Design by David Jenney
Typeset in Galliard and Gill Sans
by Arizona Typographers

Library of Congress Cataloging-in-Publication Data

Jacka, Jerry D.
 Beyond tradition.

 Includes index.
 1. Art, Indian. 2. Indians of North America—Art. 3. Art, Modern—20th century—United States. I. Jacka, Lois Essary. II. Title.
N6538.A4J3 1988 704′.0397079
88-60922
ISBN 0-87358-471-6

Contents

Preface

NATIVE AMERICAN ART TODAY IS ALIVE AND FLOURISHING, AND those who have lamented its demise may rest assured that there is no need for concern. Never before has there been such excellent craftsmanship and outpouring of creative talent, as many "Indian arts and crafts" are transformed into incredibly fine art. Furthermore, many of the artists creating these superb works of art are young—some in their twenties and thirties, some teenagers—with many productive years ahead.

This book is, first and foremost, an opportunity to introduce some of the magnificent work of these artists, while offering a brief glance at the art of their ancestors. It is not intended as a treatise on Native American art, nor is it an anthropological dissertation on the American Indian. Because we have been fortunate enough to count many Native American people (both artists and otherwise) as friends through the years, our goal was to capture the essence of the art as a whole, while giving a little insight into the artists as individuals. There will be no exposés, no earth-shattering revelations, just a glimpse into the lives of a talented people who deserve recognition for their achievements.

We also do not intend to become embroiled in the age-old controversy of what constitutes "art." Since there is no exact definition, nor any absolute method of distinguishing art from non-art, we can only believe that it, like beauty, is in the eye of the beholder. However, we personally consider these people artists and feel that their art will endure, changing and evolving as they look to the past to form their future.

With the idea of this book "wandering around" in our minds for some ten years and refusing to be put to rest, we became serious when assigned to do the May 1986 *Arizona Highways Magazine* special issue on Native American Fine Art. Although we were quite familiar with the subject and acquainted with many artists, the abundance of new and exciting art we discovered was overwhelming. And everywhere we went, we were met with enthusiasm and the same question, "Why don't you do a *book* on contemporary American Indian art?" Now, almost four years, thousands of miles, hundreds of phone calls, and dozens of interviews later (plus so much film that we're afraid to count up the costs), here it is.

The book became a very real labor of love, for it often consumed our lives for months at a time. However, we rarely objected, as we thoroughly enjoy visiting with the artists and photographing their work.

In the last few years, we have visited more museums, galleries, reservations, collectors, gift shops, Native American artists, art schools, exhibitions, ceremonials, markets, and extravaganzas than most people will visit in a lifetime as we searched for extraordinary contemporary American Indian art.

Most of the artists featured are from Southwestern tribes; those from other areas exhibit in galleries and museums in the Southwest. Although we realize there are many exceptional American Indian artists across the country, space and time restrictions dictated the scope of this work.

Our one regret has been the nearly impossible task of making selections from the hundreds of photographs taken (had Jerry not been dragged, protesting, from the camera, he would be there yet). We wish we could show every piece photographed but, unfortunately, many beautiful objects had to be omitted because of space limitations.

We do feel that the work represented is outstanding. We relied upon input and advice from museum staffs and curators, juried exhibitions, the Institute of American Indian art, collectors, traders, and art galleries, plus our thirty-five years of collecting, photographing, and writing on the subject. However, we make no claims to be judges, or even critics, simply people who truly love the art and the artists.

To them we dedicate this book.

Jerry and Lois Jacka

Three from a cache of nineteen Hohokam clay animal figurines (A.D. 700-1200) found at Snaketown, shown with a horned toad effigy carved of sandstone. The figurines stand 5⅛″ to 5½″ tall; the horned toad is 8″ in length.

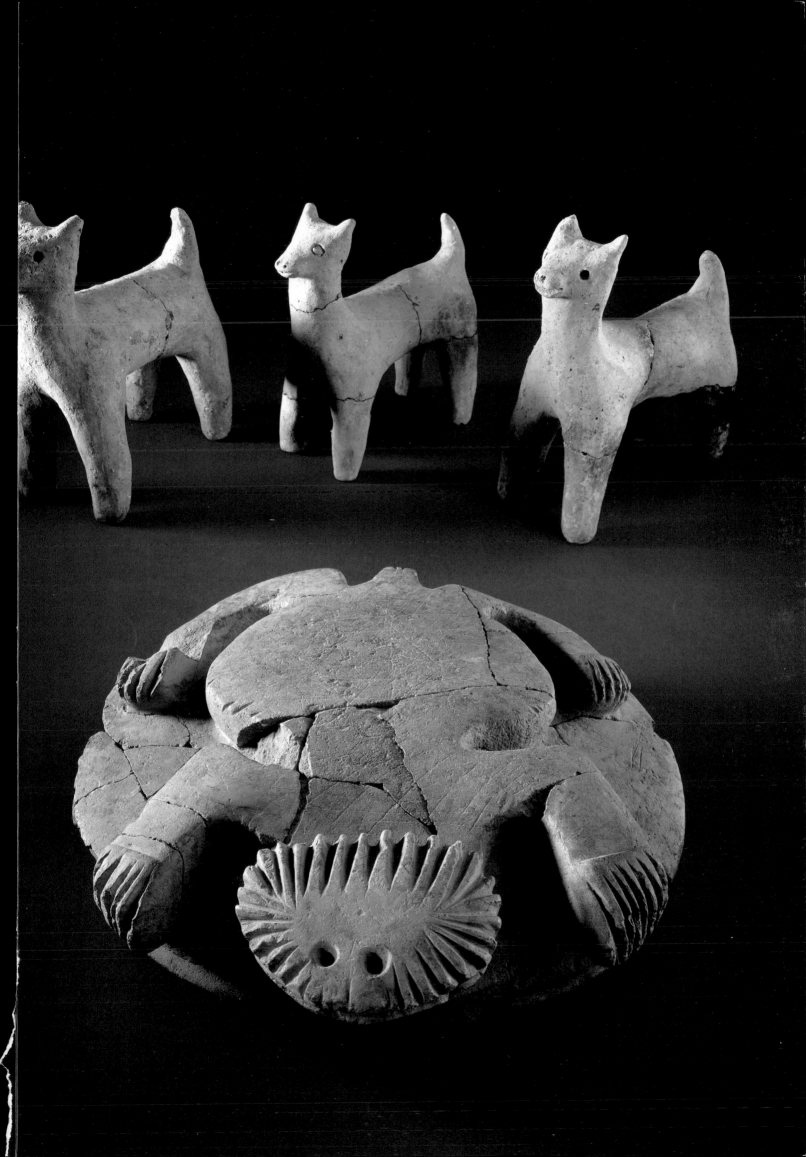

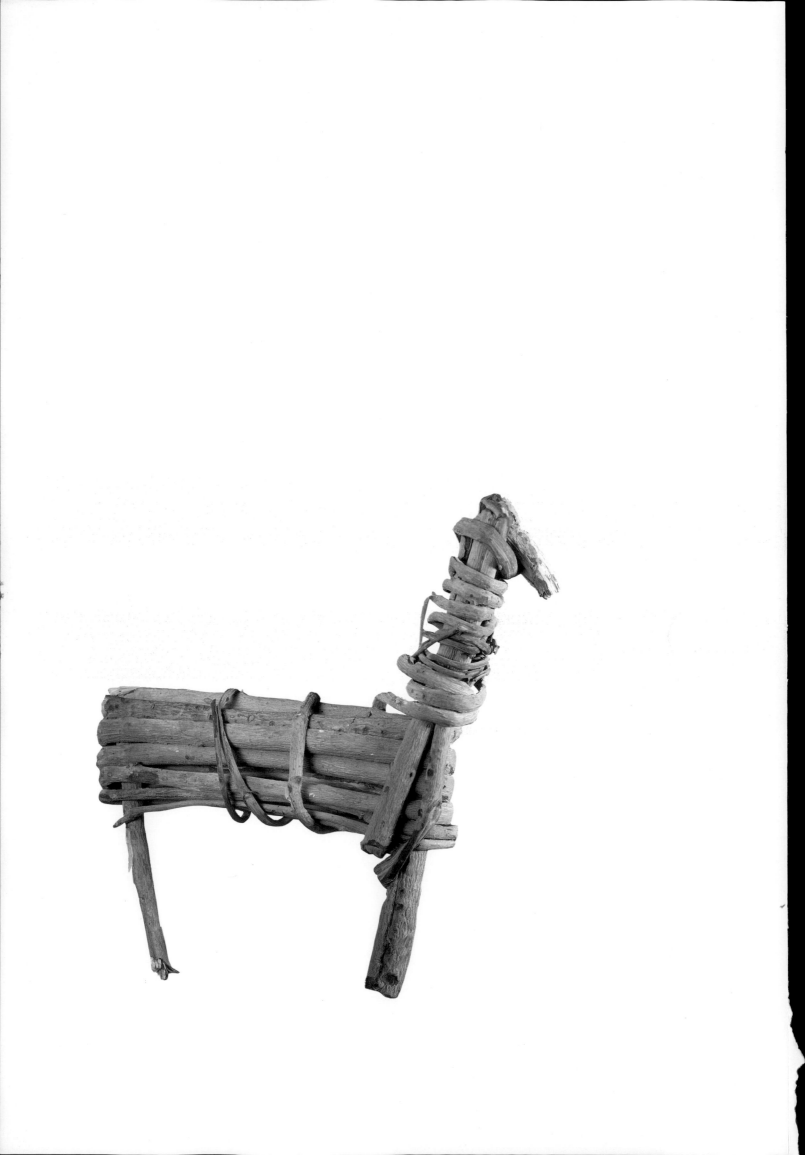

Introduction: Out of the Past

CLARA LEE TANNER

Perhaps the vision of a beautiful animal lingered in the memory of an ancient Indian hunter when he created its likeness. Familiar with working with sticks and stones, and little else, he picked up a few twigs and fashioned his recollection into reality. Found in a cave deep in the colorful walls of Arizona's Grand Canyon, this split twig figure (6″ tall) is believed to be some 4,000 years old. Inspired by the simplistic beauty of this piece, a twentieth century Hopi artist recreated the figure in fourteen karat gold set with a diamond (see page 102).

NATIVE AMERICAN ART WAS BORN OF A DEEP and abiding sense of rhythm, balance, and symmetry. Items such as early stone tools express these qualities of "Indianness"; they demonstrate characteristic features that have been passed on in an unbroken chain through all of the craft arts of pre-Columbian years. Perhaps the first Americans were aware of the need for repetitive flaking to achieve a more effective point with which to bring down the mammoth. A deep awareness may have told these people that balanced baskets would better retain gathered seed, that symmetrical clay vessels would be more likely to remain upright and be more efficient in cooking and serving food.

In the American Southwest, man's earliest stone tools reflect a growing unity between hand, mind, and artistic temperament. From crude, irregularly worked knives and points, long, delicate pieces developed; some of these tools were fashioned with a few large and often irregular flakes removed from the center but with studied, controlled, and repetitive flaking down the edges. The latter type of workmanship resulted in a beautiful symmetry that has served as inspiration to craftsmen for centuries.

Earliest men of some 12,000 or more years ago manifested their abilities through a great variety of stone tools. Points, however, were the most exceptional and artistic in style, as epitomized by the large-game-hunter's Clovis point. In time, as the bow and arrow became the hunting tools of need, small points were gems of craftsmanship; from tiny bird points to larger specimens used in hunting of deer, they reflected the best aspects of form melded with function.

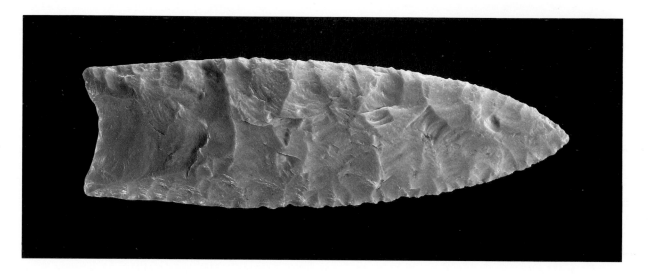

In early small-game hunting-and-gathering cultures, baskets began to be fashioned. Fragments of such baskets in coiled, twined, or wicker weaves have been found deep in Southwestern caves. There are no indications of color on these earliest pieces; either it was never present or time has erased all evidence.

The crafting of jewelry represents a third expression of early human creativity. Linked to no real practical need, jewelry is one of the oldest traditions, a fact that is perhaps attributable to the desire of humans to adorn themselves. Shells found their way from the Pacific Coast inland as far as modern-day Utah, and were formed into beads and pendants worn by the men and women of the small-game hunting-gathering cultures.

Transition

Agriculture, appearing not later than 300 B.C., might well qualify as the greatest economic incentive in the development of art. It was responsible for the invention of pottery, and inspired terrific growth in the art of making baskets. As people had more leisure time, a desire developed for clothing finer than that made from skins. And, already made in response to a desire for adornment, jewelry took a great leap forward.

Three great sedentary cultures developed in the Southwest,

Beautifully symmetrical, this Clovis projectile point, made 11,500 years ago, was found near the vertebra of a mammoth in southern Arizona.

primarily after 300 B.C. Hohokam folk in the desert area of southern Arizona, who built homes in village arrangements, developed a foundation based upon irrigation agriculture, cultivating corn, beans, and squash. In order to use corn in a variety of forms, better grinding equipment was needed, and well-shaped metates and manos were the result. Pottery evolved in distinctive styles, the cultivation of cotton meant that clothing forms could be diversified, and proximity to the Gulf of California meant that shell was available for experimentation in jewelry forms.

The Mogollon culture, centered in southwestern New Mexico, shared some of the early accomplishments of the Hohokam, particularly agriculture. This group also had permanent homes, developed their own artistic expressions in pottery, and produced fine jewelry and clothing. Some of their cultural expressions, particularly the kiva or ceremonial room, reflect contact with the Anasazi.

Anasazi is the name applied to the prehistoric culture that was centered in the Four Corners area of the Southwest — the point at which the modern-day states of Arizona, New Mexico, Colorado, and Utah meet. Flowering a little later (about 1100 to 1300) than the previously mentioned groups, these people developed great creative vigor that manifested itself in the building of magnificent cliff, mesa, and valley pueblos. They, too, can be credited with a distinctive pottery style as well as exceptional expressions in basketry, textiles, and personal adornment.

Prehistoric Crafts

Great traditions were established by Anasazi basketweavers in prehistoric times; many of these would affect some of the other craft arts. Forms were refined and passed on; some of these shapes were later echoed by potters.

Archaeologists have classified two of the Anasazi developmental periods as Basketmaker II and Basketmaker III (roughly 300 to 650 B.C.), based on the evolution of this basic craft. While the first basketry designs were simple, innovative and increasingly complex themes developed during these and succeeding periods. Color was used for contrast, with black on one side of a

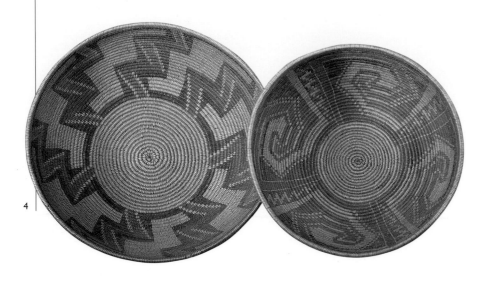

4

motif, red on the other a popular combination. Occasionally, baskets were painted, but time has served to diminish most examples of this technique.

Little is known of Hohokam (300 B.C. to 1450) basketry developments, but it is likely that modern Tohono O'odham (Papago) and Pima Indians (who are presumed to have stemmed from the Hohokam culture) derived the bases of their coiled weaving from that group.

The craft of textile weaving is traditional indeed. Objects dating to the prehistoric period include everything from simple headbands, tump lines (head or chest straps), and finely woven sandals to body garments and blankets. Materials used range from grasses, yucca, and various local plants to natively cultivated cotton. Techniques of weaving varied from simple braiding and plain loom weaves to complicated loom twills, weft-wrap, gauze, and brocading. Embroidery was also practiced. Certain weaves lent themselves to design. When colored threads were added to plain or tapestry weave, design possibilities were endless. Vertical, horizontal, and diagonal lines were easily produced in the latter, and as colored threads could be introduced at any point, continuous and spotted designs were developed.

A most interesting prehistoric twine-plaited cotton shirt (shown in this book) was discovered at Tonto Ruins, near Globe, Arizona. It must have been treasured, as it was rolled up and included with an infant buried between two baskets.

It was in ceramics that the prehistoric Southwestern Indian cultures reaped their richest artistic harvest and left their most valuable tradition. The Hohokam, Mogollon, and Anasazi people each took whatever few developments existed early in clay forming and rapidly put their own particular stamp on the craft. Hohokams favored red-on-buff styles that reflected their own rich and creative design context. The Mogollon people, on the other hand, came to emphasize a black-on-white decorative

Exceptional examples of prehistoric basket bowls of the Basketmaker III period, A.D. 400-700, from southern Utah. *Left*: 11½″ diameter, 4¼″ deep; *right*: 9½″ diameter, 4″ deep.

OPPOSITE: Incredibly well preserved, this poncho (or sleeveless shirt) was found in the Upper Ruin of Tonto National Monument, Arizona. Made by people of the Salado Culture sometime around A.D. 1300–1400, it is woven of native cotton with a non-loom, twine-plaited weaving technique.

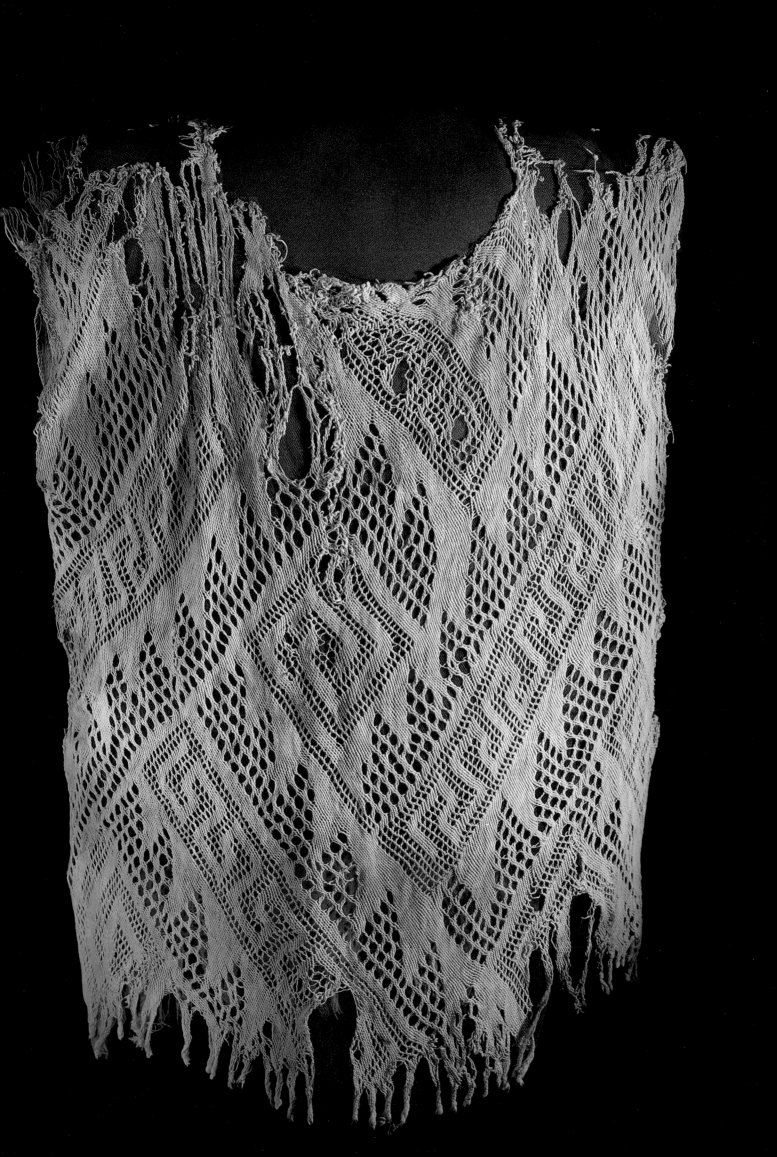

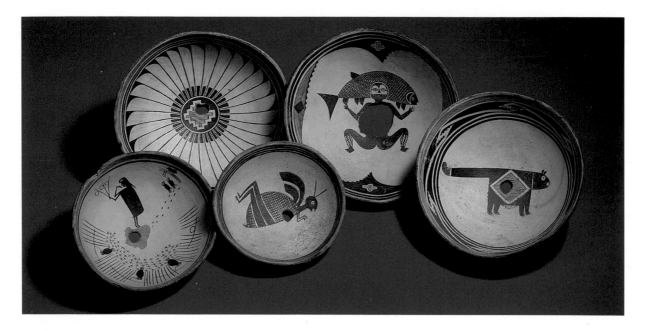

scheme, although they apparently experimented along the way with several other color combinations. The Anasazi began their efforts in ceramics a bit later than the Hohokam and Mogollon, and both their shapes and early designs were clearly influenced by the same in coexisting baskets. Some have impressions that demonstrate the piece's modelling within a basket.

In a surprisingly short time, these ancient folk began to express regional styles. Each area seemed to concentrate on distinctive forms, designs, and colors, and a general trend toward more sophisticated patterns became evident as time passed. Hohokam potters stressed great simplicity in form in their first wares. Complexity gradually set in, and a later phase, the Sacaton (900 to 1250), reflects a culmination of Hohokam ceramics in such pieces as magnificent jars with sweeping, outflowing lines that move to a low, sharp shoulder that almost hides the small, inward-turning, rounded base. Red-on-buff geometric designs decorated Hohokam wares, sometimes joined by a row of dancers with alternating headdresses; shallow bowls featured all-over geometrics or a large, centered life form, such as a crane.

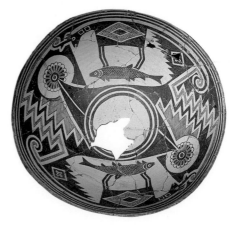

Classic Mimbres (1000 to 1130) black-on-white wares represent the apex of the Mogollon ceramic styles, with a simple

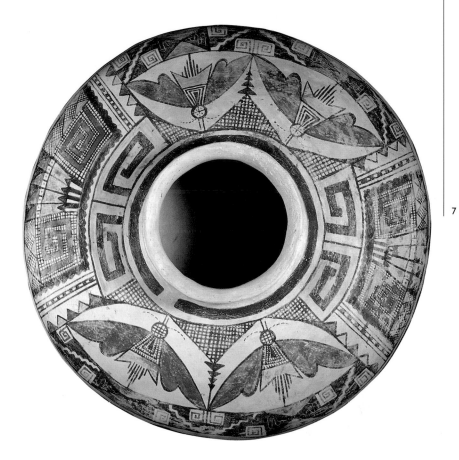

OPPOSITE, *above and below:* Mimbres black-on-white pottery bowls, often referred to as "story bowls," were made during the twelfth to thirteenth centuries in southwestern New Mexico. This imaginative pottery is noted for its elaborate geometric designs that are often combined with mythical images of people, animals, birds, or fish.

RIGHT, *above:* This Sikyatki polychrome jar was probably made between A.D. 1400 to 1600. The Sikyatki tradition resulted in some of the most artistic pottery made during that period. *Bottom:* Hohokam red-on-buff pottery from Snaketown in southern Arizona. The ladle with the human form as a handle, made between A.D. 600–700, is from the Gila Butte Phase. The three human effigy pieces, from the Sacaton Phase, date between A.D. 900–1200.

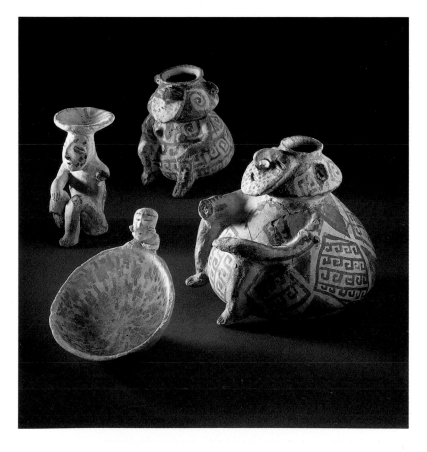

8

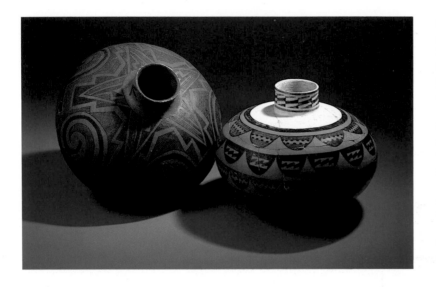

bowl form dominating. Geometric and life forms were popular, and creatures painted on these bowl interiors include crickets, mountain lions, snakes, wildcats, turtles, lizards, frogs, fish in abundance, birds, rabbits, mountain goats, and others. Although some of these are presented as picture stories, there is no sound explanation for many of them. However, some undoubtedly have a mythological background.

Anasazi pottery is best known for its many high-level local wares, such as Mesa Verde mugs, bowls, and great jars with handles placed low on their generous, rounded bodies, and Chaco wares, which have more prominent lines in repetitive units that alternate with other elements. In the Kayenta area, one of the most interesting developments was the black-on-white tradition in well-executed negative wares; however, polychrome bowls and jars were also produced. Little Colorado wares combine beautiful designs and colors—including black and red; red and white; and black, red, and white—into highly artistic expressions. Sikyatki polychrome (a later style from this area) typically has a yellowish or orange background color with brownish-black and red designs, some of them representing the finest of the prehistoric wares.

Thus, in prehistoric ceramics, certain artistic heights were reached and certain aspects of pottery decoration became tradi-

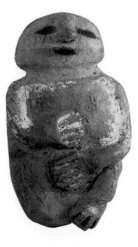

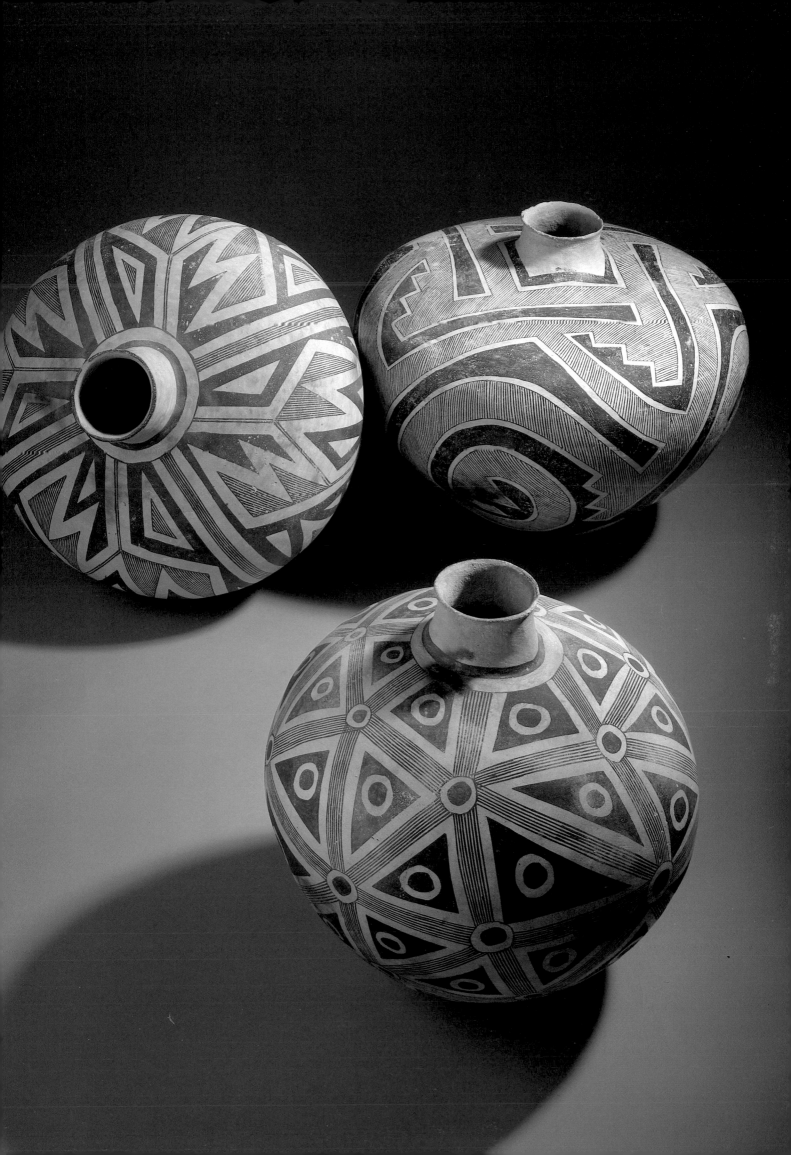

tional, influencing this craft for many centuries and giving it for-
ever a potential for change. Painting on clay allowed flights of
imagination and creativity in color and design not possible in
woven baskets or textiles.

Jewelry-making was a highly developed craft among the
sedentary prehistoric populations of the Southwest. Shell and
turquoise were favored above all else, but other materials—
including wood, bone, horn, and a variety of stones—were also
used. These materials were cut, carved, incised, painted, etched,
or set in mosaics. Pieces ranged from undecorated rings and pen-
dants to complex relief forms, such as a snake with a bird in its
mouth encircling a shell bracelet. Disc beads were often formed
from clay that was wrapped around a blade of grass, marked at
regular intervals, baked, and then cut apart at the marks.

The Hohokam developed a rare jewelry-making technique,
etching, probably using saguaro fruit wine, which has an acidity
of approximately six percent. They would conceive and execute a
design on the shell and cover it with a resist substance, possibly
mesquite gum; the shell was then dipped in the solution and the
acid disintegrated the unprotected top layer of the shell. Thus,
raised designs—frogs or other creatures—were produced. Rings
and bracelets were frequently plain shell bands with an occa-
sional carved design; a common motif was a frog or bird on the
umbo of shell bracelets. Necklaces were a mere string with a pen-
dant, beads alone, or beads interspersed with chunks of the same
or another type of stone. Pendants were varied and often glo-
rious, with the mosaic style the most elaborate, and earrings were
made from pieces of shell, turquoise, or other stone.

More unusual forms of body ornamentation included shell
anklets; knee, waist, or arm bands of conus shell; simple and
uncommon stone nose and lip plugs. Widely distributed and
commonly made were hair ornaments that usually resembled
awls. Some of these were decorated either on the ends or over the
entire length of the piece, and the designs included geometrics,
birds, or animals.

OPPOSITE, *top:* Hohokam body adorn-
ments from Snaketown, southern
Arizona. A sea shell with a horned toad
design (*top left*) that was ingeniously
etched with an acidic concentrate of
fermented cactus juice.
A slate bird pendant (*top right*) has the
head carved in profile. The shell brace-
let (*right center*) has a carved design
representing a rattlesnake with its
head in a bird's beak. The snake's rat-
tles are to the right of the bird's head
and on the underside of the bracelet.
In the center are two tiny bird
fetishes, one of shell, the other of tur-
quoise. The latter is a pendant, as
indicated by the drilled hole. The shell
necklace at the bottom is 28½" long.
Bottom: Carved and incised bone
objects ranging in length from 7¾" to
12¼". All but the tallest are from the
Hohokam Culture (dating between
A.D. 700—900) and were probably
used as hairpins. The tallest piece
(painted and incised) was probably
used as an awl by the Anasazi between
A.D. 1200 and 1350.

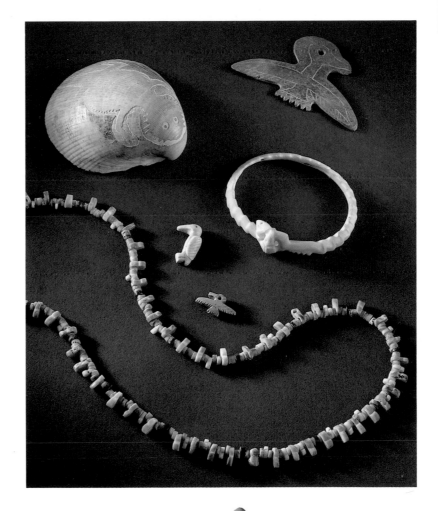

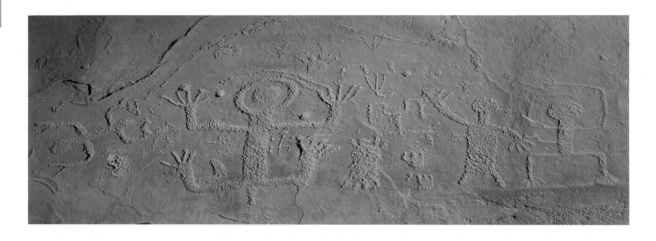

Pictographs and petroglyphs are widely distributed over the Southwest, and subject matter in both is fairly consistent, ranging from geometric and curvilinear patterns to numerous life forms. Humans are quite simply represented, yet these portrayals tell much about their activities. They may appear standing or sitting; throwing a spear; playing a flute; or as groups dancing in a row, with hands joined. The treatment of the human hand is interesting; it appears both alone and in rows, and was painted solid, in outline, or created by placing the hand against the wall and blowing paint around it. Some of these hand pictographs seem to have been made by the artist dipping the hand in paint, then pressing it against the rock.

Clay-modelled figures among the Hohokam generally served to ornament vessels such as jars or ladles; however, some were incense burners or independent figures. Stone paint palettes and paint dishes contributed to an unusual aspect of Hohokam artistry; palettes were rectangular in form, usually with a raised edge pleasingly carved in low relief, or incised, often with life forms. Stone bowls, some believed to be ceremonial, were quite varied—they might be in the form of a bird, horned toad, or other creature; a man holding the bowl; or have a group of figures around the bowl's rim.

Anasazi petroglyphs, with typical raised arms and large hands, from northeastern Arizona.

OPPOSITE: This historic Navajo wall mural in Canyon del Muerto, Canyon de Chelly National Monument, records a cavalcade of Spanish horsemen and Indians led by Lieutenant Antonio Narbona, who entered the canyon during the winter of 1804–1805. It was this "army" that was responsible for the slaughter of over one hundred Navajos in what is now known as Massacre Cave. This outstanding piece of early Navajo historical art is believed to have been executed by a Navajo named *Dibé Yazhi* (Little Sheep) sometime during the very early 1800s.

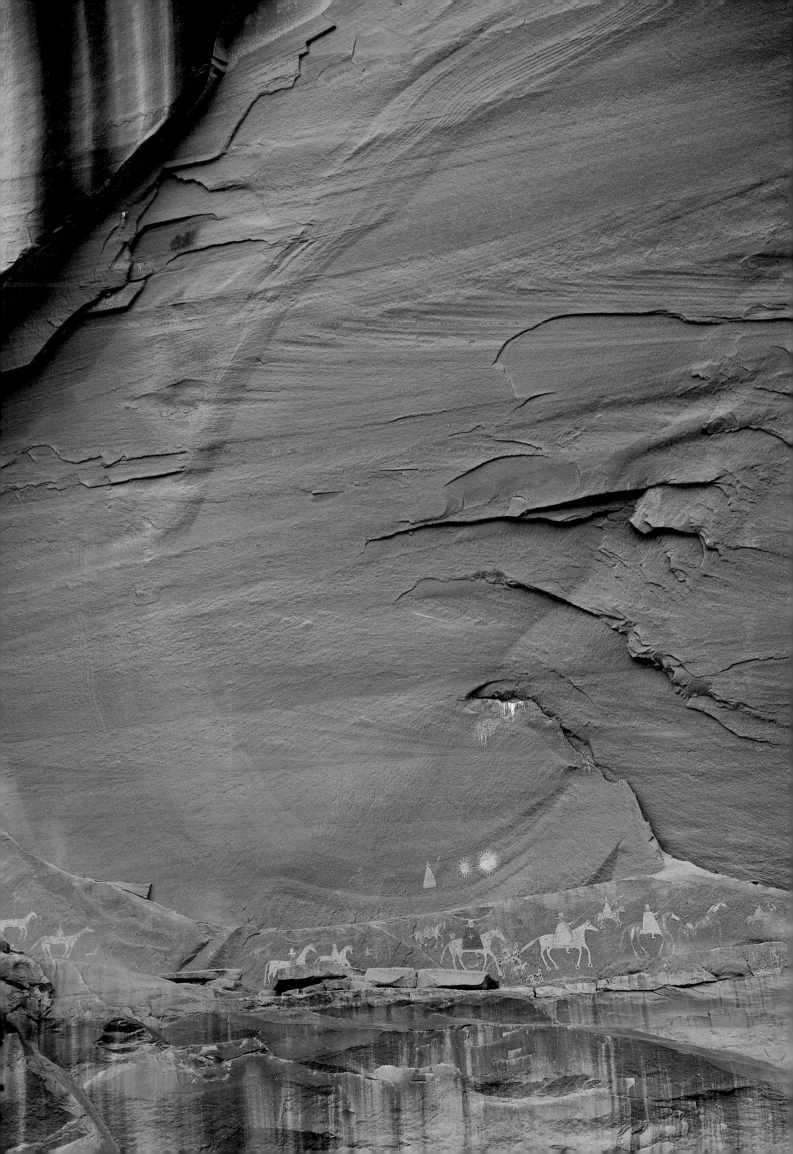

Historic Crafts

Although the date 1540 is given as the time of termination of pre-historic cultures, there is little evidence of any great break in craft expression at this time. In fact, well-established traditions continued in numerous places, with little or no observable change for many years. The adoption of European traits was slow to be realized, which ensured the continuation of weaving baskets and textiles, of making pottery and jewelry.

Generally speaking, basketry made few concessions to new-comers until Anglo Americans, via the railroad, brought new containers into the Southwest in the 1880s. Some pottery disappeared at this time also, but many of the Rio Grande Puebloans continued to use large clay storage jars until many years later. Weaving dropped dramatically at this time in the Rio Grande region when the railroad began bringing fabrics for clothing (although this was not true among the Hopi). Navajos would have forgotten their blanket weaving with the coming of traders, who brought commercial cloth in the last decades of the nineteenth century, but those very traders encouraged the thickening of the blanket into a rug form, and thus this craft was saved. Jewelry remained essentially the same among most natives, changing very little and then largely because of the introduction of a new material, silver, but that not until the 1850s.

In basketry and pottery, no changes were made in materials, for native plants and clays continued to be used. However, some few basket weavers accepted commercial dyes. No new ways of "doing" were introduced to the basket weaver, and all potters ignored the wheel and kiln until recent years; most still adhere to the old ways.

Sheep were introduced into the Rio Grande area early in post-Conquest times. Native people continued to weave their garments on the native loom in both wool and cotton, in established techniques and in age-old forms. Through these Puebloans, the Navajos learned to weave new garment styles, particularly the blanket dress and shoulder blanket, thus displacing traditional skin garments.

Perhaps one of the greatest instigators of change was the American tourist. Railroads brought them, and they became interested in the Indian—and inevitably in his crafts. Apaches

Apache basket olla, ca. 1900, containing geometric and life subjects in both positive and negative styles, a trait common to Apache baskets.

OPPOSITE: Navajo Germantown rug, ca. 1880s (55″ by 70″), with an early border style (one that appears along the blanket's edges, but not on the top or bottom). The colors and design are typical of rugs of this period.

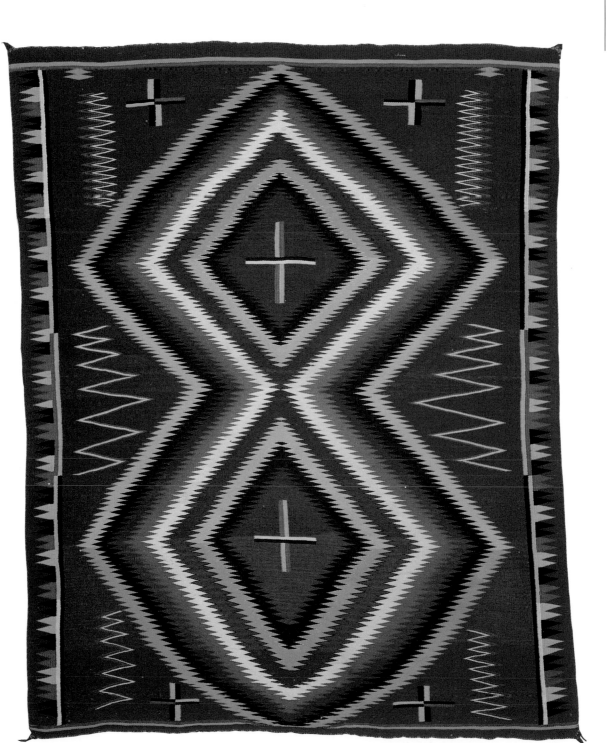

16 bettered their basket designs; Navajos put arrows and swastikas on their jewelry, and wove new styles of rugs; and pottery was revived in the Rio Grande pueblos...all for the tourist. Most of this began before the opening of the twentieth century and continued into its first decades.

Despite these changes, tradition prevailed. After the first flare of concession to the tourist, the native artisan turned back to his natural instinct for change guided by tradition and creativity, with such results as the great ceramic artistry of Maria and Julian in San Ildefonso and Nampeyo at Hopi. Nampeyo was inspired as she compared the poor quality of turn-of-the-century Hopi pottery with the vastly superior wares of her own prehistoric ancestors, which came from the Sikyatki (a fifteenth-century site) excavation. Maria and Julian accidentally happened upon their black-on-black pottery style and may not have continued it had it not been for great encouragement from an Anglo in Santa Fe.

After the turn of the century, several Indian tribes dropped out of the basketry craft picture completely, or nearly so. These included the Rio Grande Puebloan, Mohave, Yuma, and Cocopa. Basketry production was also greatly curtailed among the Pima, Yavapai, Hualapai, and Jicarilla and Mescalero Apache.

A burst of wonderfully designed coiled basketry was expressed by the Western Apache from the later years of the nineteenth century into the mid-twentieth century, but very little of this style has been produced since. They used willow as the basic material, plus black devil's claw, to produce basketry decorated with unusual geometric and life designs.

Pimas were weaving and using quantities of baskets around 1900; they also produced many fine miniatures at this time. Their coiled trays, jars, and other forms were consistently well woven of willow, and many were beautifully designed, with geometrics favored over life forms. Small or large blue beads also decorated some early Pima baskets, usually around the rim.

Tohono O'odham expressed the greatest change in basketry craft of any Southwestern Indian tribe. For coiled sewing material, they shifted from the desert willow to yucca early in this century. Black devil's claw designs became sparse as simple geometrics replaced the older, more complex ones, and life

Pottery plate (11¾″ in diameter) with black-on-black feather design, made by Maria Martinez and her son, Popovi Da of San Ildefonso. This feather design was most likely adapted from prehistoric Mimbres pottery and was also used by Popovi's father, Julian.

OPPOSITE, *top:* Pima baskets made during the 1920s and 1930s, ranging in size from 1¾″ to 18¼″ in diameter. A variety of designs include the man-in-the-maze (*left*) and the popular squash blossom (*top right*). Decorating rims with beads (mostly commercial) as in the two center baskets, came into use near the end of the nineteenth century and continued into the early 1900s. *Bottom:* Apache and (*top left*) Yavapai coiled baskets of the early 1900s. These jars and trays illustrate the most popular forms and combinations of geometric and life designs in Apache basketry of this period.

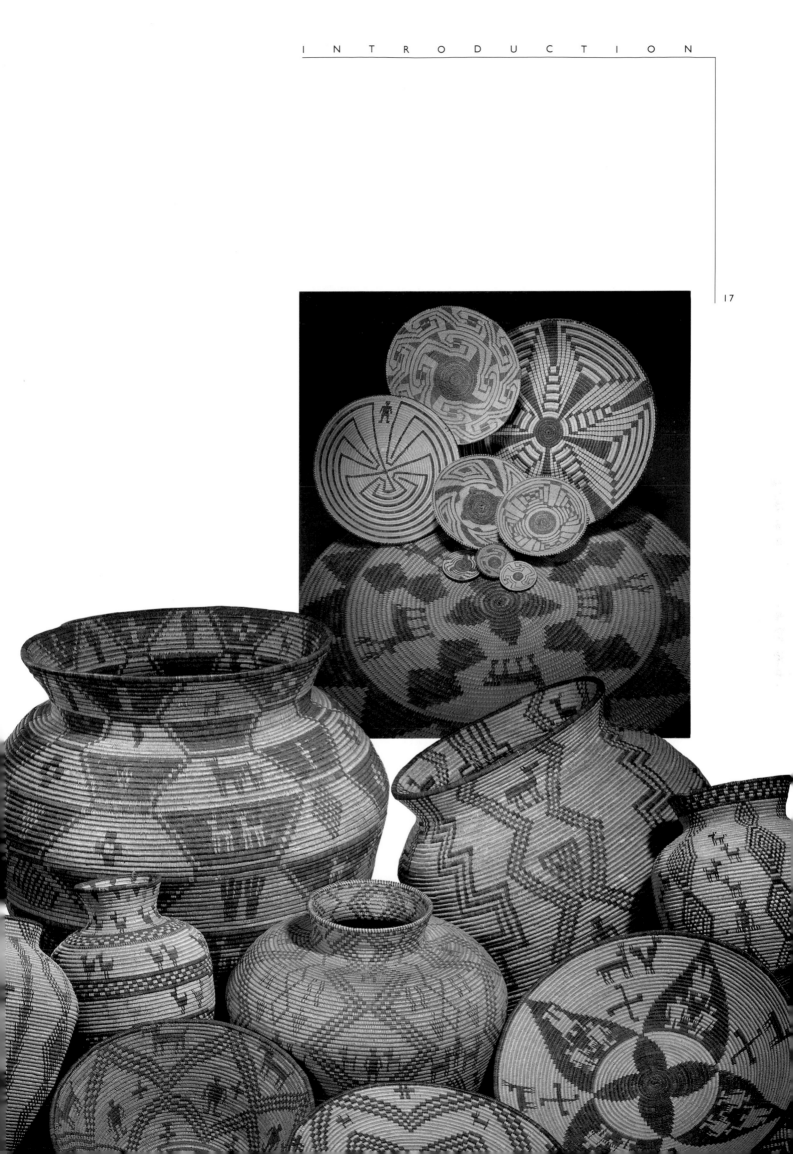

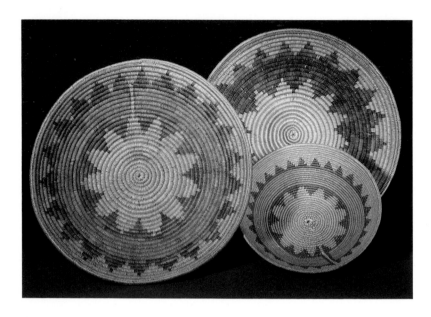

These Navajo "wedding baskets" from the 1880s, ranging in size from 11½" to 17½" in diameter and 3½" to 4½" deep, are woven of sumac. Trays with similar designs are still used in Navajo ceremonies.

OPPOSITE: Navajo "eye dazzler" rug, woven around the turn of the century. Made of Germantown yarn, the rug measures 33" by 49".

forms, including humans, animals, and birds, were added. Form also changed slowly, becoming smaller and more varied. For some years, the Tohono O'odham have woven more baskets than any other tribe, and more than they themselves ever produced before.

Hopis have reduced the quantity of coiled basketry production, but increased quality to a high degree. They perpetuated three basic techniques—plaited, wicker, and coiled—perhaps in part because they continued to use baskets. Plaited ring baskets served as sifters, while coiled and wicker trays frequently appeared in ceremonies. Designs used in wicker and coiled baskets advanced greatly, beginning around the turn of the nineteenth and into the twentieth century. In wicker weave, the Hopi developed very elaborate patterning, using a wide variety of geometrics and life forms such as kachinas and birds.

The history of textile weaving poses a fascinating chapter in the story of Southwestern crafts, for it continued to supply Indians with all of their clothing. Little was brought from the Old World to displace this native production until well into the nineteenth century.

Early in historic years, native cotton continued to be used, and then was partially replaced by wool. Sheep were sheared, the

wool carded, spun, and dyed for native use. There was some trade in commercial wool also; perhaps the best known was *bayeta,* a wool manufactured in England, traded to Spain, and brought to Mexico by the Spaniards. Some of this material, particularly in red, found its way to the Navajo and became a favorite. Bayeta blankets are still highly favored, often as top examples of mid-nineteenth century Navajo weaving. Other types of commercial wool have also been used by the Navajo through the years.

Body and shoulder blankets in the nineteenth century started out with edge-to-edge bands, developing from simple to more complex styles. Toward the end, in the 1880s, a new style, possibly inspired by Mexican weaving, had the familiar geometric motifs running from end to end, some so dramatic as to warrant the descriptive term "eye dazzler." Although dominated by geometrics, before the turn of this century a few life forms were introduced—trains, cows, trees of life—these usually combined with traditional geometrics.

As trading posts brought commercial fabrics to the Indians, changes occurred. Among the Rio Grande Puebloans, textile weaving disappeared about 1880, except for a bit of belt weaving. Shortly thereafter, this craft waned and died at Zuni, but on the Hopi mesas, it has continued to this day, particularly in the production of ceremonial pieces in cotton.

Among the Navajo, the wool blanket that had become a rug was thriving and developing into a highly artistic craft. Variety of design in blankets carried over into rugs. It did not take the traders long to suggest new ideas to these weavers, nor did it take the weavers long to develop their own. As a consequence, rugs of the first decades of this century were indeed quite different from their blanket predecessors.

Vegetal dyes were revived by a trader at Chinle in the late 1920s, and a little later at Wide Ruins. Traders' interest in various parts of the Navajo Reservation seems to have sparked, at least to a degree, what were to become regional rug types, among them Teec Nos Pos, Two Gray Hills, Ganado, Shiprock, and Lukachukai *yeis* (rugs featuring angular Navajo deities).

Inherited from the prehistoric past in the ceramic crafts were techniques and materials, forms and designs. So secure

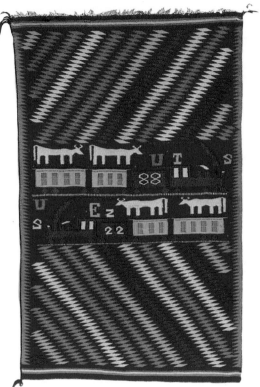

Germantown pictorial blanket, ca. 1880–1885. Figures of cows and trains were among the earliest pictorial subjects in Navajo blankets.

OPPOSITE, *top:* Hubbell Revival blanket (37″ by 72″) made in the late 1890s with an 1870s design. Trader Lorenzo Hubbell encouraged Navajo weavers to revive earlier rug designs such as this. The body of this blanket is made of a rare single-ply carpet wool yarn. Both were aniline-dyed. *Bottom:* Teec Nos Pos-style Navajo rug of the early 1900s. Woven with commercial yarns, this design developed into the typical Teec Nos Pos style.

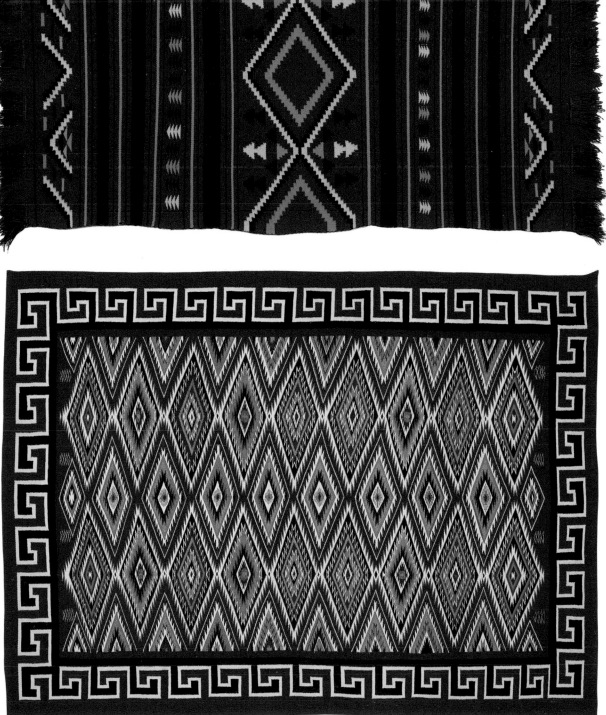

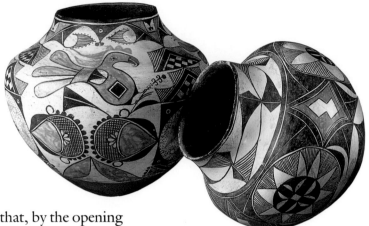

22 | were all of these characteristics in each tribe that, by the opening of this century, a Santa Clara pot could be readily distinguished from a San Ildefonso vessel, despite the fact that the two villages are but four miles apart. Other Pueblo pottery was equally as distinctive.

In the Rio Grande region, San Ildefonso has been a leader in ceramic developments for some years. Not only did Maria and Julian make their great contribution in black-on-black ware, but their son, Popovi Da, branched out in new designs that he painted on his mother's pieces. Santa Clara Pueblo potters developed great sophistication in their black and red wares, which might be plain or have a bear paw or hand design impressed high on a wall. Carving began many years ago on these two wares; on the black style in particular, a variety of carved geometrics and plumed serpent motifs were developed. Favorite themes on Zia's black-and-red-on-buff wares included a great bird, frequently alternating with a floral theme or a deer enclosed in an oval surrounded by multiple decorative patterns. Acoma pottery featured a graceful curve of the vessel's body into the neck, with the design flowing gently along these lines; favored were birds and geometrics. Zunis also used these designs, but featured a sharper

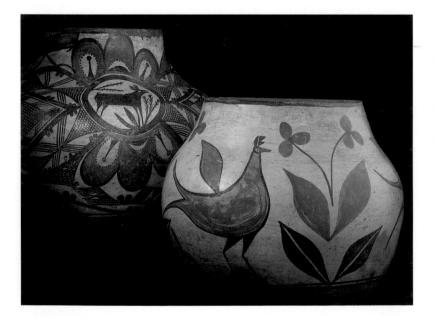

TOP: Bird motifs and geometric designs were common to early Acoma pottery. *Left:* ca. 1890, 11½″ tall, 11½″ in diameter; *right:* ca. 1900, 9¼″ tall, 10″ in diameter.

BOTTOM: Zia polychrome jars, featuring floral and bird designs remain popular to this day. *Left:* ca. 1905, 12½″ tall, 12″ in diameter; *right:* early 1900s, 10¾″ tall, 10″ in diameter.

RIGHT: Zuni pottery: *left,* canteen, early 1900s, 16″ wide at handle; *center,* jar, ca. 1890, 12½″ deep, 14″ in diameter; *right,* jar, ca. 1890, 9½″ deep, 12½″ in diameter. By the late 1800s, Zuni potters had established designs, such as the medallion-and-deer motifs, which remained popular into the 1940s.

BELOW: Hopi pottery vase made during the early 1900s, 16½″ tall, decorated with *Palhik Mana* Kachina.

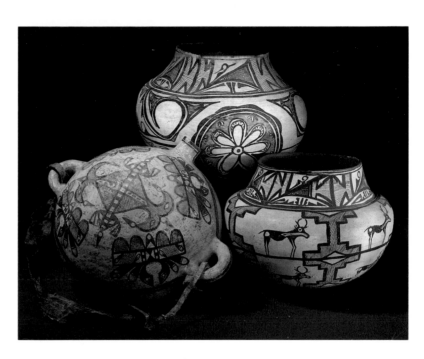

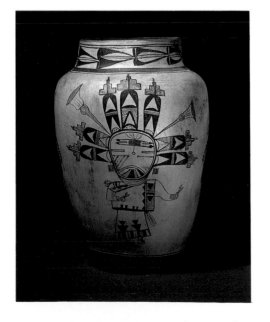

line between neck and body. Geometric motifs filled with fine parallel lines, or deer in panels separated by large medallions, were also common Zuni themes.

Hopi pottery has been an outstanding Southwestern style for many years. From the turn of the century, a ware with a yellow-tan base ornamented in black and red has prevailed; designs have included birds, bird wings, feathers, and a variety of geometrics.

Southwestern Indian jewelry developed along two paths: the old shell-turquoise route and the metal craft style. Many forms of the first appear to be similar to prehistoric pieces, particularly in their use of turquoise, shell, and other stone disc beads as well as some mosaic on shell.

Shell disc beads (or *heshi*) were both small and large, with a tendency, particularly at Santo Domingo, to refined craftsmanship. Turquoise beads appeared. To disc beads, chunks of similar or different materials were added here and there in necklaces, and coral, which came to the Southwestern Indians in the 1700s, was a greatly favored material, particularly for beads, among the Navajo.

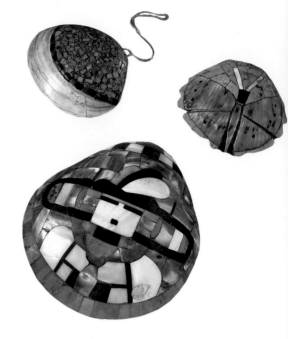

24 Silver was first introduced to the Navajo some time in the 1850s by a Mexican. A Navajo taught a Zuni about 1872; a Zuni taught a Hopi about 1898. Because of this, all early work was in the Navajo style: silver with large stones.

Hammered or wrought silver was typically created by taking a coin or an inch-square of silver and literally hammering it flat, stopping when the desired thickness had been reached. The piece was then cut out, edges finished, and stamped or set with stones—or both. In cast work, a soft stone had the desired form cut into its surface; a plain, smooth-faced stone was then tied against the carved-out piece and molten silver was poured into this mold. When the metal cooled, it was removed from the mold; its irregular edges were clipped, all surfaces rubbed smooth, and if a bracelet, bent into shape. Any stones to be added were then put in their bezels (settings).

One of the earliest pieces made by the Navajo smith was the concha belt. Circular silver conchas were attached to a leather belt, the earliest of which had no real buckle; instead, a heavy silver wire was hooked into a hole in the leather. Eventually, both cast and hammered buckles were made. Hammered pieces often matched the conchas, but cast buckles took on new features, particularly a gently curving motif in each corner.

ABOVE: Zuni pendants of seashell covered with mosaics of turquoise, coral, jet, and several types of shell. All made in the 1920s, these pieces display a style that was an outgrowth of mosaic-on-shell work done by the prehistoric ancestors of the Zuni.

OPPOSITE: The necklace at the top, of Pueblo origin, is made of brass with red beads of an unknown material. The remainder, made of silver, are of Navajo origin. *Clockwise:* small cast najas in place of squash blossoms, early 1900s; cast naja set with turquoise, 1890 to 1900; dimes used in place of squash blossoms and cast naja with turquoise, early 1900s; beads made of Mercury-head dimes, naja with turquoise, 1940s; crosses used in place of squash blossoms, cast naja, early 1900s.

LEFT: Navajo jewelry, ca. 1920–1930. Massive turquoise settings in necklaces and cluster bracelets are typical of old Navajo work.

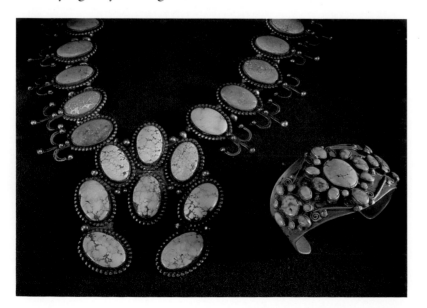

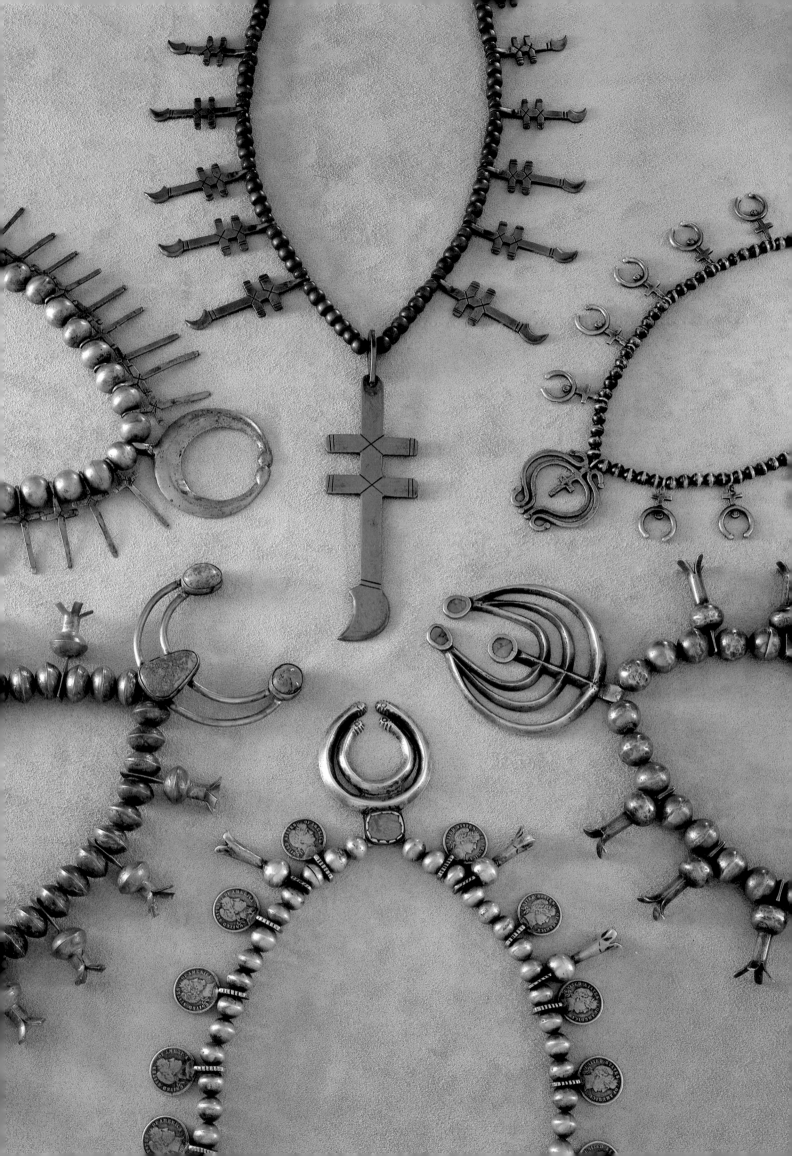

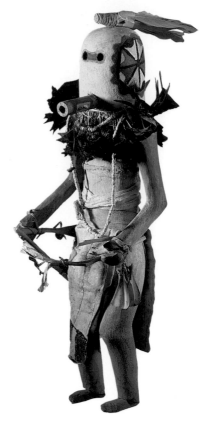

26 Squash blossom necklaces were early favorites of the Navajo. Plain beads were interspersed with graceful silver copies of a squash (pomegranate) blossom, with an added crescent-shaped pendant called a *naja*. Many variations of the squash blossom necklace and the naja developed with time, including the addition of turquoise and other stones.

 The Zuni had a tradition of mosaic work done with small stones that reached into prehistory, and it was natural for them to follow that pathway. They applied their multiple-stone concept to the squash blossom necklace in a variety of ways. One interesting expression of this was a turquoise, shell, and jet mosaic masked figure, slightly bent, in place of each squash blossom; one larger figure (bent even more) replaced the naja. Hopis did not veer from the Navajo silver-turquoise style until after World War II, when they were taught an overlay technique that they subsequently developed to a high point.

 Kachinas represent one of the most interesting aspects of Southwestern Indian religion. Although difficult to clearly define, kachinas are vital to the Pueblo people. They are spirits, deities, masked dancers, carved dolls; they live with the Hopis from December into July, then go back to their homes atop the San Francisco Peaks. They appear in dances on special occasions, masked as a deer, a hummingbird, a creature of the imagination. Their presence is profound in the public dance, in the kiva, and elsewhere.

 Mask and headpiece have always received the greatest attention in both the kachina dancer's costume and the doll. Even in the first known years of carving this piece (during the second half of the nineteenth century), the Hopi represented the diagnostic features of individual kachinas—for example, the horns of Cow Kachina—despite the fact that the body painting and dress were very simply suggested. Stiffness also characterized early dolls.

 In time, the Hopi developed new ideas in relation to kachina carving. Special attention was given to body, legs, and arms as separate entities. Then a sense of action emerged, with arms and legs carved as though in motion, and the body often reflected the dance position. Gradually, proportions and details of body parts became realistic. Throughout, painting was a vital

ABOVE: *Salam Opia* (Warrior), a Zuni kachina doll made between 1910 and 1920.

OPPOSITE: Typical of the static figures in early Hopi kachina carving, these dolls (both 11″ tall) were made about the turn of the century; (*right*) is *Hototo*; (*left*), a Hopi carving representing the Zuni kachina *Hemushikwe Okya*.

BELOW: This Hopi snake dancer (17½″ tall), carved during the 1920s, is not a kachina doll but a representation of the "carrier" in the sacred snake dance.

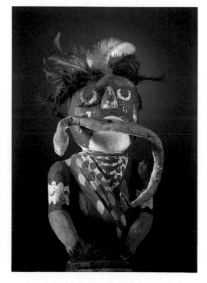

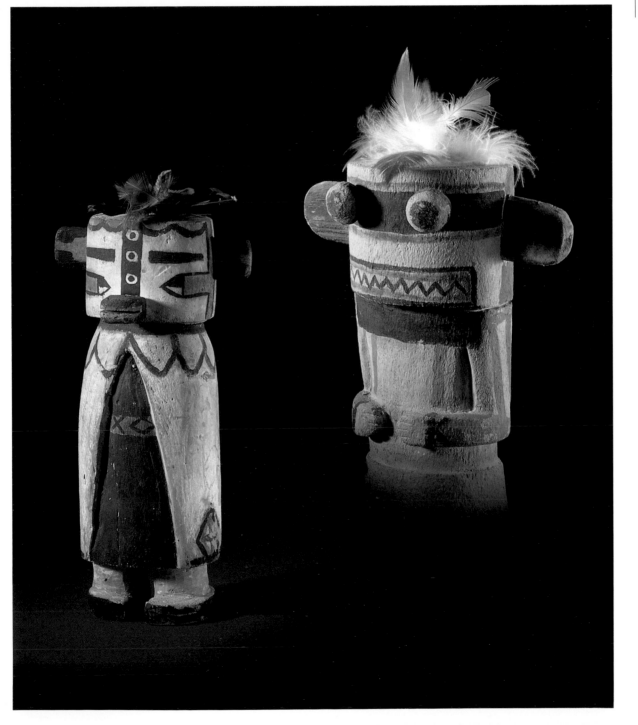

part of kachina dolls, with transitions from native paints to watercolors to acrylics and currently to stain. In contrast to Hopi pieces which normally had all features carved, including dress, Zuni kachina dolls frequently were presented in garments of cloth or skins.

Since its beginning at the turn of the century, Southwestern Indian painting has expressed two major trends. The first was transitional, from painting on craft arts to painting on paper. Second was the melding into modern American (Western European) expressions that started during the 1950s and 1960s.

Certain characteristics predominated in early Indian easel painting from the second well into the fourth decade of this century. Flat colors, no perspective, generally stiff and repetitive figures, and native subjects with emphasis on ceremonials, particularly dances—these were typical traits for some years. Paints were basically watercolors in early years, with a variety later, including acrylics and oils.

Hopi Fred Kabotie started early in his career to put a splash of dark color under or nearly under the feet of each person in his paintings. He also broke up the severe lines of repetitive dancers so typical of early ceremonial scenes, scattering the figures about in different positions. Many other artists conceded to the Kabotie style, eventually adding perspective in the extreme in the way of complete village scenes, which Kabotie also did later.

OPPOSITE: *Butterfly Drinking Water Dance*, a 12″ by 21″ watercolor by Hopi artist Fred Kabotie, was done about 1925. This painting reflects an early trait of Kabotie's, the breaking up of straight lines of dancers and excellent costume detail.

Drawings on the pages of ledgers during the mid- to late 1800s represented an extension of older pictographic art styles, which had been done on stone cliffs and animal hides (note similarities in photo, page 13). This ledger drawing, *The Brave Swordsman*, was done in crayon and tempera by a Kiowa Indian around 1880.

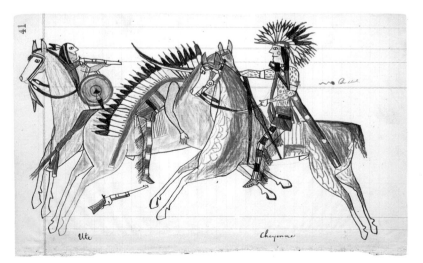

From the beginning, Navajos and Apaches were more apt to paint naturalistically and with a suggestion of background. This trend grew, and in time, complete perspective was a frequent occurrence. In his first work, Harrison Begay (Navajo) had a few stiff plants scattered about, but quickly added further environmental features—red pinnacles, fluffy white clouds, greenery. Sheep, usually accompanied by full-skirted young herders afoot or on horseback, were favored subjects. Begay emphasized details, showing silver decoration of velveteen blouses, native hairdos, horse trappings, a weaver's loom. Whatever he portrayed was carefully and often minutely detailed. His colors tended to be soft, although a bright spot might be added here or there.

Among the numerous miscellaneous crafts that were important to the native people of earlier years were shields, made by every tribe from Tohono O'odham to Pueblo. After they served as protective devices, some became significant for ceremonial use. Usually they were decorated, either with painted designs or by working the leather or skin. Bright or intense colors were not uncommon in Pueblo pieces, with designs ranging from simple geometrics to stars, horns, snakes, and, on one most ornate shield, the addition of a kachina with an elaborate mask.

Various other forms also came out of the past to influence the historic scene—rattles, flutes, and drums, some decorated; cradles with individual form and decoration; buckskin clothing, moccasins, and masks; and commercial beads, which enhanced the buckskin garments as well as utility pieces.

30

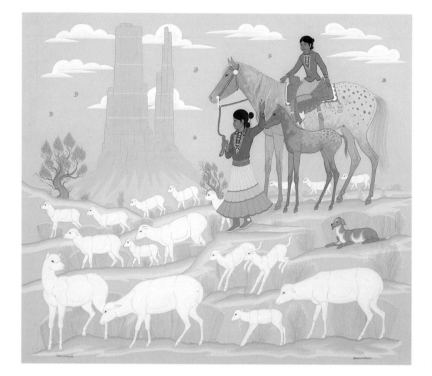

Shepherdess, a 17½″ by 19½″ water-color by Navajo artist Harrison Begay, was probably painted in the early 1960s. Begay's work had a tremendous influence on the development of Navajo art during the 1960s and 1970s.

Prior to painting on paper and canvas, American Indians used baskets, pottery, cave walls, and tanned animal hides. Painted hide shields used in warfare and ceremonies often were magnificent works of art.

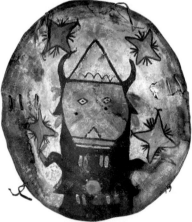

Leather shield collected from Acoma Pueblo. Probably made prior to 1800, the shield may not be of Acoma origin, but was more likely "captured" from another area. While in use in Acoma, the painting on the shield was altered as many as four times.

Indians of the Southwest, then, can be said to have responded artistically along the patterns of their ways of life. Dance and song protected and perpetuated their social relationships, their hunting, war, rain, and religious dependence on everything from corn to the creatures of the forests. All articles of practical and ceremonial use were made beautiful beyond the sheer beauty of form dictated by necessity. Clothing was ornamented with woven, embroidered, painted, and beaded patterns; designs made utility baskets more pleasurable to use. All enriched the individuals' lives and religious experiences and carried the people out of this world into another land of beauty.

Enduring traditions have prevailed throughout the lives of these Native Americans. They built upon an ever-present harmony with nature, on dreams and visions, on constant encounters with new horizons. Native art has evolved out of a unity of tradition, transition, and innovation.

OPPOSITE: This 17″ in diameter Mescalero Apache shield, ca. 1850, is made of buffalo hide that has painted and incised (cut into the hide) designs.

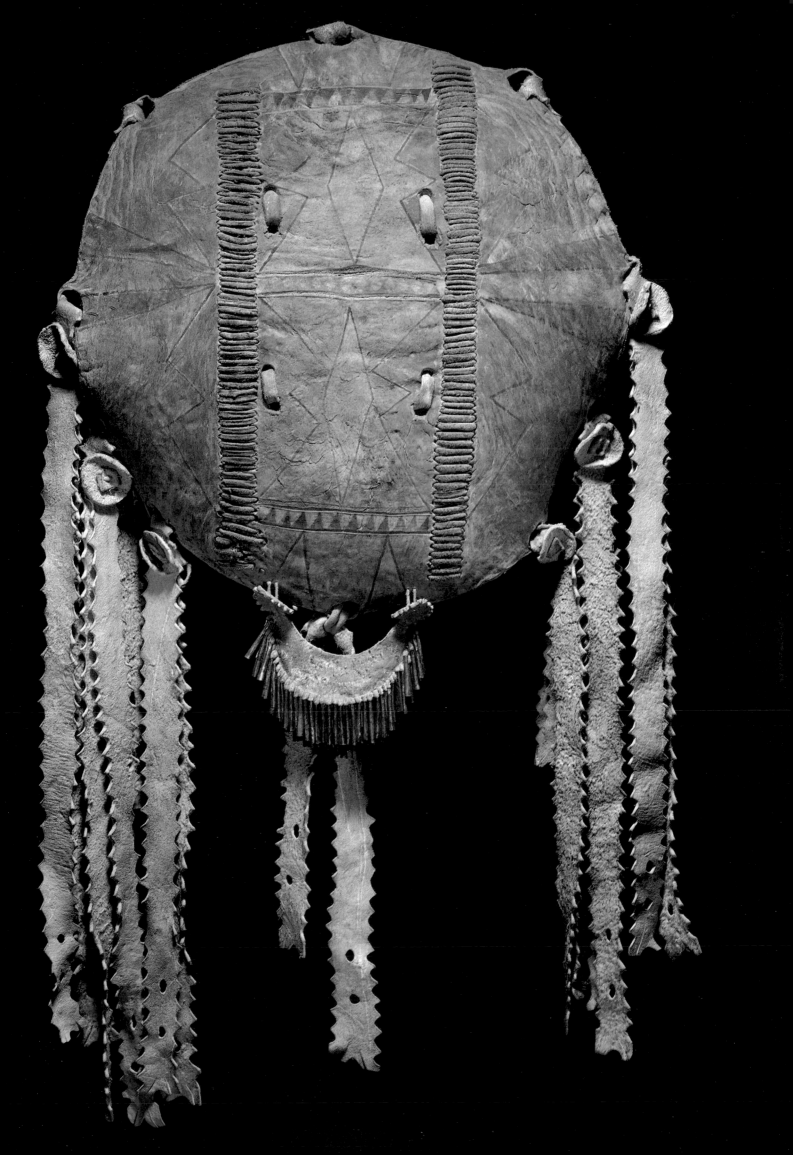

1

With roots deep in centuries-old tra-
ditions, many Native American artists
have entered into the realm of fine art.
Top left: a 40″ tall bronze sculpture,
cast from a black soapstone original
by Navajo artist Larry Yazzie; *below:*
stone effigy made by an unknown
artist who lived in central Arizona
perhaps as long as one thousand years
ago.

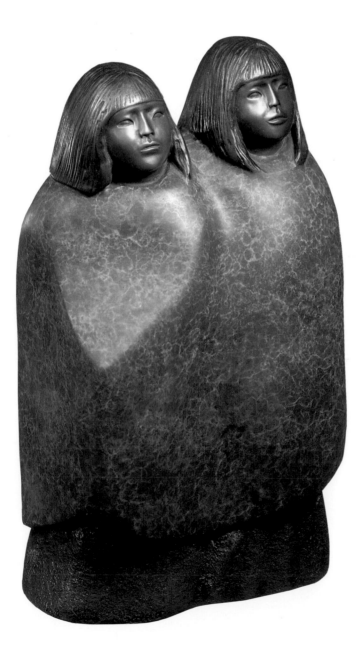

1 Time of Change

CENTURIES AGO, A TANTALIZING RESTLESSNESS filled the soul of a few Native American Indians, and the first quiet stirrings of a dream began. Haunted by a desire to create, one formed a small animal figure from twigs. A tiny turquoise bird was carved by another, and still another pecked a petroglyph in stone. A new era was beginning.

While continuing to endure the trials and dangers of their primitive world, they also began proclaiming its wonders. Seeing beauty in nature, they added to it in their own way, adorning their bodies with ornaments of shell and semi-precious stones, and embellishing baskets and pottery with artistic designs.

OPPOSITE: *The Sisters,* a 13" tall bronze cast from an original stone sculpture by Doug Hyde (Nez Perce/Chippewa/Assiniboine).

As skills were passed down through the ages, new materials became available, new techniques developed, and each succeeding generation contributed its own interpretations and innovations. By the dawning of the twentieth century, the artistic ability of the Native American was becoming legendary and the making of "Indian crafts" was already an ancient tradition.

From this timeless heritage have emerged the contemporary artists of today. They come from all tribes, men and women of all ages, all sizes and shapes, all temperaments and lifestyles: quiet, effusive, reticent, humorous, shy, or gregarious. Some have advanced academic degrees and art school backgrounds, while others apparently learned their skills by osmosis, through association with artistic families and communities. Some are from reservation homelands with strongly traditional upbringing, others were reared amid the diverse influences of urban areas. Regardless of background, they share a fervent pride in ancestry.

However, many rightfully decry the label of "Indian artist," for theirs is art created by artists who are Indian, rather than traditional "Indian art." And, though they are excellent craftspeople who have mastered the skills and techniques of their particular medium, imagination and creativity distinguishes their work from crafts. Yet they are very aware of their Indian ancestry, and even the most contemporary work usually includes some hint of heritage.

From that heritage comes the important characteristics that make up each individual's approach to his or her medium. From ancestors, they receive artistic talent; from their culture, inspiration; and from somewhere deep within comes the courage and tenacity to pursue their dreams. Tenacity is one trait all seem to share, for none of the artists has known overnight success. They have experienced years of hard work, repeated disappointment, and the continued growth demanded by life's struggles.

There is an intensity about them, some inner compulsion that fills them with single-mindedness of purpose as they constantly strive for improvement. With enthusiasm, Hopi carver Loren Phillips described the feeling behind that drive. "I keep moving, trying to satisfy myself. I'm always trying to do something that no one else has. I think about it at night. Improvement! Improvement!...All the time in my head. Advance! Advance!...It will never get out of me. I know I can do it! I push myself! It's exciting and challenging to me. I can't wait to get up in the morning and begin!"

Because artists are driven to try the improbable, the inconceivable, the unimaginable, they fervently search, though perhaps not always sure of their objective. It is not necessarily to be better than other artists, but perhaps better than themselves...to go beyond what they have previously accomplished.

As Loren Phillips added, "If you're really dedicated, you do a lot on your own. I got anatomy books from the library and studied the muscles and ligaments, and how the body looked in motion. When a kachina dance is going on, I look and learn. I see how things crease and fold, or how the leg bends. All the time, I'm watching."

OPPOSITE: In original form, kachina dolls lacked the detail and lifelike qualities found in today's finer carvings. The two figures at the bottom, a Hopi Crow Mother, *Angwusnasomataka* (*left*) and a Zuni Shalako (*right*), were made during the 1930s. The 23″ tall Great Horned Owl, *Mongwa* Kachina (*top*), is the work of Hopi artist Loren Phillips. Carved of one piece of cottonwood root (only the bow and arrow were made separately and added), it typifies the excellence of the sculpture-quality kachina dolls now being produced by some Hopi carvers.

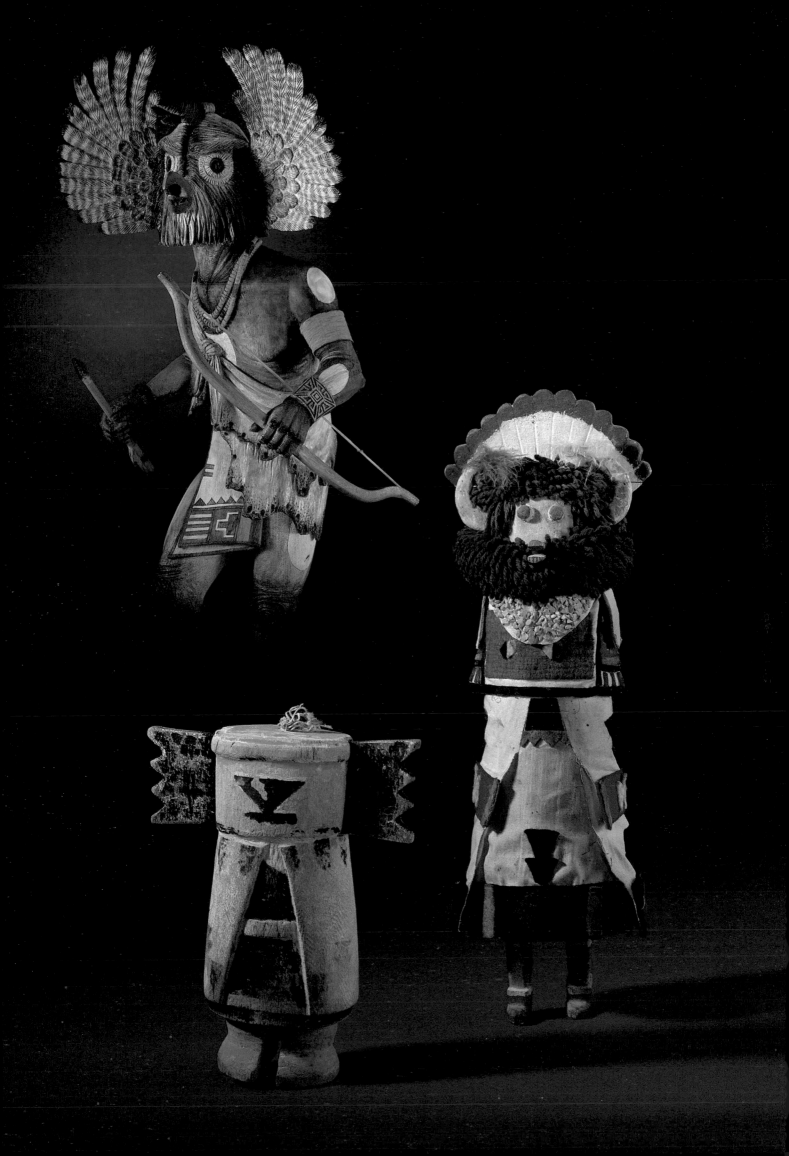

Dennis Numkena, Hopi architect and painter, succinctly expressed much the same feeling. "It's my mission in life to refine and make better as I am learning. I am forever growing!"

Driven by a desire to excel, the artists experiment, exploring new and different methods, often more interested in the doing than in the "done."

Ben Nighthorse (Cheyenne), a Congressman who raises thoroughbred quarter horses on his Colorado ranch, worked for almost ten years to develop a new style of jewelry. "I was trying to develop a jewelry style with the texture and subtleness of sand-paintings by inlaying and laminating different colored metals, and it finally came together. My sandpainter friends have nicknamed it 'Sandpaintings in Silver.'" Ben tried to explain a very involved process in simple terms. "There is no plating or coloring of this jewelry. I start with as many as five different met-als: twenty-gauge thick, 18-karat gold; sterling silver; copper; brass; and German silver. It is handcrafted by cutting out the designs [as in Hopi overlay], then inserting and silver soldering a different metal into the cutouts. It is very labor-intensive (thirty-eight steps, if I use four metals). But I believe it is the first really new style of Indian jewelry in more than two decades."

New techniques and different styles are attempted for any number of reasons. In fact, sculptor Doug Hyde (Nez Perce/ Chippewa/Assiniboine) admitted that at first he was a little reluc-tant to try bronze as a new medium. "Stone has so much matrix and variation in color, I couldn't visualize how things would look in bronze. I worked on black stone first, just because it was more like smooth metal, and I worked a patina into the metal so it would have the feel of stone. But now I'm comfortable with bronze and know how something will look." Then he added with a grin, "It's exciting to try something different."

Another experiment may come from a mind teeming with curiosity. As Hopi potter Al Qöyawayma talked, he pondered his subject almost as though talking aloud to himself. "There are so many mysteries out there. Like Sikyatki pottery...I wonder how it was made, where did they get the colors, clays, etc. Other pots look like Sikyatki, yet have a different type of paint. Are we deal-ing with one individual potter, one village, or what? How did

Inspired by the ceremonial art of sand-painting, Ben Nighthorse (Cheyenne) conceived this new style of inlay/overlay jewelry, using metals such as gold, silver, copper, and brass.

they form their clay? Is mine like theirs?" The creative mind suddenly leapt ahead to another thought and he added, "Pottery made in the past was reflecting its present; most pottery today reflects the past. I find myself wondering what I can do to reflect the present."

The search goes on as artists strive to answer questions in their minds and express feelings evoked by their imagination. As a result of that search, an interesting phenomenon has occurred. Because of their desire to be free of all constraints, tribal lines are being crossed, cultures assimilated, and sexual barriers broken. As individual artists rise on merit alone, today's art is becoming a blend of contemporary styles that bear no label.

Often, however, a price has been paid for this individuality. Some artists encountered family opposition to any deviation from traditional art forms. When Nancy Youngblood Cutler, from a long line of noted Santa Clara potters, began to experiment with new, contemporary designs, not all family members approved. "But," Nancy said quietly, "I would have gone out of my mind just making the same things over and over." Perhaps that is one primary difference between the artist and the craftsman; the craftsman is content repeating his work, albeit with

excellence, while the fertile imagination of the artist will not allow him to remain passive.

Contemporary artists are encouraged by the success of those who led the way into the realm of fine art. In seeking to satisfy their own desire for fulfillment, these individuals broke away from traditional "Indian art," thereby helping to pave the way for others.

Allan Houser (Apache), known as the "Patriarch of American Indian Sculptors," opened the floodgates for a new generation of artists. Forming Native American tradition into bold sculptural lines, he not only had an impact on the students he taught over the course of fifteen years at the Institute of American Indian Art, but has inspired countless others.

Santa Clara potters Joseph Lonewolf and Grace Medicine Flower also initiated a trend with their finely detailed, incised designs. "It all started at San Ildefonso," Grace insists. "I give all the credit to Popovi and Tony Da. They were really the first [to use these particular techniques], and I was so impressed with Tony's work." However, in adapting the incising to her own designs, Grace created a style so different that she earned a place among the top innovators. Joseph Lonewolf, Grace's brother, created his own version of incised pottery. His strong, vibrant designs of wildlife and ancient symbolism offered a contrast to the light, airy butterfly-and-blossom motifs of Grace's delicate vases and seed bowls.

Popovi and Tony Da of San Ildefonso are son and grandson, respectively, of the world-renowned potter, Maria Martinez. Polychrome ware, which had been abandoned around 1925, was reintroduced by the late Popovi. By experimenting with firing, he created sienna and black-and-sienna wares, and perfected gunmetal wares, all within a few years' time. Tony not only popularized the use of turquoise on pottery, but was among the first to incise or etch designs. Incising, also referred to as *sgraffito*, is executed on the pottery after it is fired. Designs are etched through the outer layer (or layers) of slip covering the surface of the clay vessel.

Tony and the late Helen Hardin, of Santa Clara Pueblo, were among the first painters to depart from traditional styles.

Tony Da, grandson of Maria, the famed San Ildefonso potter, created new dimensions in Pueblo pottery by incising designs into his red, black, and sienna pottery and further embellishing it with turquoise. Here, the *avanyu* (plumed serpent) forms the central design theme.

While still in college, Tony began creating exceptional abstracts, often incorporating ancient Mimbres designs. Helen Hardin is considered an innovator for two reasons. First, it was most unusual for a Pueblo woman to be a painter (the women made pottery, the men painted), and second, her precise geometric abstracts became a much-admired style. In breaking the bonds of tradition, she opened doors for others, particularly women.

Credited with bringing about major changes in Navajo jewelry, Kenneth Begay strayed from tradition with the simple elegance of his designs. Most Navajo jewelry of that period was massive with large turquoise stones, and the grace of Kenneth's style inspired a new trend.

Charles Loloma (Hopi) is readily acknowledged as the grand master and leader in contemporary jewelry art. The first to use rare gems, he created colorful collages of exotic stones on jewelry with unusual architectural shapes, all inspired by the Hopi world in which he lives. His bold, imaginative designs and inimitable style have earned him international renown.

However, the first wave of contemporary artists found that acceptance of their art was slow in coming. When Charles first entered his unique jewelry in Native American exhibitions in the late fifties, it was rejected as not being "legitimately Indian," for it didn't meet the predictable criteria of Indian art styles.

Galleries at one time refused to accept contemporary paintings by Jaune Quick-to-See Smith (Flathead/Shoshone/French-Cree) stating that they "weren't Indian enough." So Jaune formed The Grey Canyon Group. "I rounded up half a dozen Indian artists like myself who were having the same problems," Jaune explained (two of them, Emmi Whitehorse and Conrad House, are included in this book). "I'd put on a pot of stew and we'd sit and talk." But Jaune also began writing to museums and galleries across the country and eventually arranged thirteen group exhibitions for one summer season. Later, an exhibition of their combined works toured the United States for two years. "It goes to show what can be done," Jaune commented. It certainly does in this instance, for those few struggling individuals, whose art was "not Indian enough," have now become leaders among contemporary Native American artists.

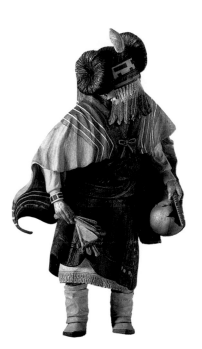

The *Kachin-Mana* by Dennis Tewa (Hopi) displays subtleties of motion; the windblown cape and skirt and the twist of the head and body seem to give life to this one-piece carving.

OPPOSITE: Among the first to break traditional barriers in painting was the late Helen Hardin of Santa Clara Pueblo. Hardin's acrylic, entitled *Recurrence of Spiritual Elements* (22″ by 23″), is typical of the style that she introduced to American Indian art.

In the past, many gallery owners discouraged change in traditional art forms, for they knew that the buying public wanted "Indian art." And, indeed, buyers questioned why they should purchase art that was not readily identifiable as "Indian."

Potter Jody Folwell (Santa Clara) talked about her beginnings as a contemporary artist. "I decided I must become more ingenious, for without a 'name,' I couldn't *give* my pottery away," she explained. "I watched a neighbor doing incising on his pottery and decided to take something I could do [traditional Santa Clara pottery] and go a little more abstract. I didn't want to go too 'far out,' but even the half-step I took was too traumatic for most dealers and buyers." Then Lee Cohen, owner of Gallery 10, recognized her unique talent and purchased two of her pottery pieces at Santa Fe Indian Market. He soon returned, offering to buy everything she made.

Another problem that often plagues the artists is the use of deities or sacred objects in their designs. Torn between artistic desire and the wish to keep inviolate the spiritual essence of their culture, each must set his own rules. A very thoughtful Dennis Tewa (Hopi) pondered the issue before discussing it rather solemnly. "The kachinas are to be respected, I know; I take part in ceremonies myself. But, according to Hopi prophecy, one day the kachinas will no longer exist. I like to think that by carving kachinas, I'm helping to preserve that part of our culture. Maybe someday, my people will be glad that I did."

Delbridge Honanie, *Coochsiwukioma,* carves wooden sculptures that portray Hopi daily life. "I don't carve scenes from our ceremonies, because those events are sacred and secret," he explained. "I carve scenes from everyday life: working, planting, and, once in a while, something from one of our legends."

Clifford Brycelea (Navajo) has been taught that he must not duplicate certain ceremonies, legends, or objects. "There are a lot of things I can't do. I try not to put everything on canvas because some things are so sacred. If I paint even a part of those things, I have to bless myself first; I say a prayer and sprinkle corn pollen."

The *yei bi chai,* powerful deities of the Navajo, are one of the most popular subjects among artists because of the intensity of the feelings they evoke. However, each artist places limitations on using these images.

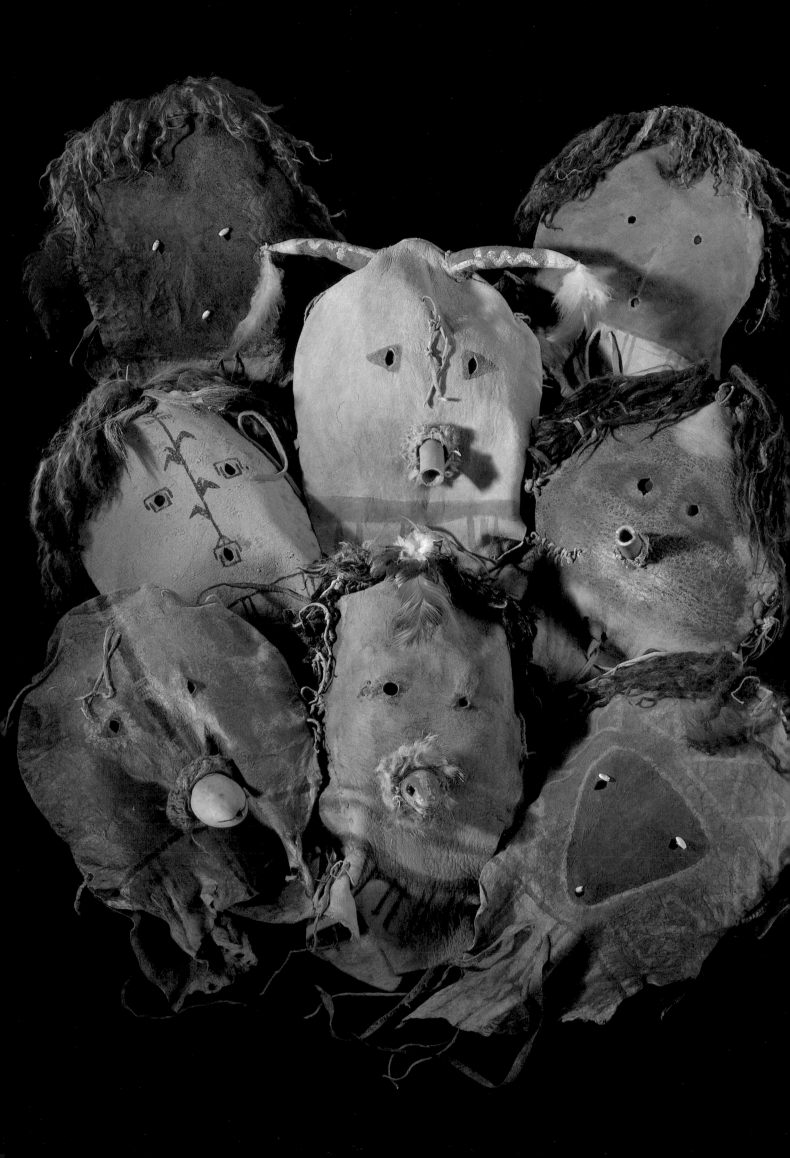

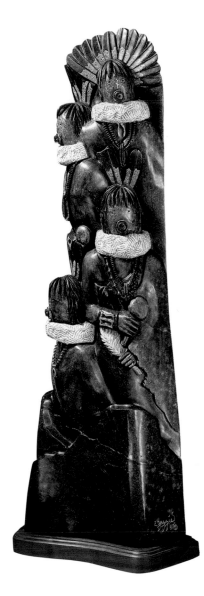

Contemporary Navajo sculptor Larry Yazzie portrays the *yei bi chais* in this 45″ tall black soapstone piece, entitled *They Chant Through the Night.*

OPPOSITE: *Yei bi chai* masks of the early 1900s used in Navajo ceremonies. Made of tanned deer skin, they are embellished with mineral paints, dyed wool wigs, fox skins, and feathers. In themselves excellent examples of early ceremonial art, the *yei bi chai* is now the subject of many contemporary Native American art forms.

45

Ric Charlie (Navajo) spoke of using the figures in his jewelry: "I feel a sense of power when making *yei bi chais*. They are spiritual healers, Gods that protect. I never portray them as they really are. If I go too far [in depicting their image], my casting will not come out. It's like I hear them say, 'Not this time, Ric. Maybe another time.'"

Other artists alter the color or design of significant symbolism. Joe Ben Jr., Navajo creator of contemporary art sandpaintings, explained. "I take the designs as they are used in the ceremonies, but change the true colors, because it would be sacrilegious to use them. I use my own color interpretations."

Navajo sculptor/painter Tomas Dougi Jr. can't bring himself to do art that might offend his people. Reared in a very traditional Navajo family, Tom's ancestral history reads like no textbook ever written. When Kit Carson rounded up the Navajos in the winter of 1863-64, Tom's great-grandfather took his wives and children to Navajo Mountain for protection, thus avoiding the long walk to Bosque Redondo. Much of Tom's family, including his father, still live in the Navajo Mountain area. "I would love to sculpt my grandfather on Haystack Mountain," Tom says with regret, "but my father says 'No.' Maybe someday…" However, respect for his heritage outweighs his artistic desire.

In many Native American cultures, sexual barriers exist for artists, although they are gradually fading. Definite lines were drawn over the years as to which arts could be practiced by men and women; for instance, Navajo rug weaving was done by women, Hopi weaving was done by men. Few, if any, men were potters, although there were those who painted designs on pottery made by women of the family. When Tom Polacca (Tewa/Hopi), of the Nampeyo family of potters, first began making pottery, he didn't acknowledge his work. Then came the day that a trader arrived unexpectedly as the pottery was being fired, and Tom was "discovered." He then proceeded to publicly forge to the forefront of the carved pottery designers, with many other men following his lead. Yet two Navajo men, weaving some of the most magnificent contemporary rugs today, insist on remaining anonymous because of peer pressure.

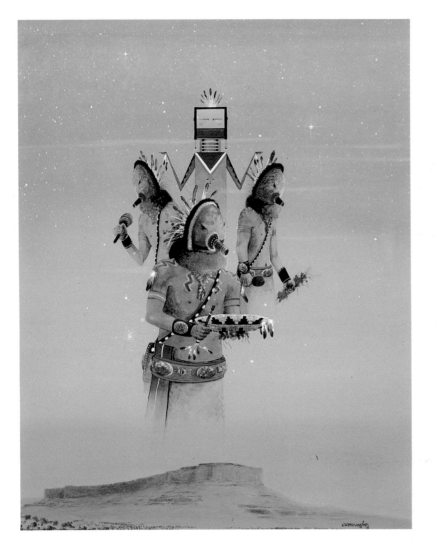

This watercolor, *Yei bi chai With Mesa* by Clifford Brycelea (Navajo), represents the sacred spirits appearing over a sandstone mesa in Navajoland.

OPPOSITE, *top: Yei bi chais* are the prevalent theme in this sandcast jewelry by Ric Charlie (Navajo), set with diamonds, rubies, turquoise, and coral. The three silver pieces at the left incorporate a technique unique to this artist, in which patina is applied to the surface of the silver, thus producing varying hues similar to patinas that appear on bronze sculptures. *Bottom:* The pottery jar by Lucy Leuppe McKelvey (Navajo) incorporates the *yei bi chai* mask as an important design element.

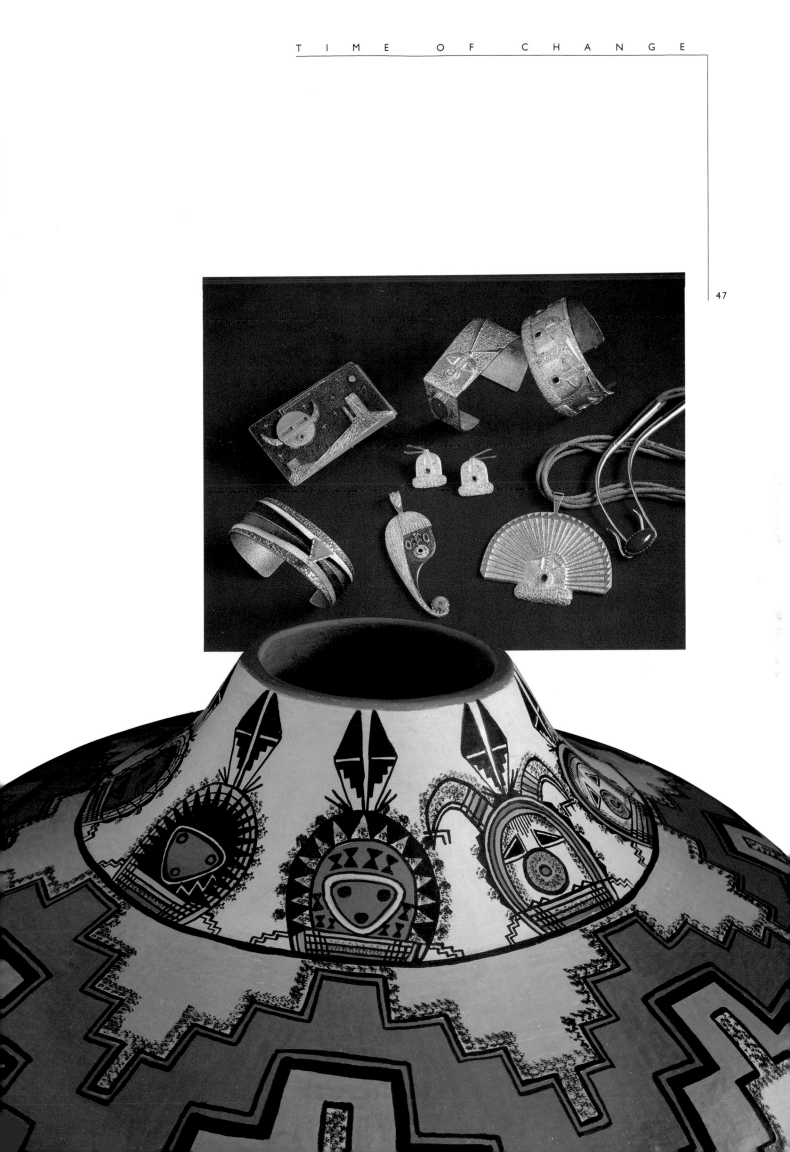

There are no absolute solutions, and while these problems exist, each artist must individually make the final decisions. However, it is becoming somewhat easier, as cultural and family criticism lessens. Whatever the cost, the tide will not be stemmed. Exceptional artists continue to come forth, stepping beyond tradition to declare themselves.

As its popularity increases, non-traditional work is gaining an international audience, and Native American artists exhibit their work in Italy, Australia, Germany, France, Japan, Finland, and other countries.

Charles Loloma has traveled the world, lecturing and taking part in exhibitions, and pieces of his jewelry have been given as Gifts of State to foreign dignitaries, including the Queen of Denmark. Creations by jeweler Ted Charveze (Isleta) are also included in her collection, and in that of the Princess of Luxembourg as well. Commissioned to create several exclusive pieces of jewelry a year for Percy Marks, a prominent Australian firm, Ted also designs jewelry for Paris-based Cartier, as well as Imperial Enterprises in Japan.

During a 1983 audience with the Pope, Santa Clara sculptor Michael Naranjo (blinded in Vietnam) was invited to "view" the famed Italian sculptures at the Vatican by touch, which is normally not allowed. However, that once-in-a-lifetime experience recently became "twice." During the filming of a CBS documentary featuring Michael, he was asked if anything in the Italian museums had been missed, and immediately answered, "Michelangelo's *David*." Then he laughingly explained, "He was so large, all I could reach was his big toe." CBS took charge. Michael and his wife Laurie were flown to Florence with a film crew of six. A scaffold was erected for Michael, and he clambered around, touching the *David* from all angles while the cameras rolled.

"But," Michael remarked, "if it had never been filmed, if it was never shown on television, I still gained so much. It was incredible!"

Architect/painter Dennis Numkena embarked on an exciting new venture that led to Vienna. Invited by the Austrian government, he is designing sets and costumes with a contemporary

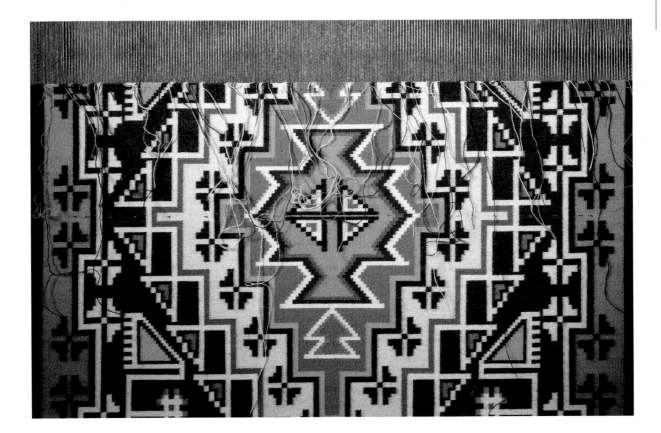

Partially completed masterpiece on the loom of a Navajo man who prefers to remain anonymous. Weaving only on a part-time basis, he creates some of the finest of contemporary Navajo tapestries. His work incorporates Burnt Water colors with intricate rug patterns of the Two Gray Hills area.

Hopi theme for Vienna's production of Mozart's opera, *The Magic Flute*. Taking a one-year sabbatical from his architectural firm, Dennis has made several trips to Vienna to work on the project. "I'm going to stay a month or so when I make the final trip," Dennis explained. "My plan is to follow Mozart's trail—visit some of the places he did, go to some of the pubs he hung out in. I want to get the feel of what the people are like. This is so great, because it involves three of my loves: art, architecture, and opera."

It is a time of change in the Native American art world. Innovations flourish as new artists appear on the scene, while other artists, already successful, are reaching out in new directions, their talents continuing to unfold and develop.

As Tony Moná, Artistic Gallery manager, thoughtfully remarked, "There are a lot of restless souls out there."

RIGHT: The craft of making jewelry is transformed into contemporary art by Andy Lee Kirk of Isleta Pueblo. The beads are of sugilite (*left*) coral (*right*), and hand-wrought, 14-karat gold with single accent beads of turquoise, opal, and lapis lazuli. The pendants are cast gold (*left*) and fabricated gold set with coral and diamonds (*right*).

BELOW: Constantly seeking new ways to interpret prehistoric art through his sculptured pottery, Hopi Al Qöyawayma creates a myriad of shapes and styles that not only reflect the past but also capture the essence of contemporary Indian art.

OPPOSITE: There are many inspirations underlying American Indian art today. Nancy Youngblood Cutler (Santa Clara) began incorporating seashell motifs in her work after vacationing on St. Martin's Island; still, ancient tradition continues to be an influence as she uses eleventh and twelfth century Mimbres feather designs (*top right*) and stylized interpretations of ancient melon-shaped pottery vessels (*lower right*) in her work.

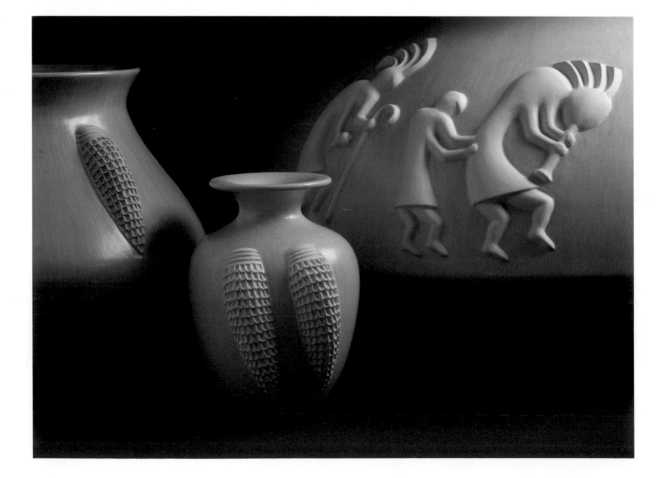

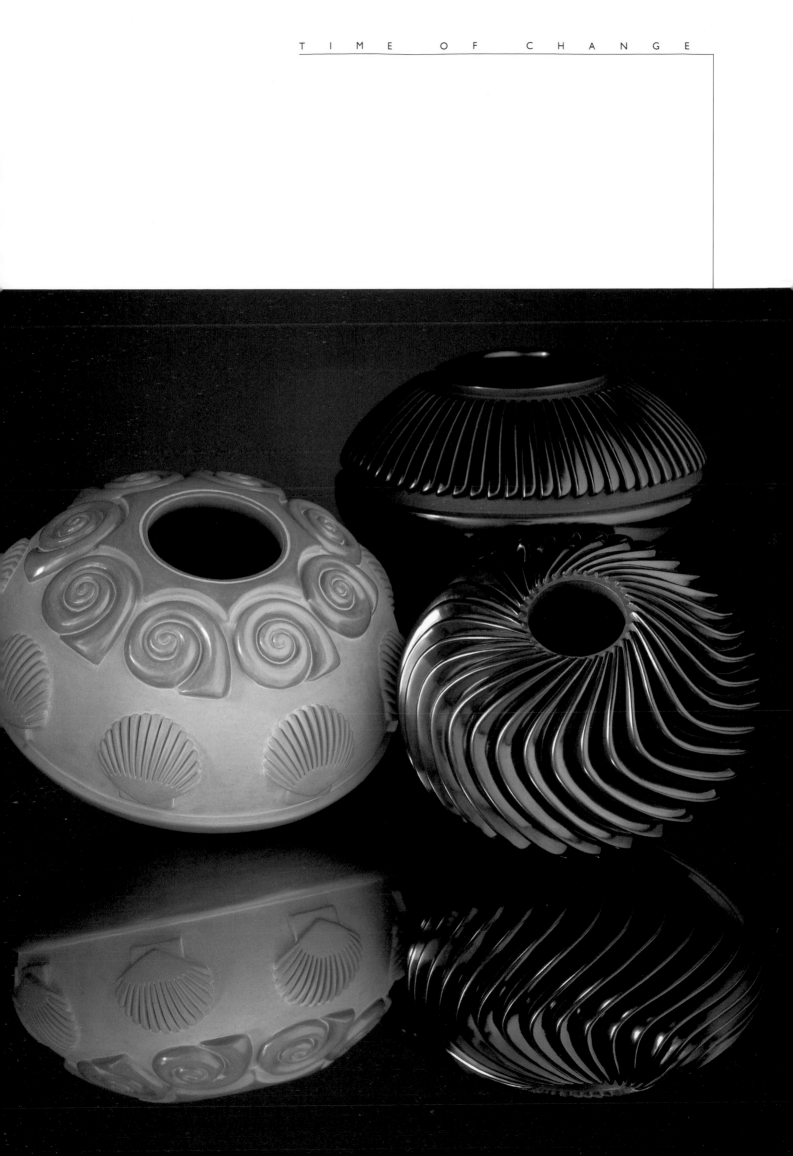

Necklaces of beads were among the earliest forms of body adornment for Native Americans. *Above left:* Necklaces of turquoise, shell, argillite, lignite (jet), and other materials were made during prehistoric times in the southwestern United States. Made with stone-age tools, these beads are incredibly delicate and finely executed. *Above right:* John Christensen *Keokuk* (Sac/Fox) brings a new dimension to the art of bead-making. Averaging .036 of an inch in diameter, with hand-drilled holes that measure .012 of an inch in diameter, the beads are made of 14-karat gold, sterling silver, coral, turquoise, lapis lazuli, serpentine, jet, pipestone, ivory, amber, and a variety of shell.

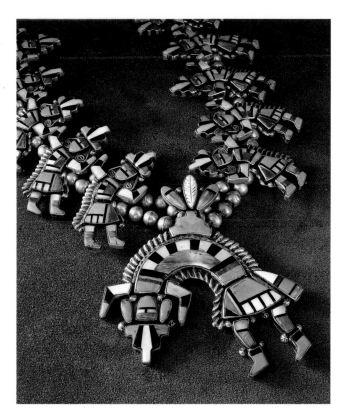

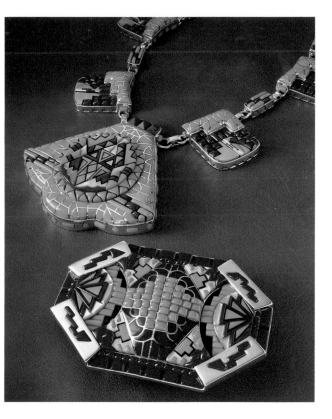

ABOVE LEFT: Typical of the mosaic inlay style of Zuni jewelry, the necklace by Merle Edaakie, made in the 1930s, features Rainbow deity figures.

ABOVE RIGHT: Carolyn Bobelu (Zuni) sets turquoise, coral, jet, and shell in multiple levels to create jewelry with striking architectural qualities. The buckle, *Promise of a New Day,* and the necklace, *Alive With Beauty,* represents a bold departure from the mosaic inlay and channel setting of stone and shell that had become hallmarks of Zuni jewelry by the 1940s.

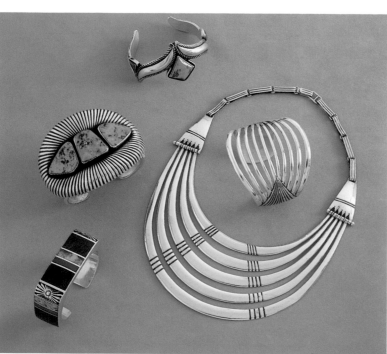

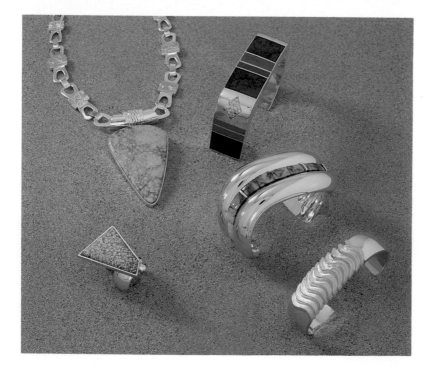

ABOVE: A distinctive trademark of the ancient Hohokam potter was the use of a single abstract design to form the entire pattern on their red-on-buff pottery. This piece, made between A.D. 600 and 1,000, has the "flying bird" motif.

OPPOSITE: Dorothy Torivio (Acoma) has developed her own style using repetitive designs that appear to expand and contract in concentric unison.

LEFT, *top*: By the 1950s, the bold but simple styling of the late Kenneth Begay set new trends in Navajo jewelry. *Bottom*: Harvey Begay, Kenneth's son, now creates exceptional works that combine his father's influence with training in design and gem-setting from the late Pierre Tourraine.

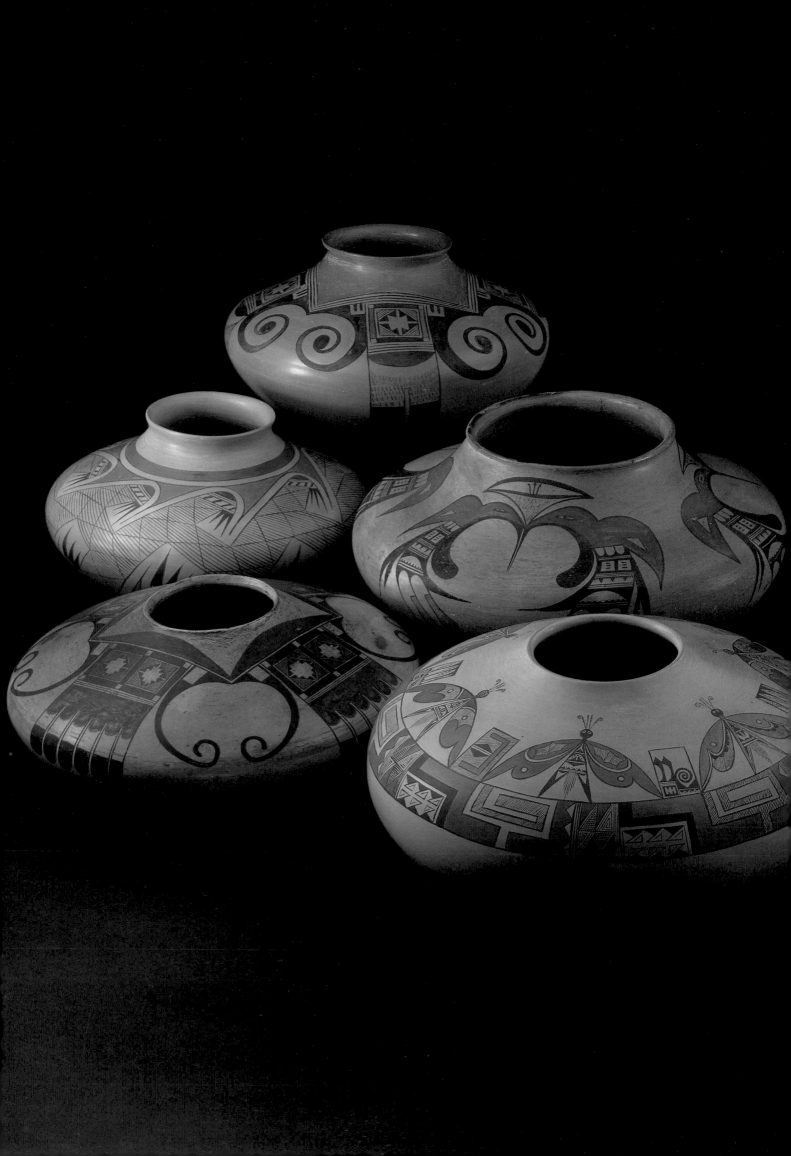

Nampeyo was the Tewa / Hopi pot-
ter credited with the revival of
fifteenth century Sıkyatkı polychrome
wares. Her three daughters—Annie,
Nellie, and Fannie—were also excel-
lent potters and, today, Nampeyo's
descendants continue to carry on the
family tradition.

OPPOSITE: Three generations of Nam-
peyo pottery: *Top/top left* are by
Fannie Nampeyo (daughter); *upper
right/lower left* are by Nampeyo; *right
front* by Dextra Quotskuyva (great-
granddaughter). Note the use of the
butterfly design similar to prehistoric
motifs; Dextra is known for her use of
ancient pottery designs adapted to
contemporary styles.

Several male descendants of Nampeyo
have also become noted potters.
Her great-grandsons (*right*) Gary
Nampayo Polacca (Thomas Polacca's
son) and (*below*) Loren Hamilton
Nampayo both create unique styles
using their own variations of carving,
painting, and incising.

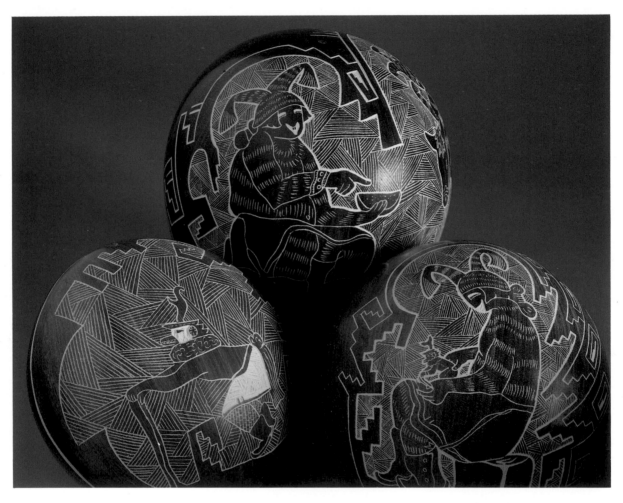

Thomas Polacca's daughter, Carla Nampeyo (granddaughter of Fannie) created these delicate seed jars. Incised with deer dancers and Koshari clowns, they range in height from 2¾″ to 5¼″.

OPPOSITE: Fannie Nampeyo's son, Thomas Polacca, has added his own innovations to the Nampeyo pottery tradition. In this multiple-exposure photograph, three views of a completed vessel appear above the same piece, which is also shown in the initial stage of carving. The design is carved and incised in detail, then sanded, polished, and painted before the final step of firing.

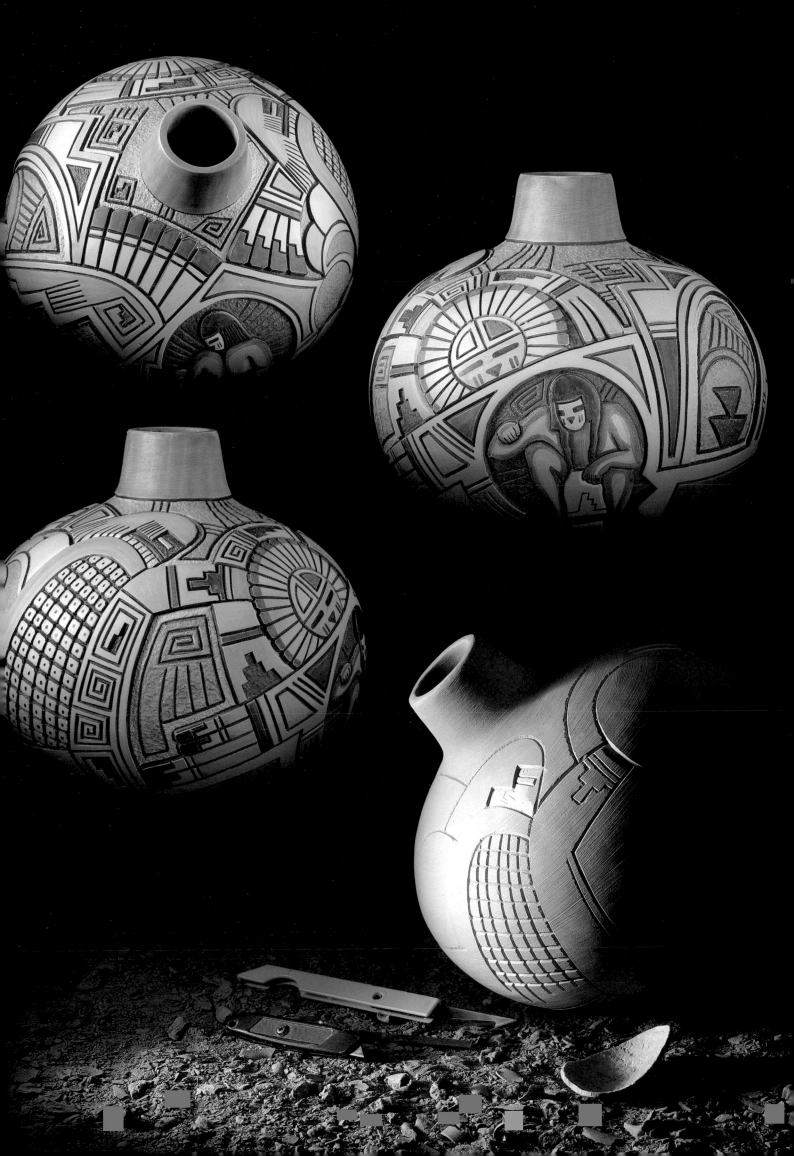

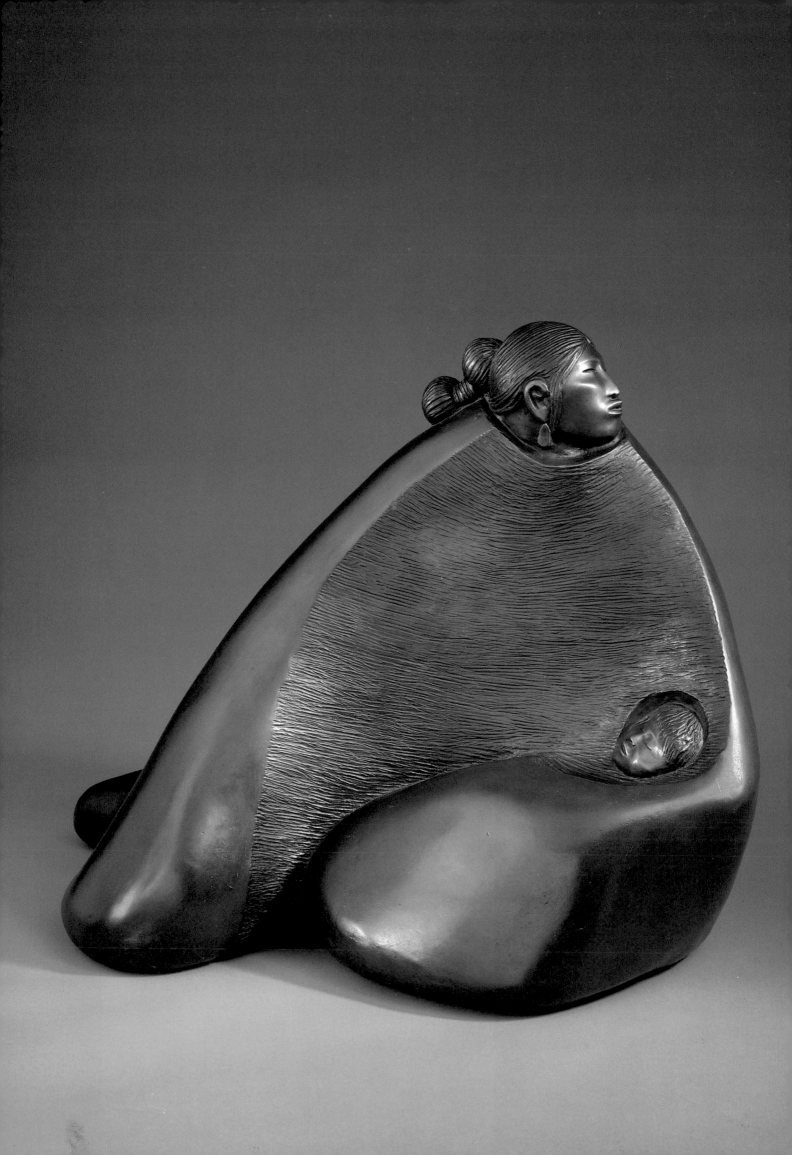

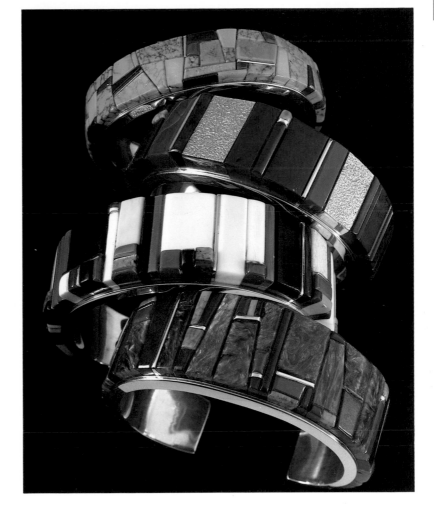

Charles Loloma (Hopi) and Allan Houser (Apache) were in the forefront of the contemporary Native American art movement. Loloma, a potter and a painter, became internationally recognized for his extraordinary jewelry (right) that incorporates exotic precious and semi-precious stone in silver and gold creations. His success encouraged other Native American artists to enter into a new realm of fine art.

OPPOSITE: Allan Houser demonstrated that Indian artists could excel in the fine arts of painting and sculpture. He taught and inspired countless successful artists, and continues to create masterful bronzes and stone sculptures. Shown here is *Sound of the Night,* 18½″ tall.

62

Brushpoppers, a 30″ by 32″ pastel by Jaune Quick-to-See Smith (Flathead/ Shoshone/French-Cree), is one of a series of paintings representing the artist's interpretations of the West Mesa Escarpment near Albuquerque, New Mexico, that is estimated to contain at least 15,000 petroglyphs.

OPPOSITE: The paintings of Dennis Numkena, renowned artist and architect, often reveal his background in design. The Hopi artist commented of his oil on canvas, *Dancing Spirits of the Fourth World:* "It is an expression of new Indian architecture...a combination of the futuristic and fantasy."

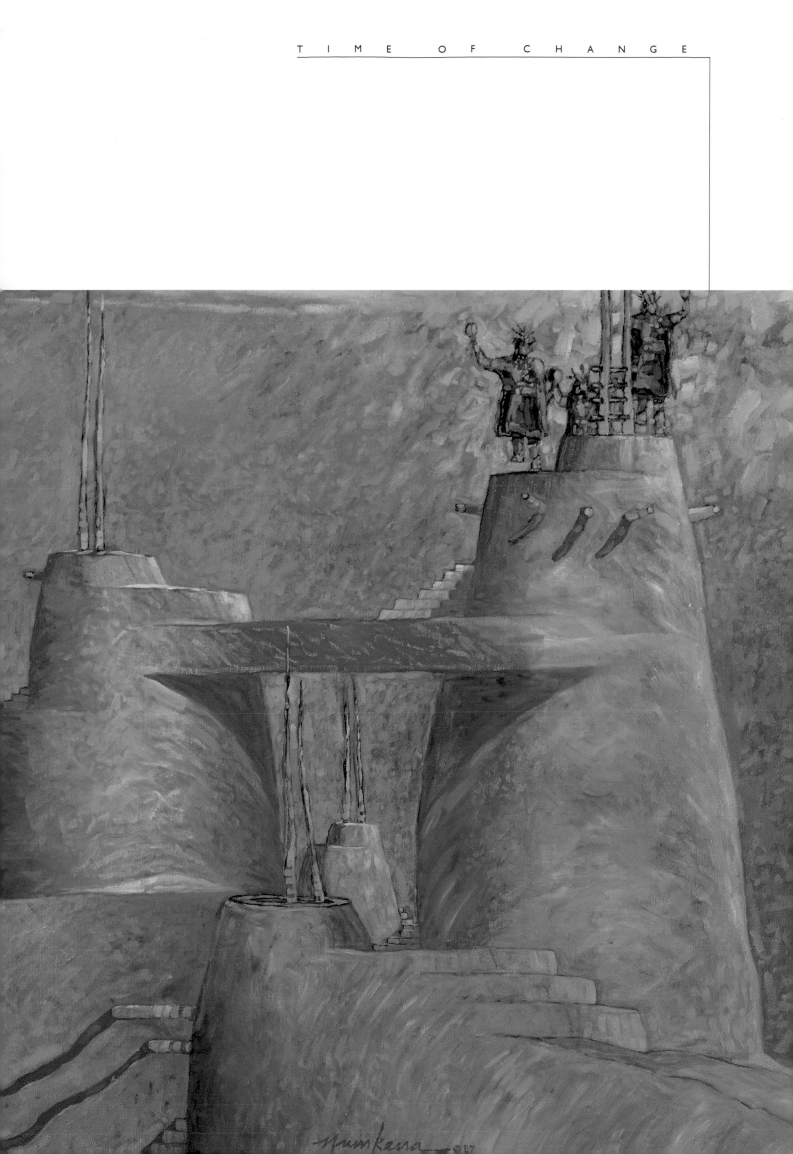

2

Continuing a centuries-old tradition,
Angie Reano Owen of Santo Domingo
Pueblo creates unusual jewelry by
applying shell, turquoise, and a variety
of other stones in mosaic fashion on
shell and cottonwood.

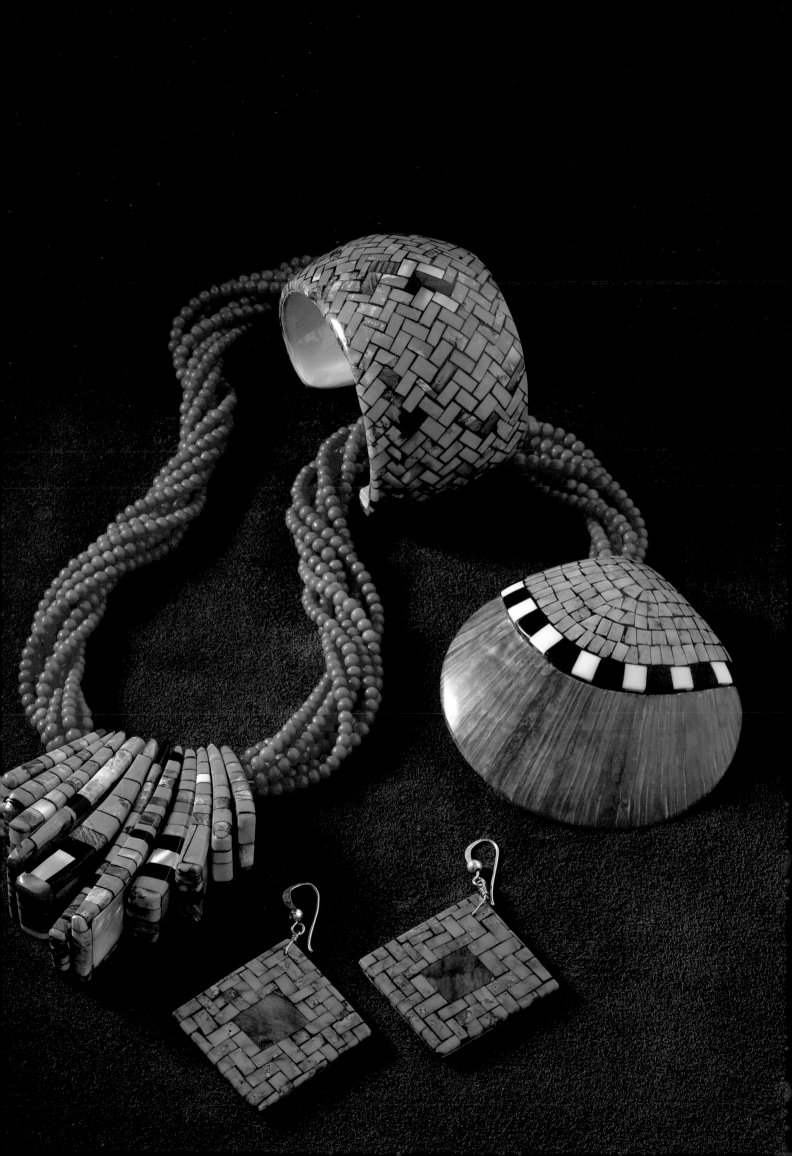

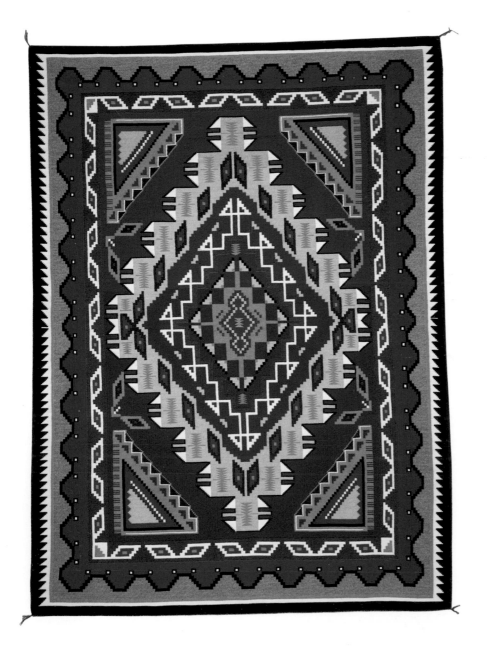

2 Enduring Traditions

Native American artists today walk a pathway that has been traveled for thousands of years. In their memories lie the traditions of their ancestors, in their visions lie the horizons of the future. As time-honored art forms are interpreted in contemporary designs and revolutionary colors, cultural heritage is never far below the surface.

Although some artists use more traditional symbolism than others, it is not necessarily the reservation-born-and-bred individual who is the most traditionally oriented. Perhaps it is as one artist commented, "Because I was taught nothing about my heritage, it created a mystique about that part of my life. Now I want to learn everything, be involved in every way, and make every effort to preserve my culture."

Many artists from urban areas across the United States lament being reared away from native homelands, and some have "gone home" to reservations in adulthood. Because they risked losing their heritage, perhaps they feel a need for stronger cultural ties, or they search more diligently for inspirational closeness with their ancestors.

Dedicated to their heritage, many reservation-reared artists were quite content with their way of life and remained on their native homelands. Others left in young adulthood, off to universities, the armed forces, or simply traveling the country, but eventually they returned home to stay. Still others, raised on reservations, now live elsewhere but return periodically.

"I have a need to go home to my reservation," explained Jaune Quick-to-See Smith. "There I feed my imagination and dreams. That is how I reach out and strike new horizons while I

OPPOSITE: Ganado Red Navajo rug (60″ by 72″) woven by Marie Shirley. The white, browns, and gray are natural wool colors; the black and reds are aniline dyes. The use of brown and two shades of red make this a striking and unusual example of Ganado weaving.

reach back and forge my past."

Jeweler James Little, born and raised in a remote area of the Navajo Reservation in northeastern Arizona, returns home as often as possible. Inspired by the scenic beauty of his homeland, his mother's rug designs, and his memories of legends told around the fire at night, he goes home as if seeking renewal…and to help his widowed mother with the sheep and cattle. And she, a lovely little Navajo lady with the bearing of a queen and a shy smile, surveys her ancient Navajo "kingdom" from the back of a horse.

Seeking renewal in native homelands is easily understood. Most reservations are in fairly isolated areas, where it is quiet and peaceful. In speaking of his home near Shonto and Tsegi canyons, Baje Whitethorne (Navajo), agreed. "When I was four or five years old, we'd go out into the countryside picking piñon nuts. Later, I went there quite often to sketch. I love the quietness, and paint what I feel. I wonder if it will all be there a hundred, two hundred years from now."

Even villages quite close to urban areas seem far removed from all the "hustle and bustle." With the slower lifestyle comes a feeling of having taken a step back into time, which undoubtedly contributes to the strong bond between artists and their ancestors. They return to ancestral homes as if to drink at the wellspring of their creativity, and ideas seem to flow endlessly.

To many Native Americans, art is a way of life. Generation after generation have shared their skills and techniques and passed along their talent. Hopi painter/carver Neil David Sr., a third-generation artist, says, "We looked on sketching as a human activity as natural as eating, forming friendships, or watching kachina dances." In fact, so many Hopi are involved in art of various kinds—drawing, painting, carving, dancing, weaving baskets, and making pottery—that they have been described as "the largest artistic community in the world." While this is certainly true of the Hopi, it is also true of other Native American cultures.

Joseph Lonewolf recalls his family life as being like that of any other Pueblo child. "We'd sit in the evenings and do beadwork, drawing, painting, clay modelling, woodworking, while our grandparents told us the old legends and stories…."

OPPOSITE: *Night Dance,* an original stone lithograph by Neil R. David Sr., captures the scene as kachinas prepare to enter a kiva to perform during the Hopi night dances.

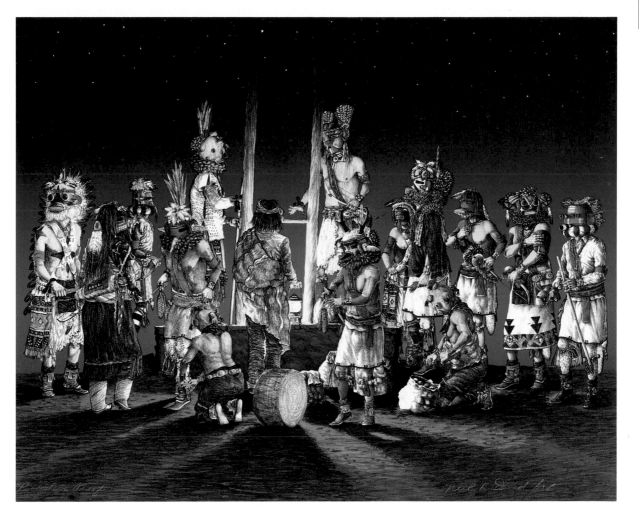

Grandparents played a very important role in the lives of many artists, for extended families often lived together. Some were raised by grandparents or often spent entire summers with them, perhaps herding sheep in remote areas or living in a village rich with ceremonial life. Whatever the circumstances, grandparental influence was strong.

Navajo Redwing T. Nez says that his painting, *Her Precious Time,* reflects his feelings about his grandmother. "When I was a child, I watched her weaving. There was an intensity; her eyes would glitter with color. I watched how she would look at the rug she was weaving in a special way, studying it, figuring out how she would weave it. She was careful to do it right because her time was precious."

Danny Randeau Tsosie (Navajo), who says he has painted since he can remember, spoke of his grandmother with respect and great warmth. "She was an herbalist, perhaps you might call her a medicine woman, and she taught us what plants were what. She told us stories, and taught us songs and what the ceremonies meant."

A rich heritage for any youngster, theirs was an environment almost certain to perpetuate artistic talent. Reservoirs of creativity, these contemporary Native American artists stand out even in their multitalented culture.

Innovations abound today, even in very traditional art forms such as weaving. Many unusual rugs are woven: raised outline, which have a three-dimensional appearance; two-faced, which have a different design on either side; and a unique double-rug, with a design of one style in the center surrounded by one that is totally different, giving the illusion that a small rug lies atop a larger one. Pictorial rugs, long a favorite with both weavers and collectors, have now become mazes of intricate figures in a kaleidoscope of color.

Employing centuries-old methods, many Navajo weavers create imaginative designs and introduce unexpected colors. Others, however, continue to create tapestries of traditional styles, notable for their ultrafine weaving and extraordinarily intricate designs.

An excellent example of this is a Two Gray Hills rug, woven

OPPOSITE: This Two Gray Hills tapestry, 60″ by 104″, was woven by Navajo sisters Barbara Teller Ornelas and Rose Ann Lee. It received five awards, including Best of Show, at the 1987 Indian Market.

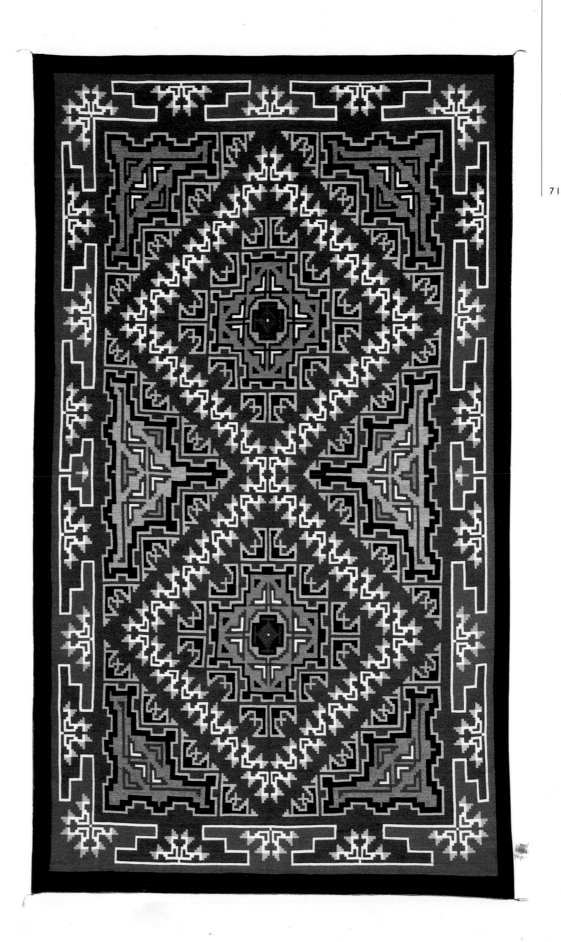

by sisters Barbara Teller Ornelas and Rose Ann Lee. In the midst of moving to Tucson, Barbara's husband, David, appeared at our doorway one day with a snapshot of the rug in hand. We immediately made arrangements to photograph the rug, for we felt it was a masterpiece. Others apparently agreed, as the rug won five awards, including Best of Show, at the 1987 Santa Fe Indian Market. Since the weavers worked only part-time, the rug was four years on the loom, while the actual weaving consumed two and a half of those years. Six to eight months (accumulated over the four-year period) were required just to prepare the necessary wool from five sheep. The colors—except for the black, which is aniline dyed—are natural wool, some cross-carded (two or more colors blended) to make various shades of brown and gray. The sisters now laughingly admit that they didn't work for a time because they refused to speak to each other after a family spat; but the disagreement passed and work went on. There was certainly no rift on that August morning at Indian Market. The two sisters sat on the plaza, the brilliance of the mass of colored ribbons hanging from their prize-winning rug matched only by their exuberant smiles. Excellent examples of today's artists, Rose Ann weaves Two Gray Hills rugs exclusively, while Barbara weaves Ganado and Burnt Water styles as well.

As artists leave behind definitive styles, there is a refreshing absence of predictability to their art. Sculptor Doug Hyde believes that blending of tribal affiliations can be credited, at least in part, to the Institute of American Indian Art in Santa Fe, New Mexico. "We [the students] had free cultural exchange at the best level—art. It broke down a lot of barriers." With this assimilation of cultural information, artists have the freedom to expand and experiment in an ever-widening creative world. Hopi culture is one of Doug's favorite subjects; his former wife is Hopi, and as he laughingly explained, "It's a long way from Santa Fe to the Nez Perce in Idaho." Doug feels that intermarriage also broadens the artists' outlook, as being welcomed into societies other than their own adds further dimension to their art.

Intermarriage has also influenced the pottery of Navajo Christine Nofchissey McHorse. Married to Joel McHorse of Taos Pueblo, she learned to make pottery from his grandmother.

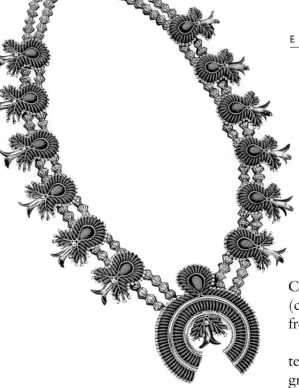

This needlepoint necklace by Edith Tsaybetsaye (Zuni) was awarded First Prize at the 1987 Annual Zuni Artist's Exhibition at the Museum of Northern Arizona.

Christine now creates an unusual style of micaceous pottery (common to the Taos area) that incorporates shapes and designs from Navajo and Pueblo cultures.

Today's pottery reflects its ancient roots in the hands of contemporary potters, for most were taught by mothers, aunts, or grandmothers. Generation followed generation, with each individual adding a personal touch to vessels made the old way, hand-formed without a potter's wheel. Though a few contemporary artists do use a kiln to fire their pottery, the majority still fire outside with sheep dung, juniper, or other traditional fuel.

Contemporary styles are not necessarily newborn, but may be recreated. "Nothing is ever completely new," remarked Grace Medicine Flower. "What we call contemporary today will be considered traditional tomorrow. I think our ancestors did the same things years ago and now we are rediscovering them."

Many ancient pottery vessels attest to that fact. Intricate designs from Mimbres and Sikyatki wares are often included in contemporary motifs, and incised designs have been found on Rio Grande pottery dating from the fifteenth century.

"There's really nothing new in what I do," Joseph Lonewolf insists. "I simply rediscovered some of the secrets known to my ancestors, the Mimbres people, nine or ten centuries ago. So what I do is not new, just so old that it is new again." Given new interpretations by today's artists, venerable techniques and designs live again.

Barbara and Joseph Cerno, of Acoma Pueblo in New Mexico, recreate a style of historic pottery that, while popular in the nineteenth and early twentieth centuries, had not been made for years. Exceptional artists, the Cernos produce extremely large vessels adorned with Acoma, Zuni, and Mimbres designs.

Rooted in the stone fetishes and altar pieces of the distant past, contemporary sculptures speak of ancient heritage as stories are sculpted into stone, legends into bronze. Whether it be the lifelike stone or bronze images of Oreland Joe (Ute/Navajo) or the fanciful clay figurines of Elizabeth Abeyta (Navajo), they manifest the feelings of the artists for their traditions.

The art of basketry is gradually evolving into the contemporary art world of the Native American. Few revolutionary

74 changes have been made, though some basketweavers are experimenting with new color combinations and unique designs. Others create extraordinary, finely woven baskets, which by excellence alone have earned a place among today's contemporary arts.

Several Tohono O'odham (Papago) basketweavers create outstanding miniature horsehair baskets with intricate geometric designs and human and animal figures. Palomino, roan, black, and sorrel horsehair are used for variety in color. Noted for her exceptionally fine horsehair baskets, Norma Antone creates miniature masterpieces from approximately one inch to five inches in diameter. One small basket has 248 human figures made of brown and black horsehair, woven with approximately sixty wraps per inch. As we talked with Norma at the 1987 Santa Fe Indian Market, a Texas tourist decided to purchase a similar basket. Norma gently cradled the tiny basket in her hands for a long moment, running one finger around its rim. At last, she reluctantly handed the basket to its new owner, remarking with a hesitant smile, "I worked on that for months. There's no way I can afford to keep it, but it's like parting with a little of myself."

During the last few years, a traditional Hopi art form has moved into the contemporary art world. Kachina dolls, traditionally static figures, have evolved into intricate wood carvings of lifelike detail, depicting both action and grace. Still hand-carved from a cottonwood root, today's finer contemporary kachinas (often including the base) are made from one solid piece of wood. Occasionally, small items such as a bow and arrow may be added, but the head, arms, legs, clothing, antlers, and other accoutrements are integral parts of each carving. Furthermore, the bright colors formerly used are more subdued as a result of recently developed staining techniques. Hopi carver Lowell Talashoma makes it all sound quite simple: "I study each root until I can picture the final carving that's inside, then I just remove the parts of the wood I don't need." Nevertheless, the one thing these kachinas are not is simple. Intricately crafted, perfect in every detail, and alive with motion, each is a testimonial to the talent and creativity of the artist.

The expertise of prehistoric American Indians in using

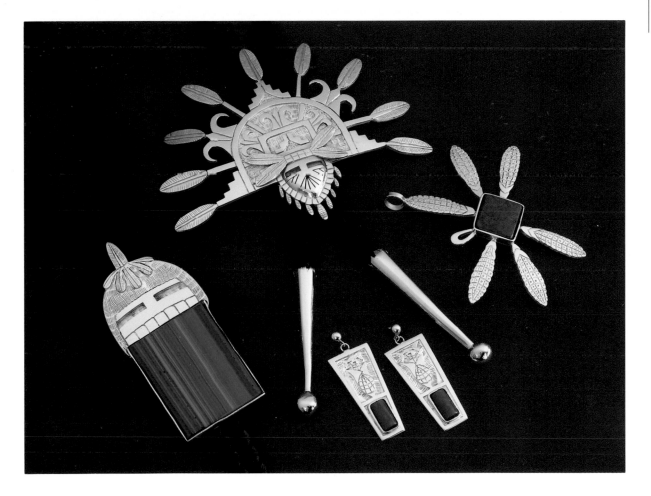

Watson Honanie (Hopi) combined gold and silver in the overlay technique to create these stunning pieces. The beard of the long-hair kachina mask (*left*) is of malachite, and the corn pendant (*right*) is set with sugilite. The face of the *Palhik Mana Kachina* is represented in the bola tie, and the earrings set with coral contain symbols of the Corn Maiden.

primitive tools to form tiny turquoise beads with minute center holes was remarkable. Equally remarkable, however, is the creativity of today's jewelry artist. Sleek, classic designs in gold or silver are adorned not only with the more familiar turquoise and coral, but also with exotic stones from around the world.

Regardless of the materials used for these modern masterpieces, traditional techniques have endured. Both smooth and textured designs enhance the gold and silver of today's jewelry creations. Some are cast in tufa stone, some by the lost wax process, and others are fabricated or include designs in gold or silver overlay. Many exceptional pieces are an ingenious combination of more than one process. No matter how contemporary they

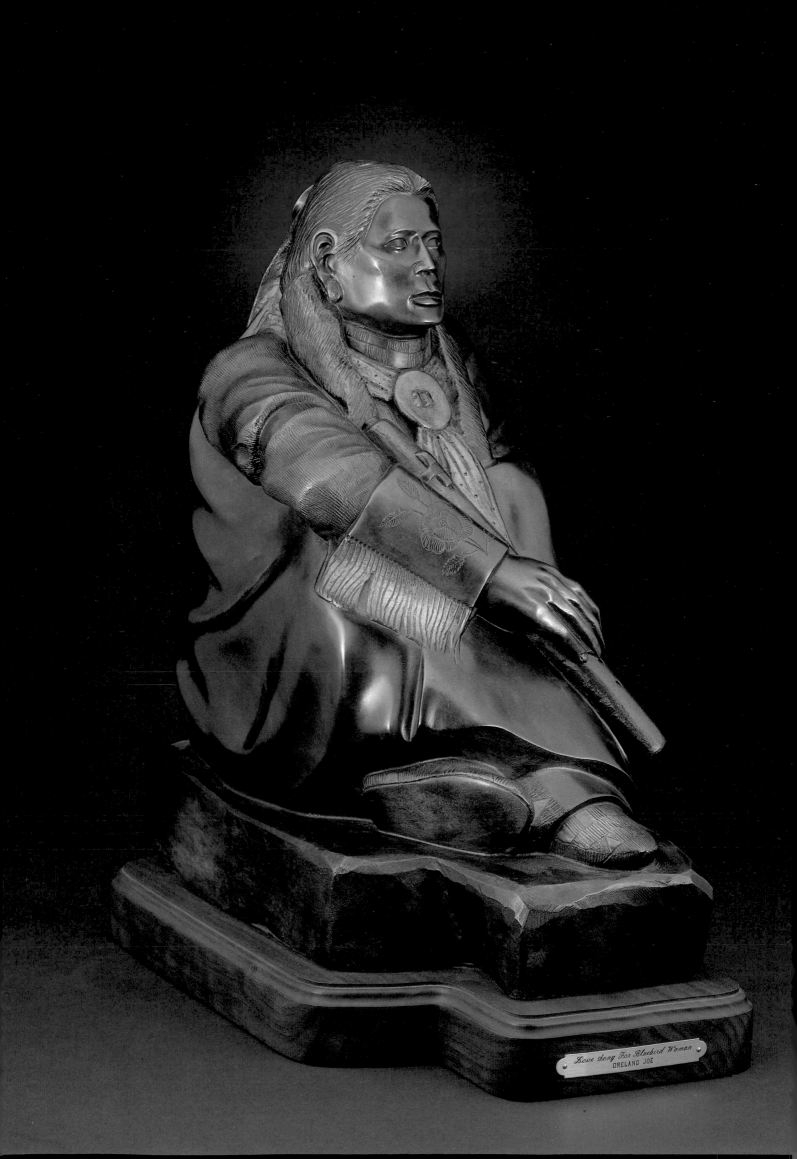

Love Song For Bluebird Woman
ORELAND JOE

OPPOSITE: *Love Song for Bluebird Woman,* a 19″ tall bronze by Oreland Joe (Ute/Navajo), aesthetically preserves Native American tradition.

may be, a touch of tradition is usually included: *yei* figures, kachinas, rug designs, or symbols of nature and ancient petroglyphs.

Exceptional beads are fashioned from a wide variety of materials including coral, jet, lapis lazuli, turquoise, gold, silver, and various types of shell. Some are the size of marbles, others infinitesimally small. John Christensen, *Keokuk,* (Sac/Fox) produces beads that are only .036 of an inch in diameter, while that of the inside holes is a mere .012 of an inch. Cut from sheets of silver or gold, metal beads are hand-pulled (drawn through a hole in a small "draw plate"), stone beads are hand-rolled, and both kinds are hand-polished. Strung on double-strand silk, the finished beads are so fine that they flow through the fingers like a creamy liquid. Derived from the earliest of Native American body adornments, these beads are a highly refined form of an ancient art.

Petroglyphs, pictographs, and murals painted on kiva walls were among the earliest forms of American Indian art. Whether such art was created for ceremonial purposes, as trail markings, clan signs, or mere doodlings on a boring afternoon, imagination and talent were necessary to create these early designs.

Today's painters tell exciting stories of the past in a vast array of media, including oils, pastels, prisma, watercolors, egg tempera, and more. Using both simplicity of form and very complex designs, they strive to keep their traditions alive.

Spiritual figures, traditional symbolism, and scenes from everyday life fill canvases by the score, yet each artist's work is different. Whether it be the pastel portraits of Navajo Clifford Beck, Neil David Sr.'s portrayal of a kachina ceremony, or Baje Whitethorne's rather whimsical depictions of traditional Navajo scenes, each in his own way pays homage to his people.

Inspired by cultural memories, Native American artists walk a pathway that stretches before them into the horizons of the future, as far as the imagination can travel.

Describing his life as a young boy near Shonto and Tsegi canyons, Navajo artist Baje Whitethorne recalled, "I loved the quietness." While capturing the drama of Navajoland, his work unquestionably conveys the feeling of tranquility. The subject of this untitled acrylic, 19″ by 28″, is a Navajo camp hidden somewhere in Tsegi Canyon.

OPPOSITE: Another Navajo artist, James King, *B'ee Ditt'o,* excels in recording traditional Navajo lifestyles. His oil on canvas, *The Gamblers,* portrays Navajo men gambling while a squaw dance is in progress in the background. Joining these renegades are bootleggers operating out of their wagon at the right of the painting. The horseman behind the rock at the left represents a lawman who keeps peace and order during the dance.

80

Inspired by memories of his grand-mother, twenty-seven-year-old artist Redwing T. Nez painted this 22½" by 29½" mixed media portrait of her, entitled *Her Precious Time.* It was awarded First Prize and Best of Show at the 1987 Annual Navajo Artist's Exhibition at the Museum of Northern Arizona.

OPPOSITE: Clifford Beck (Navajo) often incorporates the ancient Anasazi symbol of the bighorn sheep into his paintings. He explained, "I am a member of the Many Goats Clan, and in doing this I pay homage to my clan." This 32" by 42" pastel, entitled *Ancestral Imagery,* portrays the close proximity of the Navajo people (portrait) to the Zuni people (pottery jar) and the fact that the Navajo migrated into a culturally and historically rich area (petroglyphs).

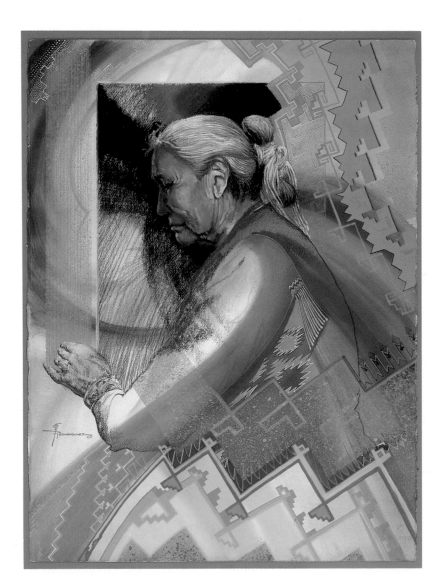

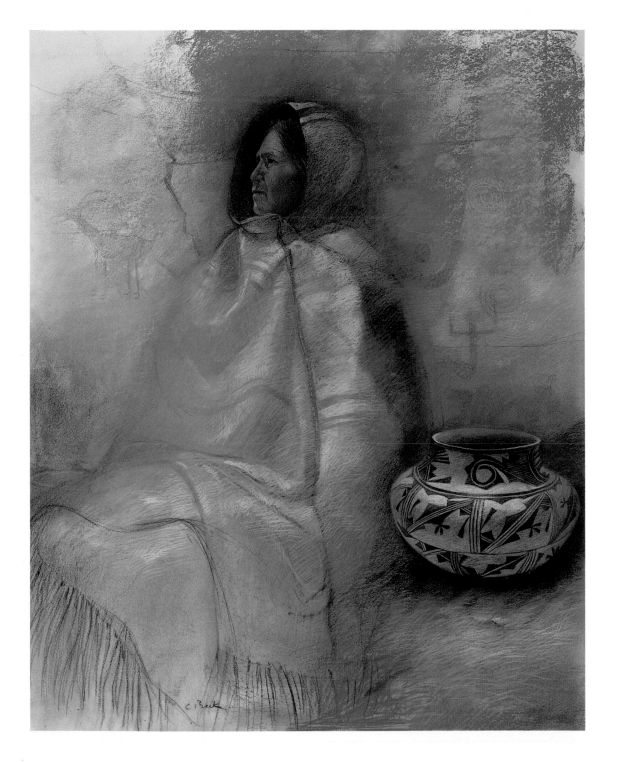

82

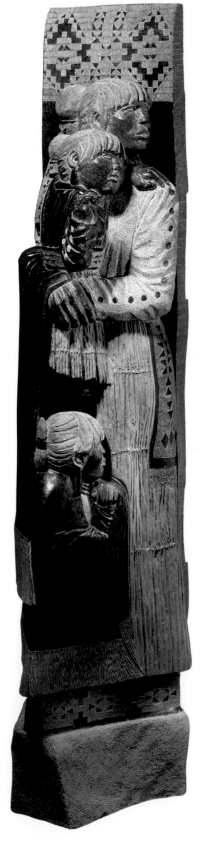

LEFT: *Blessing Way,* 63″ tall sculpture of black soapstone by Alvin Marshall (Navajo).

OPPOSITE: Doug Hyde (Nez Perce/ Chippewa/Assiniboine) created this life-size sculpture of Hopi basket dancers, entitled *Reed Clan,* from a five and one-half ton piece of limestone.

BELOW: *In the Wind,* 19″ tall (*left*) and *Showing Her Best,* 25″ tall, both sculpted from Utah alabaster by Tim Nicola (Penobscot).

84

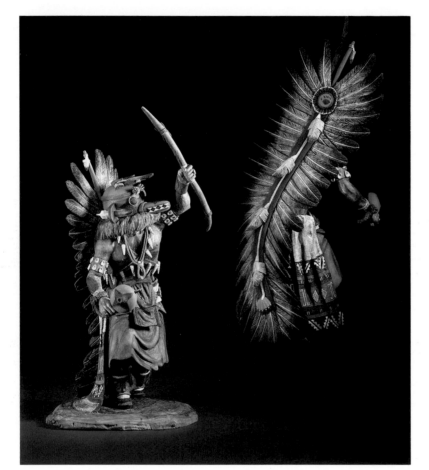

LEFT: This *Sakwahote* (*Blue A'hote*), Kachina, 16½" tall, by Cecil Calnimp-tewa (Hopi), is a superb one-piece kachina sculpture.

OPPOSITE: Early stages of the carving process by Dennis Tewa reveal the minute detail and absence of any pieces added to the original piece of cottonwood. Superimposed within the photograph is the finished piece, a stately Crow Mother Kachina, *Aangwushnasomtaka.*

BELOW: The *Ahola,* a Chief kachina, 15" tall, by Ros George (Hopi) is another excellent example of the one-piece carvings being created today.

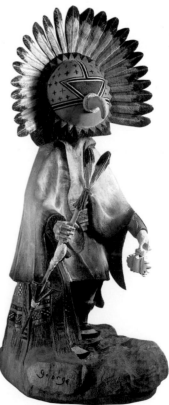

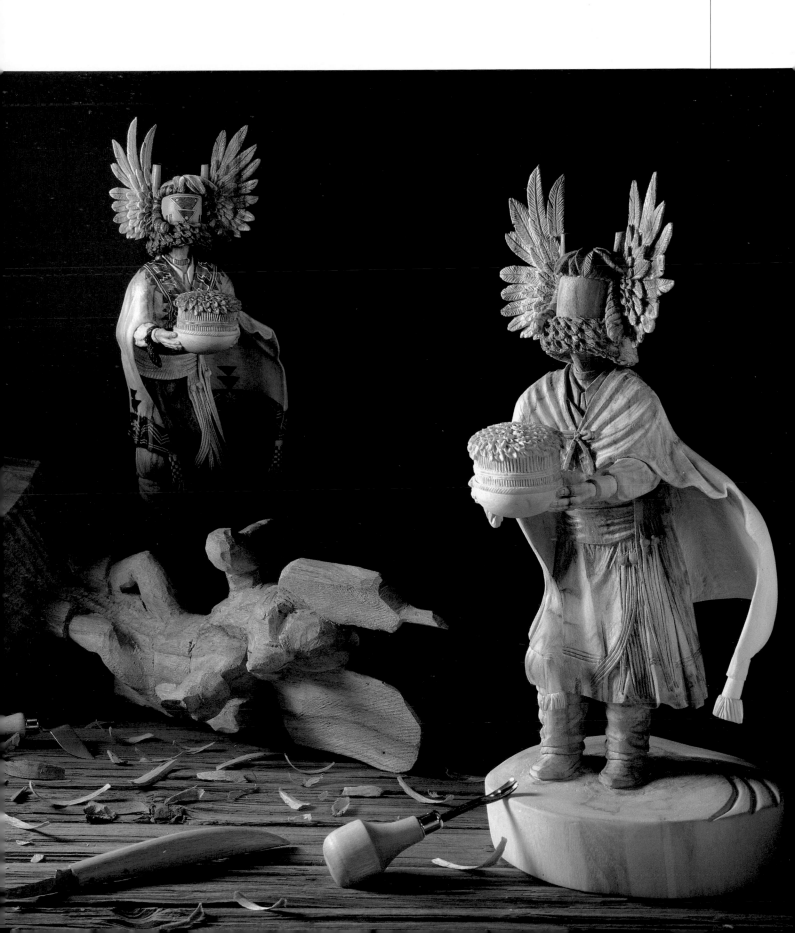

Navajo/Hopi potter Nathan Begaye creates an extraordinary variety of pottery styles: *left to right,* water jar with Navajo deities and a corn-husk stopper; small jar with the shape and design of Hopi Sikyatki polychrome pottery; seed jar with influences from thirteenth century Anasazi black-on-white pottery.

OPPOSITE: Christine Nofchissey McHorse (Navajo) uses mica-rich clay from the Taos area to make her unusual pottery, which has Navajo, Pueblo, and non-conforming designs. *Clockwise from top:* wedding vase, modified gourd-shaped jar, shallow bowl with lizard lid, and a stirrup vessel patterned after an Anasazi motif.

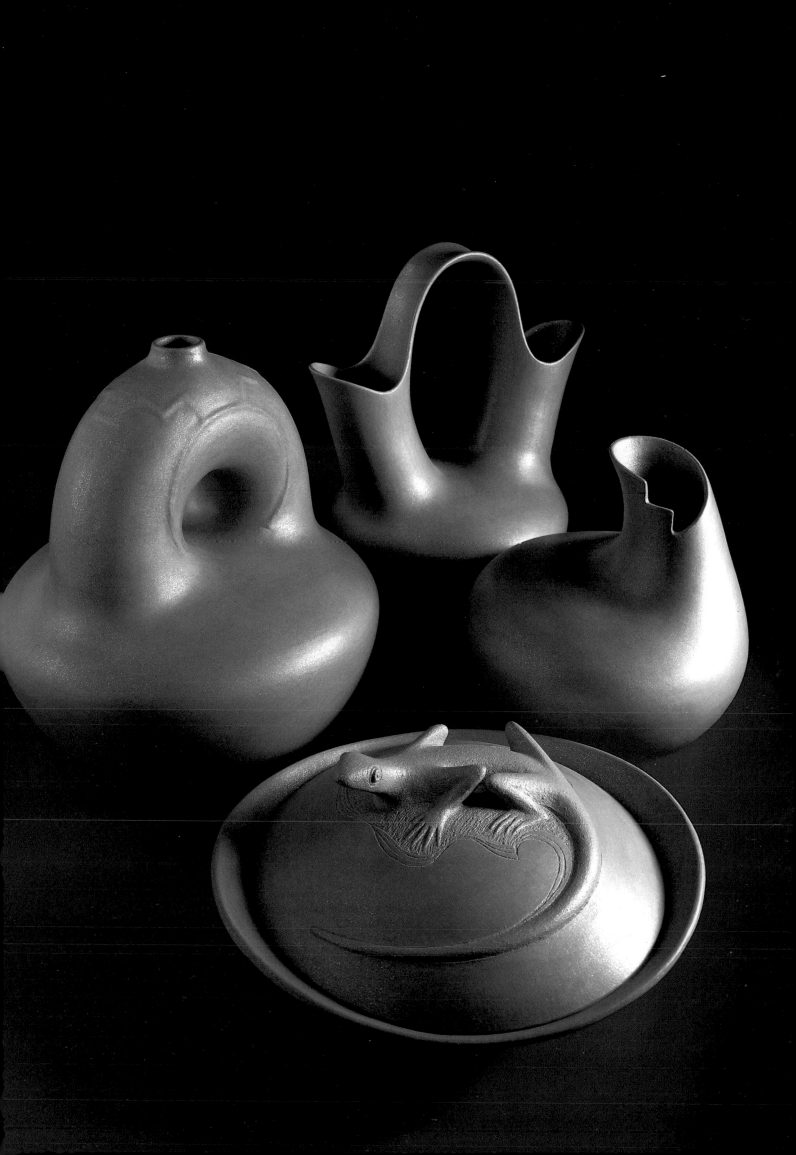

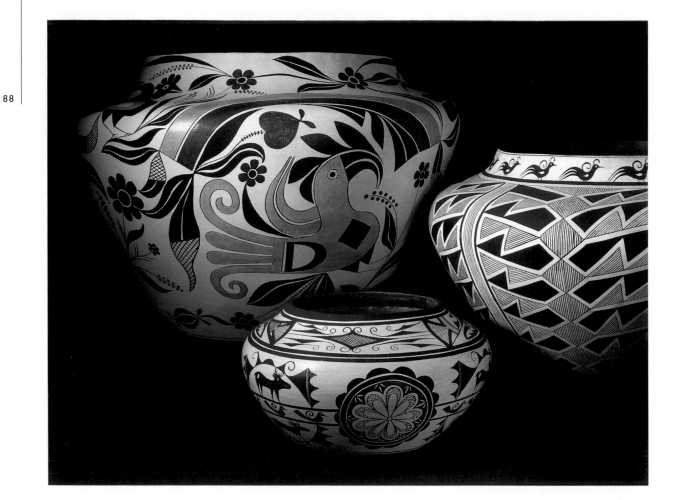

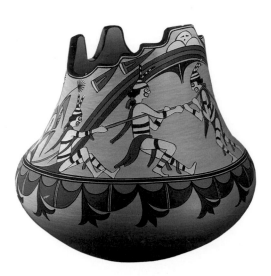

ABOVE: The "revival" pottery of Barbara and Joseph Cerno of Acoma Pueblo: *left,* typical Acoma style jar of the early 1900s, 20″ tall, 25″ in diameter; *right,* Acoma storage jar with geometric designs adapted from prehistoric pottery, 14¾″ tall, 21″ in diameter; *foreground,* replica of early twentieth century Zuni jar, 7¾″ tall, 12″ in diameter.

OPPOSITE: Hopi Rondina Huma paints mosaics of Hopi designs on her distinctive pottery.

LEFT: Rainbow and cloud symbols frame a scene depicting frolicking Koshari clowns on this pottery jar by Lois Gutierrez-De La Cruz of Santa Clara Pueblo.

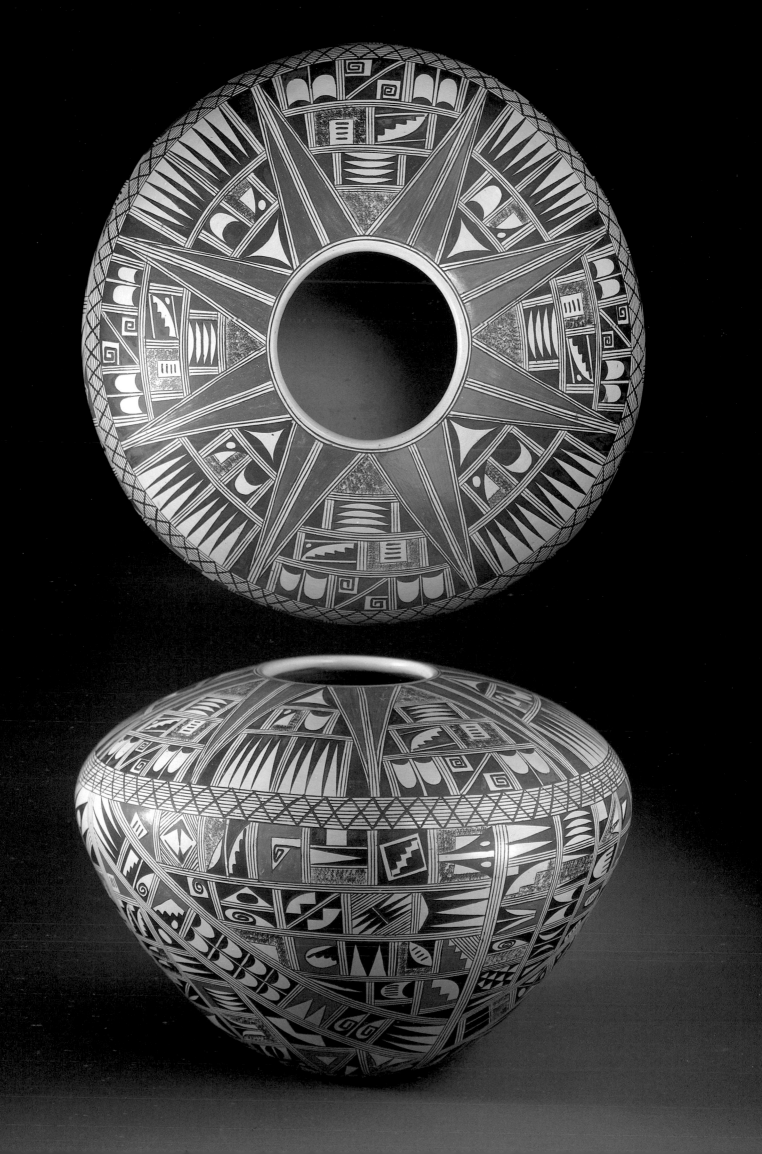

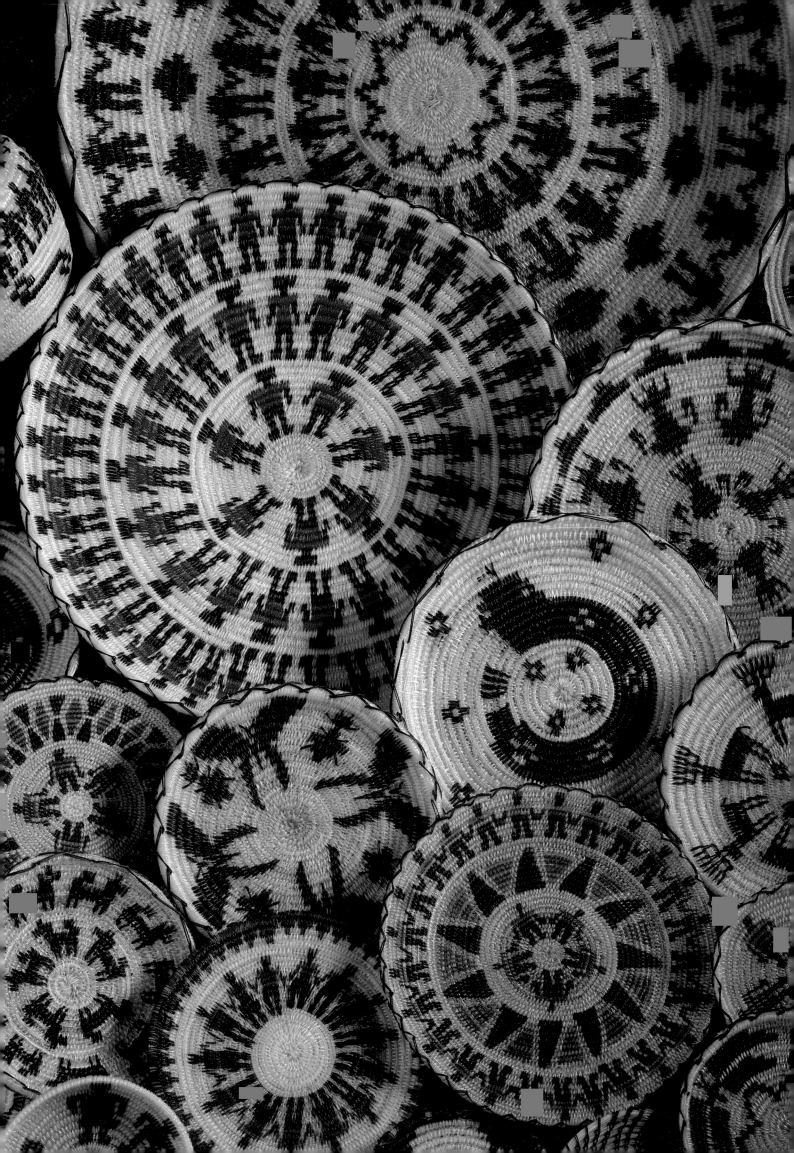

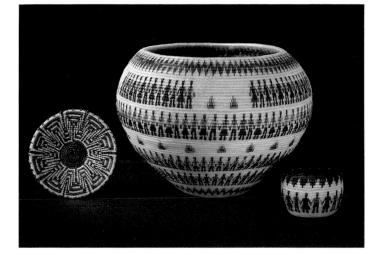

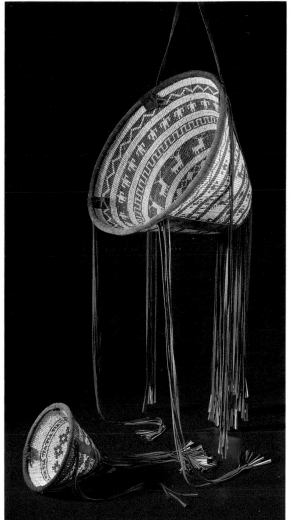

OPPOSITE: Several Tohono O'odham weavers make excellent miniature horsehair baskets. These range in size from 1¼″ to 4¼″ in diameter and were made by Rose and Norma Antone, Dorina and Ruby Garcia, and Charlene Juan.

ABOVE: Three miniature horsehair baskets made by Norma Antone (Tohono O'odham); *left,* 2⅜″ in diameter, *right,* 1½″ tall. The center basket is 4″ tall and has 248 human figures.

RIGHT: Apache weaver Beatrice Kenton incorporated human, animal, and geometric designs in her finely twined burden baskets made of current brush. Note the use of reverse or negative designs—white on the inside with the same design occurring in brown on the outside. The top basket is 14½″ in diameter, the bottom, 6½″ in diameter.

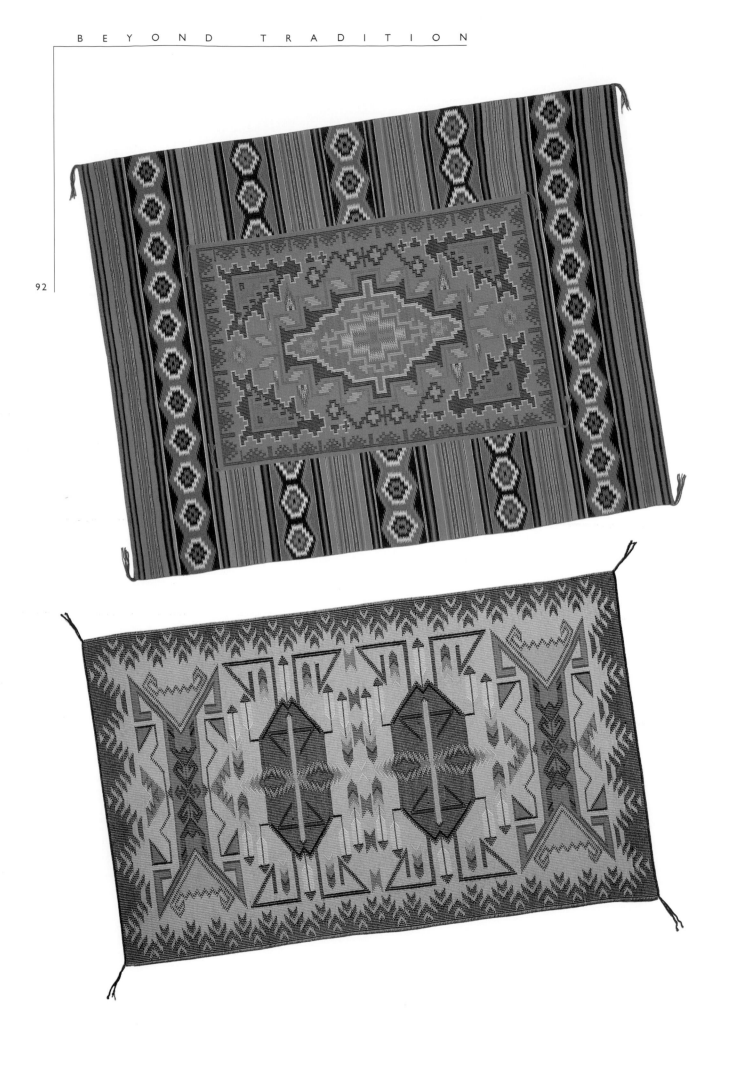

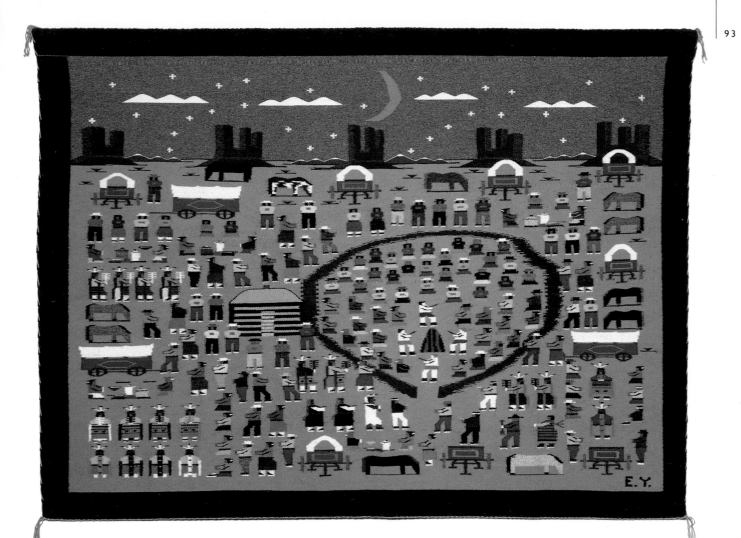

OPPOSITE, *above:* An unusual rug-within-a-rug, or double rug, by Marie Watson (Navajo). Outer areas are woven in a Wide Ruins – Pine Springs style with a flat tapestry weave. The center has a Burnt Water design, done in the raised outline weaving technique. *Below:* This example of raised outline weaving is by Lorraine Scott (Navajo).

Pictorial Navajo rug, 72″ by 53″, by Ellen Yazzie, contains 270 figures depicting various aspects of traditional Navajo life.

3

Hopi artist Al Qöyawayma's pottery,
embellished with his finely sculpted
clay figures, stands alone as clay art-
istry of the highest degree. *Left:* The
Kachin' Mana carries an offering of
sacred corn; *right:* the Flute Player is
rooted in prehistoric Anasazi art and
Hopi religion. The stone walls and
doorway of an Anasazi dwelling are
represented in the foreground.

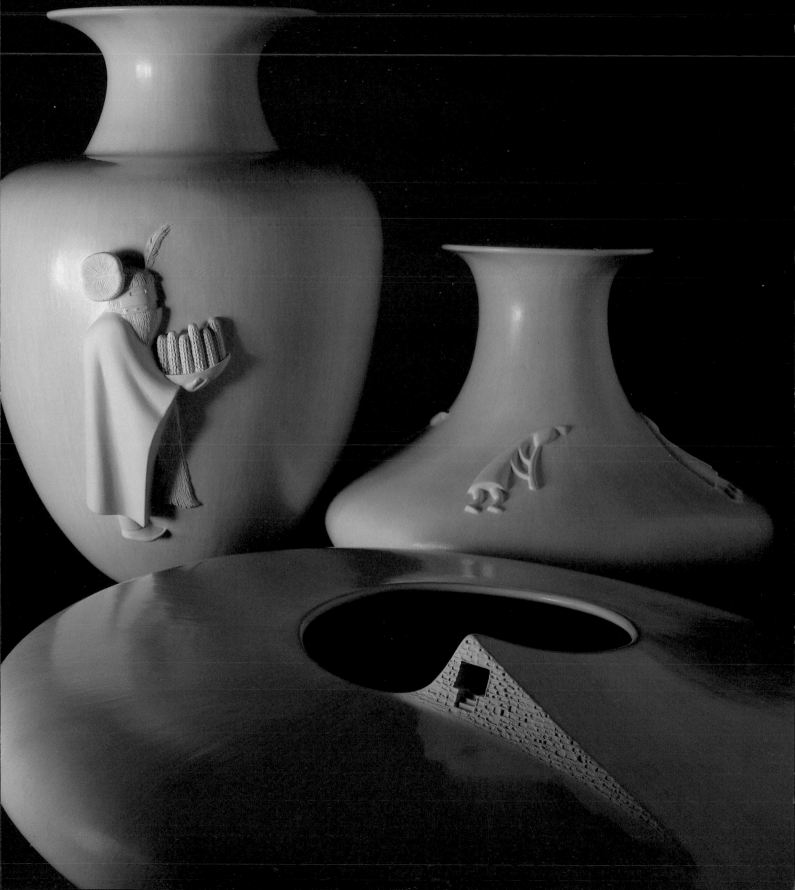

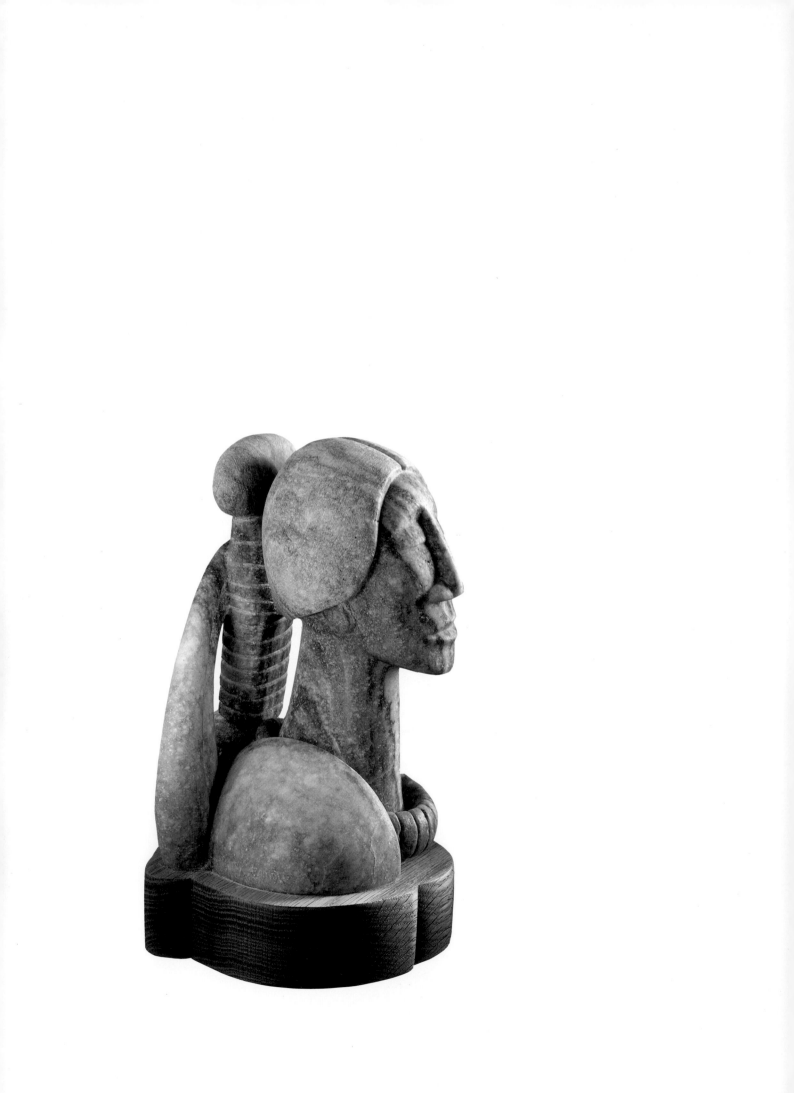

3 New Horizons

OPPOSITE: *The Changing of the Moon,* 10" tall sculpture of alabaster by Tomas Dougi Jr. (Navajo); the arch at the left represents a rainbow that joins her with the earth.

As the past inspires Native American artists, so the future leads them on. As they step out beyond tradition, there is exciting new drama to their art; fresh with promise, it continues to whisper of timelessness. Yet, as the artists travel toward that distant horizon, some special influences have directed them along that particular pathway.

First, and perhaps foremost, is the Institute of American Indian Art, which opened in Santa Fe in 1962 with a staff of four, one of whom was jeweler/painter/potter Charles Loloma. A year later, artist Fritz Scholder (California Mission) was added to the staff, to be followed shortly by sculptor/painter Allan Houser.

With well-deserved pride, Charles Loloma reminisced about the early days at the Institute. "The original idea was to use our backgrounds as stepping-stones to project beyond all Indianisms, to blend a traditional point of view with contemporary expression for talented young Indians. My 'style' fit right in." Charles feels that the school has accomplished those goals, adding that "the artists who are doing great today are primarily 'Institute people.'"

There is little doubt that the Institute has had a profound influence on contemporary Native American arts and artists. In fact, many of the artists featured in this book (particularly sculptors and painters) attended the school, and still others have been influenced by artists who trained there.

Further encouragement is offered by the many museums and associations sponsoring art exhibitions for American Indians. Several special events are notable in the promotion of the artists and their work. Each summer, the Museum of North-

ern Arizona in Flagstaff hosts three annual Artist's Exhibitions—Hopi, Navajo, and Zuni—that feature the talent of Native Americans from those tribes.

The Gallup Intertribal Ceremonial and Santa Fe Indian Market (both held in New Mexico each August) are two very popular events among Native American artists and collectors. Probably nowhere is more art displayed at one time than in Santa Fe, a mecca for multitudes of artists who enter their work in the competition and sell it to the public. As hordes of visitors arrive on the scene, unrestrained enthusiasm reigns. "Market" is a wonderful opportunity to buy, or simply admire, magnificent art and meet the artists; many sell from booths on the plaza, while gallery exhibitions are held for others.

The Indian Arts & Crafts Association is an organization made up of dealers, museums, galleries, and artists whose goals are "to protect, preserve and promote Indian arts and crafts." An Artist of the Year is selected annually in juried competition. Several individuals included in this book have been chosen over the years: Virginia Stroud, Carolyn Bobelu, Charlie Pratt, Clifford Brycelea, and Jake Livingston.

The Heard Museum in Phoenix, Arizona, promotes American Indian arts with several events, including a Fine Arts Invitational and a Craft Arts Invitational (which take place biennially in alternating years), and the Annual Guild Indian Fair each March, which includes a Student Arts and Crafts Exhibition. Ongoing artists-in-residence programs at The Heard Museum, the Museum of Northern Arizona, and others also provide opportunities for the artists. Though only a few are mentioned, there are many exhibitions and any number of excellent museums across the country dedicated to promoting Native Americans and their art.

Time and again, artists mentioned the encouragement they received from entering one of these exhibitions. Richard Zane Smith (of Wyandot descent) had made pottery for years, but declared that "It wasn't until 1982 when I entered two pots at The Heard Museum that I realized that the corrugated pottery I was making appealed to others, too....I was mainly doing it for myself. Winning the awards for my pottery provided the encour-

OPPOSITE: Richard Zane Smith (Wyandot descent) recreates an ancient style of corrugated pottery. Using centuries-old methods of coiling, scraping, and pinching the clay, he then embellishes the large jars with striking painted designs.

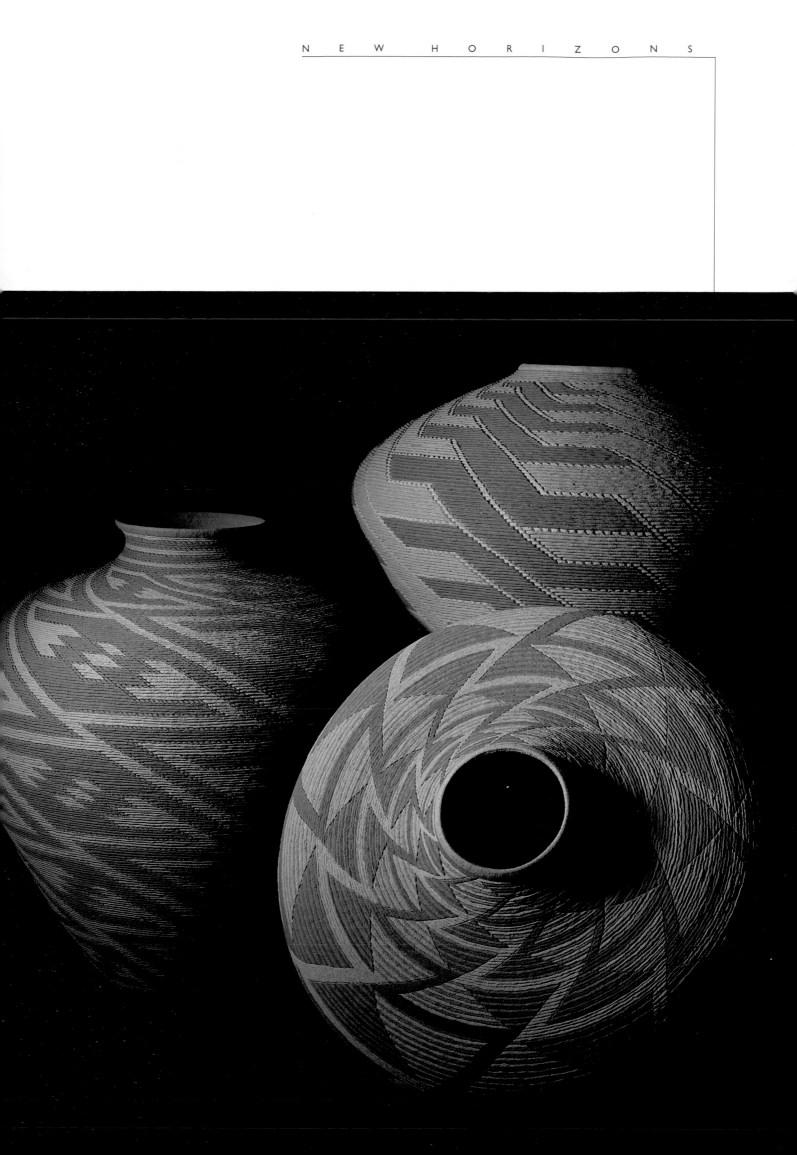

agement to continue." Navajo sculptor Alvin Marshall also praised the museums, adding that "The Heard Museum made me believe in myself. I found that there were people who admired my work and had faith in me." The prize money motivates artists to produce works of the highest quality, and the exhibitions provide a much-needed public platform. As Baje Whitethorne noted, "It was after my work appeared in exhibitions at the Museum of Northern Arizona, The Heard Museum, and Indian Market that I became recognized."

The multitude of galleries across the country and many traders (both those at reservation trading posts and those who travel to remote areas to purchase art for resale) not only promote Native American art, but often influence the artists' work as well. Although in the past the majority of gallery owners may have wished to keep "Indian art" traditional, today many encourage artists to use their imagination to move forward into the mainstream of the art world. Rosemary "Apple Blossom" Lonewolf was excited about that very thing. "Often galleries dictate what I make. Of course, they know what sells. But they would tell me what to make, saying, 'Bring so many pieces with butterflies, and so many with flowers.' I think the same thing happens to every person who has a tradition. The public wants certain things, and that's good — it gives us a base. But it's very stifling to an artist not to be able to do what you want. It was wonderful talking to Lee Cohen. He said, 'Go for it. Do whatever you like. However you want to interpret it is fine!' This is like a new beginning for me. It's great after sixteen years to be able to say 'Hey, this is exciting!' "

Many gallery owners or traders suggested or encouraged the very changes that today make a particular art style unique. It is not unusual for them to invest thousands of dollars promoting artists, buying their materials, and often subsidizing them so they can afford to work a year or more on a project. Other types of assistance are also provided by some galleries. The Lovena Ohl Gallery in Scottsdale established a trust fund in order to offer scholarships to Native American artists. Sometimes the scholarship is applied to art lessons, for others it may provide support for a career that is just getting underway. At one time, it enabled

Navajo jeweler James Little to be tutored in English; because of a hearing disability (partially corrected by surgery when James was nineteen), the opportunity to learn English was denied him in his youth. As his jewelry career progressed, James learned to speak some English, but as he was thrust into the mainstream of the contemporary art world by his talent, further tutoring became a necessity. Introduced to Lovena Ohl at that time, James became the recipient of a scholarship. Today, his English has improved dramatically and his jewelry creations defy imagination.

In speaking to the top contemporary jewelry artists, two names are consistently mentioned as major influences. One, certainly, is master jeweler Charles Loloma, who probably has influenced more artists than any other one person. Not only jewelers have been inspired by his free-spirited designs, but other artists as well, and in daring to challenge tradition, he won acceptance for all.

"Charles Loloma really impressed me," stated Jesse Monongye (Navajo/Hopi), "because I knew he was the best. He really had an impact on me, especially when I first started. He gave the rest of us something to shoot for."

Charles also offered others the opportunity to learn, most notably, his niece, Verma Nequatewa. When only sixteen years old, Verma began training with her uncle and has worked side-by-side with him in his workshop at Hotevilla (on the Hopi Reservation in northeastern Arizona) for some eighteen years. Another niece, Sherian Honhongva, joined Charles about ten years ago and continues to work with him today.

Charles has been an inspiration to young artists in yet another way. "About two years into the program at the Institute of American Indian Art," Charles explained, "I realized the kids were talented artists, but they didn't know how to fly. We have learned through anthropology that all Indians are supposed to be introverts, and it is often very difficult for us to open up and talk to people." So Charles, not pleased with what he was seeing, devised a sales technique from a Dale Carnegie course. He led a speech class in which the students made tapes of their voices. "And," Charles added, "they didn't like what they heard." The students all agreed that the speech class was their most difficult

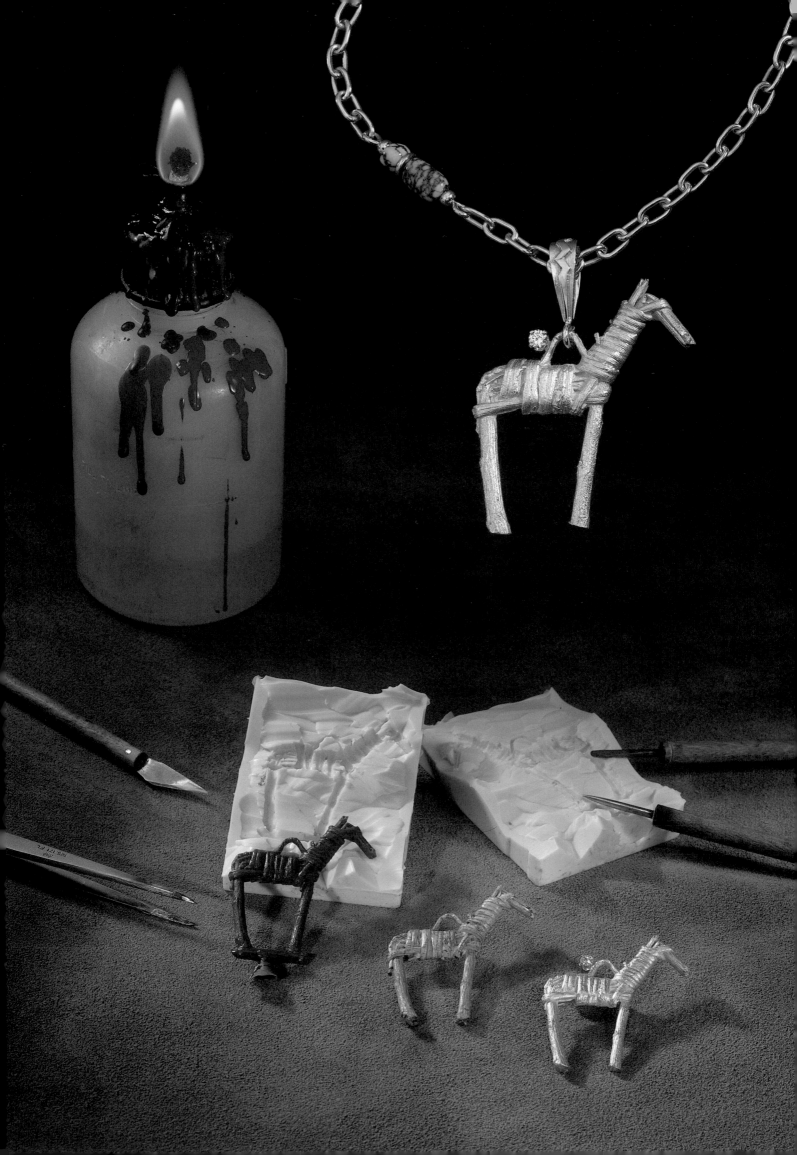

OPPOSITE: Creating this 14-karat-gold replica of a 4,000-year-old split twig figure, Hopi jeweler Charles Supplee first made a split twig miniature (*center figure*) in much the same way as the original was made centuries ago. A silicone rubber mold of the figure was then formed, which was used to produce a wax replica (*left figure*). The wax figure was coated with investment (plaster-like material) to produce a second mold or investment shell. The shell was then heated, melting the wax and allowing it to escape through a sprue (passage). Molten 14-karat gold was then poured into the shell and allowed to cool. The result is the 14-karat gold figure set with a diamond (*top right*).

one, but when interviewed two years later, they also agreed that it was the class that had been most beneficial.

The other person mentioned by contemporary jewelers as a major influence is the late Pierre Touraine, a highly acclaimed, internationally award-winning French jeweler. Working in his Scottsdale studio on a one-on-one basis with a select few over the years, Pierre assisted the artists in setting gems and refining techniques. More importantly, he encouraged them to expand their imaginations and venture further into the international world of design.

At Pierre's invitation, Ted Charveze moved from Kansas City to Phoenix. "Otherwise, I probably never would have done it," exclaimed Ted. "My work already had a slightly continental look; I imagine that's what caught Pierre's eye. He was a very important person in my life. He gave me the courage I needed to step out beyond the traditional aspect, to break away from conformity. He gave me the ability to compete on an international basis." Ted has an incredible talent, which has been inherited by his daughter, Elizabeth Charveze-Caplinger, who began making jewelry under her father's tutelage when she was fourteen years old. Her designs are unique, her craftsmanship is excellent, and today, Elizabeth, twenty-eight, creates exceptional jewelry.

Harvey Begay, son of Navajo innovator Kenneth Begay, had been creating his own unique styles for years, but "was searching for a further catalyst." He found it in Pierre. Selling his home and business in Colorado Springs, Harvey moved to Phoenix to work with Pierre. It was a move that Harvey would not regret, and he now speaks warmly of their association. "One of the main things he did for me was to introduce me to the magic of diamonds," Harvey commented. "He was a superb artist, and I'm truly grateful for what he showed me. So many people don't want to share their knowledge."

However, Pierre desired nothing more than to pass on his knowledge to Native American jewelers, and he was a master at spotting those with exceptional promise. Seeing some of Charles Supplee's (Hopi) work in the window of a Scottsdale shop, Pierre offered his expertise and assistance, which was eagerly accepted. "It was the best move I ever made," Charles said. "I

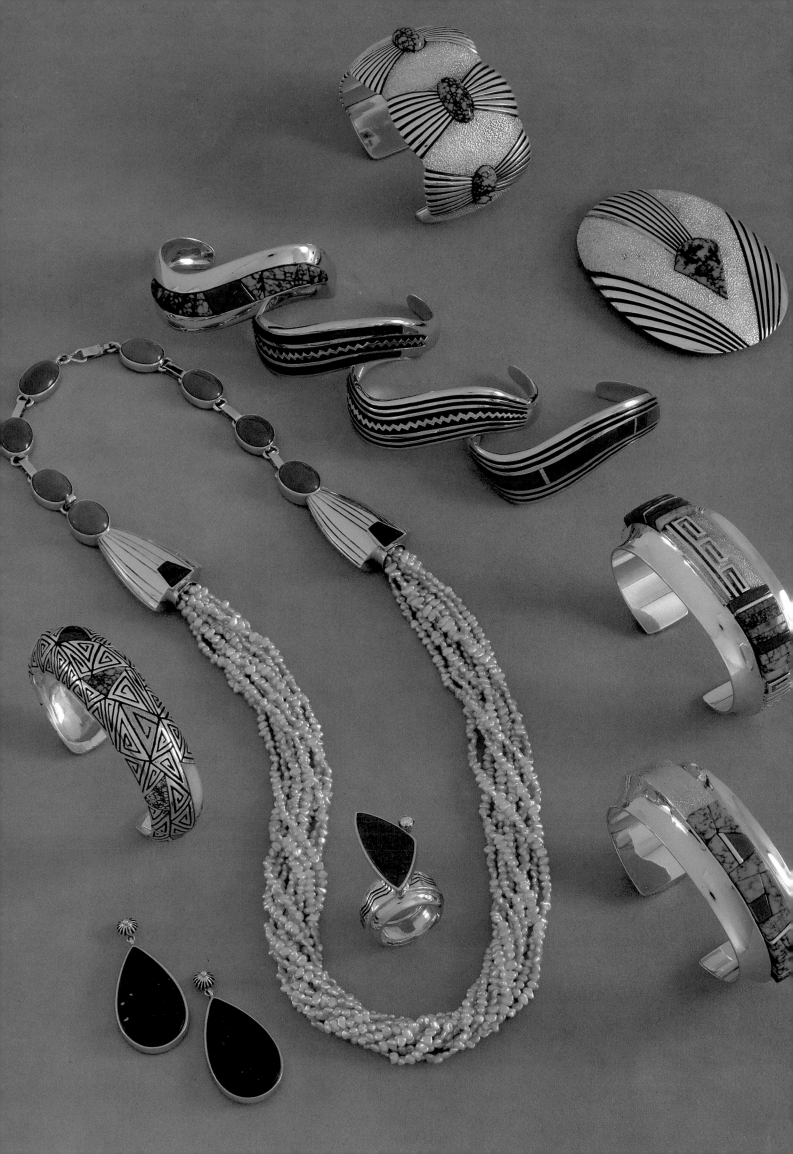

OPPOSITE: The versatility and exceptional craftsmanship of Navajo jeweler Harvey Begay becomes obvious when viewing this display of his work. Materials such as Biwa pearls, turquoise, coral, and lapis lazuli are combined with fabricated, cast, and hand-textured silver and gold to create very distinctive and fashionable jewelry.

spent all the time I could with Pierre. Though he taught me the more advanced mechanics of jewelry making, the main thing he taught me was the psychology behind designing."

Although Pierre died in 1983, his contribution to contemporary American Indian jewelry endures. For, like a pebble dropped in a pool, his European influence spreads in ever-widening circles as other artists are inspired not only by Pierre's jewelry but by that of his half-dozen protegés as well.

Although today's artists have been aided and encouraged by numerous positive influences, negative influences also abound. Many artists have agonized over feelings of inferiority, some have battled alcoholism, and all have suffered to some degree from the derogatory stereotypes applied to "Indians." Yet they have overcome these problems, and today there is a new-found awareness and growing pride in Native American ancestry.

"The hardest thing about being an Indian is to have a lot of pride," stated jeweler Jesse Monongye candidly. "I want to use my talent to bring pride to my people. The old Navajo ways teach you how to become a man, to prepare for life, and to depend on a Higher Spirit. I spent ten years away from those teachings. I had to learn the hard way, but now I'm starting over. In the life I have left, I only want to do my best."

White Buffalo, a Comanche raised among the Navajo at Shiprock, Arizona, faced some rather unique problems. Tended by Navajo sitters while his parents worked, Navajo became his native tongue. Upon beginning school, he was constantly punished (as were many others over the years) for not speaking English. Yet years later, when his Navajo friends encouraged him to make jewelry, he refused because jewelry was traditionally made by the Navajo, Hopi, and Zuni. However, at the urging of his Navajo wife and several silversmiths in her family, he was finally won over. "Besides," he explained, "I finally realized it was just another medium. I have to give credit to Charles [Loloma], he opened the door for guys like me. He made it okay to express an idea that was not traditional." White Buffalo went on to become one of today's most ingenious and creative silversmiths, noted for his exceptional silver flatware and hollowware vases, trays, and coffee and tea sets, as well as his jewelry. Today, Alvarez

and Maria (his teenage son and daughter) represent fourth generation silversmiths as they make jewelry and exhibit along with their father.

Many Native American artists have been discouraged from higher levels of education by perhaps well-meaning, but misguided, teachers or counselors; yet they have gone on to excel. Navajo artist Clifford Brycelea was told by a high school guidance counselor that he would never make it through college. However, Clifford not only received a scholarship to Ft. Lewis College in Durango, Colorado, but obtained an art degree in three years and was ready to begin work on his master's when he made the decision to become a full-time artist.

Virginia Stroud (Cherokee/Creek) left the university she was attending in protest when she was advised by her art professor to "quit painting the Indian subject or fail." "I still feel that an art school's purpose is to teach materials and their uses," she explained, "not to dictate style and subject matter."

Jaune Quick-To-See Smith was told in high school that, although she had average grades, her test scores showed she was definitely not college material. "But," she explained, "that was not unusual for that time. Many Indian students were turned away." However, Jaune was determined to become an artist. "That dream had been in the back of my mind since I was six," she said. "I didn't know exactly what it meant, but it was when I was happiest. And school was like a magnet, I couldn't stay away." After struggling through twenty-two years of college (working to earn a living, raising a family, attending school at night,...and painting), she graduated summa cum laude. Very proud of her master's degree (and rightfully so), she now lectures around the country, encouraging Native American youngsters.

Artists often overcome difficulties and disadvantages by sheer determination, will power, and hard work. And art is, among other things, hard work. Using chisels, saws, hammers, grinders, goggles, breathing masks, clay, scrapers, polishers, knives, paint, turpentine, dyes, sanders, and many other types of specialized equipment, they create exemplary works.

However, most of them have known hard work before, for their pasts include a conglomeration of occupations: welder, teacher, boilermaker, book illustrator, secretary, rodeo bronc

OPPOSITE: *Spiritual Peace,* a *Tasap* (Navajo *yei bi chai*) Kachina by Lowell Talashoma is an excellent example of a bronze casting made from a Hopi kachina sculpted of wood.

TASAP · NAVAJO YEI BI CHAI
Spiritual Peace
LOWELL TALASHOMA SR.

rider, printer, engineer, sheepherder, draftsman, sociologist, heavy equipment operator, machinist, architect, mechanic, and monument maker. While the majority are full-time artists, some also have other careers, including a construction worker, engineer, actor, teacher, a Congressman, and one who raises buckin' bulls for rodeo stock contractors. Native American artists are a diverse group linked by the essence of their heritage and talent.

Seeking new means of expression, a few carvers today create kachinas cast in bronze. Carved of the traditional cottonwood root, the kachina is used to form a mold for a wax casting. The lost wax process is used to fashion a ceramic mold for the molten bronze that becomes the final piece. The subtle colors of the finished kachinas are patinas applied by chemically staining the metal. These bronze kachinas are a unique Hopi art form, prized by collectors.

Contemporary sculptors transform tradition into elegant figures of stone and metal. Tomas Dougi Jr. chose translucent red alabaster for a poignant sculpture of a maiden awaiting the return of her mate. However, it is not to be, for the warrior has been killed in battle. Tom, who writes poetry to accompany many of his sculptures, penned the following lines to go with *The Long Wait*:

The warmth of her tears
touched my heart
on the eve of my long coldest night.
The wind whispered of the distance
we will be at dawn.
Many sunsets we have seen
from one another's arms.
The midnight of your absence,
the stars of the memories
of your smile.
The horse I travel on
will take me through the storm
back to the place we departed
and together we shall see
the sunsets and the moons
yet to come
from one another's arms.

Sculptors work in a variety of mediums including copper, lime-stone, brass, bronze, soapstone, and marble. Occasionally, a sculpture such as an unusual porcelain figure appears on the scene. The one included in this book was created as an experiment. Though Tex Wounded Face (Mandan/Hidatsa) usually works in stone, he wanted to try something different. "I wanted to find something that has lasting value, that was unique and rare. I developed three different patterns and lost over thirty pieces in either firing or the claying process, because of the large size [23″ long, 14″ high] and the internal stress factor of the piece. I tested nineteen different types of porcelain and over sixty glazes. This is 'a first' for its size."

As long as creative minds are tantalized by the untried and fascinated by the unique, artists will continue to experiment. Paintings today are often a blend of styles for that very reason, as traditional subjects are combined with exploratory abstract designs. Dolona Robert's (Cherokee) work has been described as "contained abstraction," as the geometric designs on the blanketed backs of her native people are a form of abstract representation.

At first glance, W. B. Franklin's (Navajo) symmetrical painting, *Corn Spirit Conversations,* appears to be the likeness of an unusual Navajo rug; however, upon closer scrutiny, the vertical designs become a row of Corn Spirits, intermediaries between the Navajo (the human forms across the bottom of the painting) and the spirit world (represented by the indistinct forms across the top). Pueblo villages rise mystically above a translucent play of design and color in the paintings of San Juan artist, Tommy Edward Montoya, *Than Ts'ay Ta.* Both Tommy's subtle style and W. B. Franklin's abstract images include a blending of traditionalism and non-realism, although opposed in approach.

Many contemporary potters combine mediums as they adorn an elegantly shaped vessel with a complex painting, a graceful sculptural design, or both. Each piece of Dorothy Torivio's (Acoma) pottery is decorated with a single repetitive design that grows and recedes with the shape of the pot. Her intricate patterns often appear as optical illusions, with black and white designs seeming to inverse themselves before the observer's eyes.

Intrigued by ancient Anasazi pottery shards found near his

Winnebago potter Jacquie Stevens allows her creative imagination to stray from traditionalism as she creates her unusual pieces. Micaceous clay, random-indented designs, fire clouds, and a "broken" rim place this piece in the category of abstract pottery art.

OPPOSITE: Drawing upon visions of the many Indian pueblos along the Rio Grande in northern New Mexico, Tommy Edward Montoya, *Than Ts'say Ta,* of San Juan Pueblo, created this oil pastel, *Pueblo Dreams.*

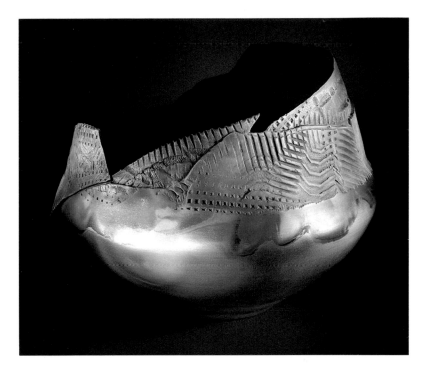

northern Arizona home, Richard Zane Smith began experimenting with native clays and traditional coiling methods. He now recreates Anasazi corrugated ware in extremely large, thin-walled vessels. His innovative—yet deeply historical—style features unconventional, but graceful, shapes with highly unusual abstract designs.

Other contemporary pottery is unpainted, relying upon shape or carved design for its beauty. Winnebago potter Jacquie Stevens's large, hand-coiled, smoked clay vessels are spectacular examples. Enhanced by the natural colors of the native clay, most of her pottery is adorned only with simple incised designs and the gorgeous fire clouds that result from pit firing. With a grin, Jacquie explained the unusual shapes of her pottery: "I don't like symmetrical things. I go sort of crazy at the end, dipping edges and creating odd tops to the pot."

Pottery created by Al Qöyawayma is characterized by elegant symmetrical shapes, flawless finish and simple sculptured designs. An environmental engineer, Al learned pottery-making

from his aunt, the noted Hopi potter, educator, and writer Elizabeth White, *Polingaysi*. In his quest for artistic perfection, Al has researched pottery from many museums and private collections, analyzed clays, and studied prehistoric pottery shapes and designs. But he is quick to point out that "my pottery is not scientifically designed. In fact," he adds laughing, "my fellow engineers view it with some puzzlement and wonder." And well they may, for the philosophy behind Al's pottery-making is very unlike that of an engineer. "As a potter, I am respectful of the clay. I have been taught to let a pot be what it is going to be; you cannot force or hurry the clay. During the creative process, I am privileged to be present, watching as the unseen hands and the gift of the Creator's energy flow into my work."

Unusual color schemes and cross-cultural use of designs highlight modern basketry. Cherokee Mavis Doering's wicker basket designs are woven in rarely seen pink and purple shades (made from natural dyes), with feathers occasionally added for adornment. Mavis's talented use of subtle colors takes the art of basketry one step further from the past.

Although the talent of Navajo textile weavers is legendary, today's artists become ever more innovative. At one time, Two Gray Hills, Pine Springs, Ganado, Crystal—all of these elegant rug styles, and many more—were readily identifiable by the area in which they were made. Today, though the older styles endure, many weavers are achieving new heights of creativity by combining unexpected colors and designs. Some work with an amazing array of natural dyes, resulting in color subtleties not previously seen in Native American weaving. Vegetal dyes are derived from a multitude of flowers and other plant parts, including unusual sources such as lichen, cactus, potato skins, beets, red onion skins, and coffee grounds.

The weaver's interest in innovation is often stimulated by traders and gallery owners, and some new trends have developed due to that influence. With a trader's advice and assistance, a few weavers work in partnerships; "dye artists" from one area supply the yarn (dyed in colors normally used in their area) and other weavers use that yarn to weave rug designs common to their particular region.

OPPOSITE: Displaying twenty-five subtly blended vegetal dyed colors, the 6′ by 9′ Burnt Water-style rug was woven by Sadie Curtis and Alice Belone of the Ganado area. It represents an outstanding achievement in contemporary Navajo rug art, produced by weavers in one area in collaboration with dye artists from another. Collector/dealer Steve Getzwiller, who commissioned the rug, obtained the participation of six weaver/dye artists from the Burnt Water region to dye wool yarn especially for this piece.

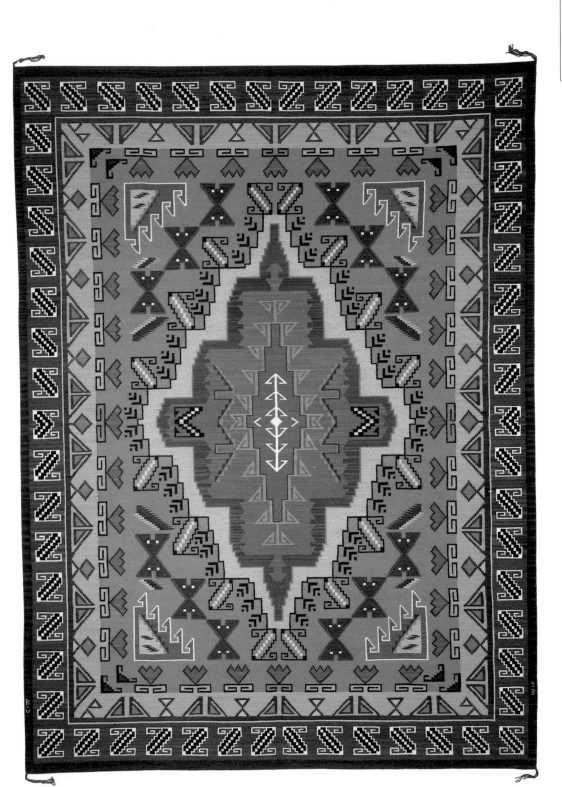

Weavers from the Coal Mine Mesa area used traditional colors and designs to weave raised outline rugs until local traders encouraged experimentation. They then began using Burnt Water colors in various regional designs. Due to the relocation program on the Navajo Reservation, some of the Coal Mine Mesa weavers have now moved to an area near Sanders, Arizona. Several of these weavers, again with the encouragement of traders, combine subtle Burnt Water colors with Teec Nos Pos designs woven in the raised outline technique. These rugs are sometimes referred to as the New Lands Outline style.

Ramona Sakiestewa (Hopi) is a most resourceful weaver who has broken with tradition in several ways. First, Hopi men ordinarily do the weaving, and second, Ramona uses a European horizontal (or floor) loom, rather than the vertical loom used by the Pueblo and Navajo. She has traveled extensively, and in Peru worked with native weavers who sought to improve their craft. While there, she began studying native dyes and now, continuing to experiment, she creates a marvelous array of colors. She uses not only plant dyes—onion skins, native walnuts, mistletoe, sunflower seeds, madder root, chamisa, and others—but also insect dyes: cochineal (primarily from Peru) and lac (from southeast Asia). In a fascinating process, Ramona places cochineal, the minute insect that lives on the prickly pear cactus, into a blender to make a powder that becomes the dye product. The cochineal must be handled cautiously, for the caustic acid it contains can, and often does, cause blindness to those who regularly handle it, particularly the native pickers. Marvelous variations of red and purple shades are obtained from cochineal, while the lac produces spectacular red-orange, bright pink, and deep burgundy. Ramona's interest in color is reflected in her exceptional weavings, and she is a dye artist extraordinaire.

When speaking of artists extraordinaire, today's jewelers immediately come to mind. As they search for new avenues of artistic expression, their work becomes timelessly classic, with little obvious traditionalism. It may be a magnificent Ted Charveze creation of gold, Australian opal, and six carats of diamonds; or a striking silver necklace of discoidal beads with a lapis lazuli pendant by Gibson Nez (Navajo); or an incomparable gold

necklace set with sugilite and diamonds by James Little; but it is pure art.

That art is enhanced by the use of exotic, precious, and semi-precious stones: diamonds, turquoise, coral, emeralds, lapis lazuli, shell, pearls, ivory, opals, topaz, black jade, malachite...the list goes on and on, for the artists continually seek rare and unusual stones in their desire for innovation. Two new gemstones, charoite and sugilite, have recently come into use. Discovered in the late 1970s, both gems have been used by American Indian artists only during the last few years. Charoite, a lacy, fibrous stone of varying shades of purple, is acquired from the Charo River in Siberia, U.S.S.R. Sugilite, which comes from the Kalahari Desert of South Africa, has been marketed under several trade names, including Royal Lavulite. Consequently, either name (sugilite or lavulite) may be used by the artists in describing their gemstones but they are in fact one and the same. Both sugilite (which ranges in color from translucent, pale lavender to deep, opaque purple) and charoite add a delightful contrast to the textured or highly polished gold and silver of today's jewelry.

Contemporary jewelry often has a sculpture-like quality and may—like a Larry Golsh (Pala Mission/Cherokee) creation of white gold, black onyx, and diamonds—appear architectural in design. Larry, who was a student of engineering and architecture before switching to fine arts, trained under Ben Goo at Arizona State University, and later with Paolo Soleri and Pierre Touraine. "I have a strong design background," Larry explained. "I am basically a metalsmith and usually use the stones as accents. I am an experimenter; I like doing things that are different, and inspiration is everywhere—in cactus, seashells, rocks with sculptural forms." Led by a love of simplicity and an innate sense of style, he creates exquisite works of art.

Imagination, creativity, and initiative compel the artists to seek new horizons. Though they feel the tug of the spirit for the old ways, even stronger is the lure of a new world beckoning.

116

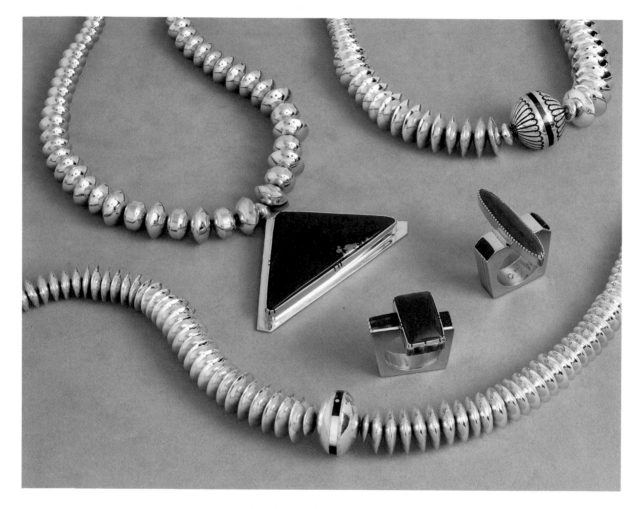

Jewelry of gold and silver by Gibson Nez (Navajo/Apache). The rings are set with coral, and a 100-carat stone of lapis lazuli adorns the gold necklace.

OPPOSITE, *left:* This concha belt by Gail Bird (Santo Domingo/Laguna) and Yazzie Johnson (Navajo) was one year in the making, from design stage through final fabrication. Of sterling silver with basket designs from several Indian tribes, it is set with Tyrone turquoise, coral, lapis lazuli, Bruneau picture jasper, and gold. *Right:* Larry Golsh (Pala Mission/Cherokee) spent one year designing and making this bracelet-and-ring set. Of white gold, it is set with onyx and 15 carats of pavé set diamonds. Beads are of lapis lazuli-accented with turquoise, the pendant is charoite set in 14-karat gold.

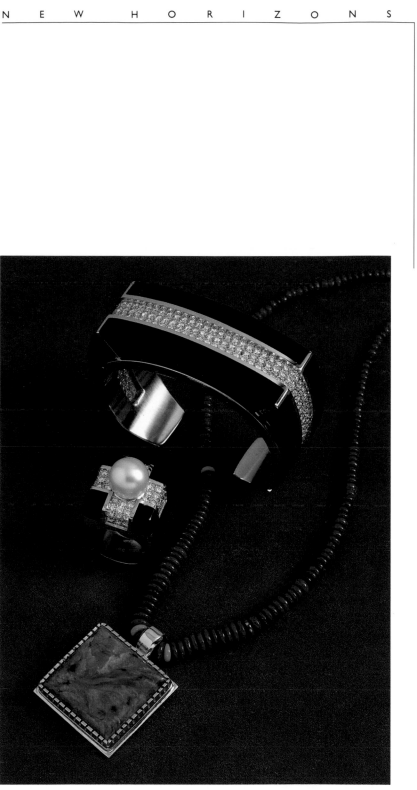

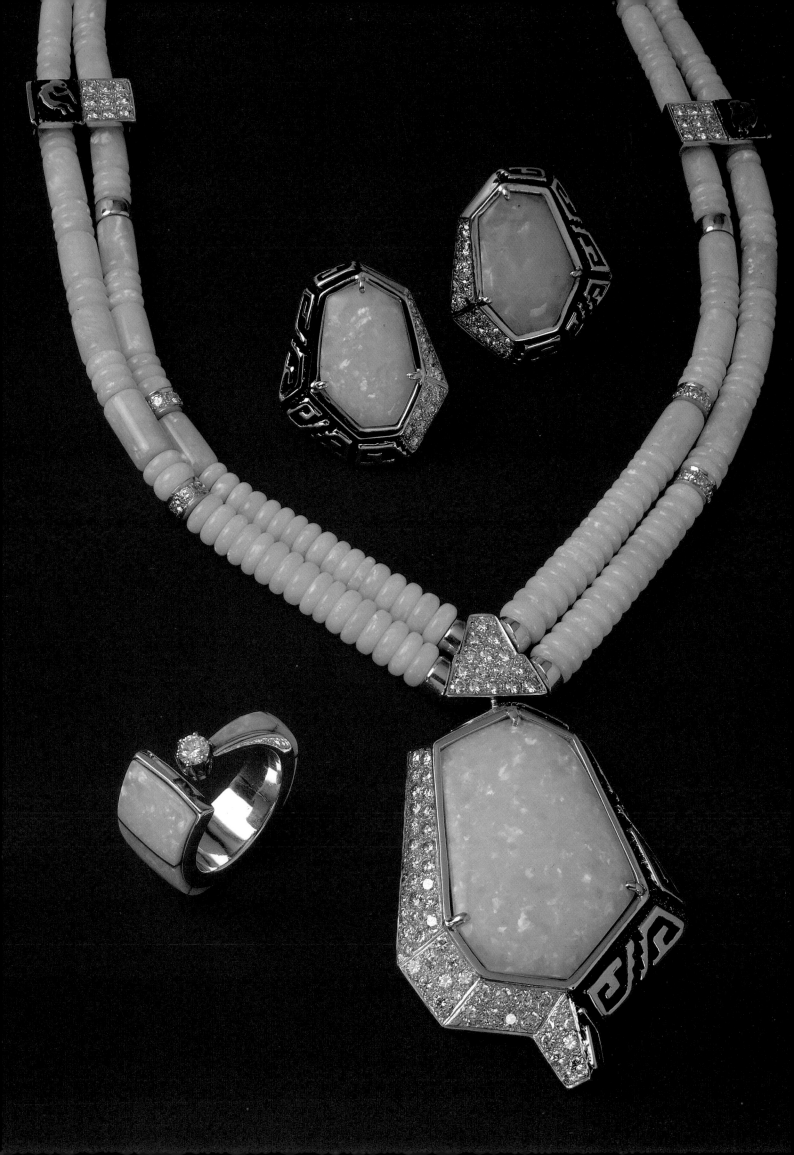

OPPOSITE: This set by Ted Charveze (Isleta) combines several techniques. Australian opal in bead and cabochon form are set in 14-karat gold that combines fabrication and the lost wax casting methods. It contains 6 carats of diamonds, mostly pavé set.

RIGHT: Fourteen-karat-gold necklace with hand-made beads, and a tufa-cast and fabricated pendant set with diamonds and sugilite by James Little (Navajo).

BELOW: This jewelry by Al Nez (Navajo) combines lapidary inlay work with sandcasting (pendant) and hand-wrought fabrication. These 14-karat-gold pieces are set with turquoise and lapis lazuli.

120

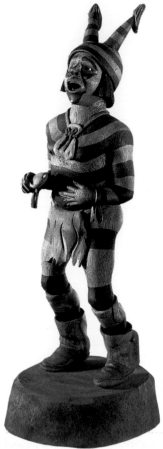

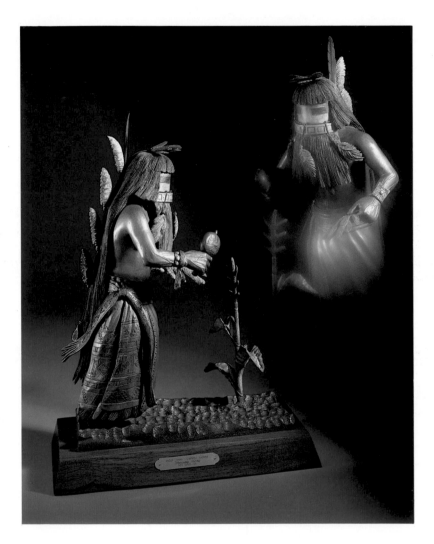

ABOVE: Alvin James Sr., *Makya,* was among the first carvers to break Hopi kachina-carving tradition by creating exceptionally lifelike features and revealing the natural qualities of the wood. He was also a forerunner in producing bronze castings from Hopi wood carvings. Shown here is a 14″ Hano Clown.

OPPOSITE: A 14½″ tall Hano *Mana* Kachina, sculpted entirely from one piece of cottonwood root (including the base) by Cecil Calnimptewa (Hopi). Although carved by hand, it goes far beyond tradition in its sculptural, lifelike qualities, unusual colors, and the realistic setting carved into the base.

LEFT: Following the lead of sculptors who produce bronze castings of their stone originals, Hopi Kachina carvers occasionally issue limited edition bronze castings of their work. *Growing Song,* a Long-Hair kachina (*Anguk' China*) sculpture by Neil David Sr. is shown here.

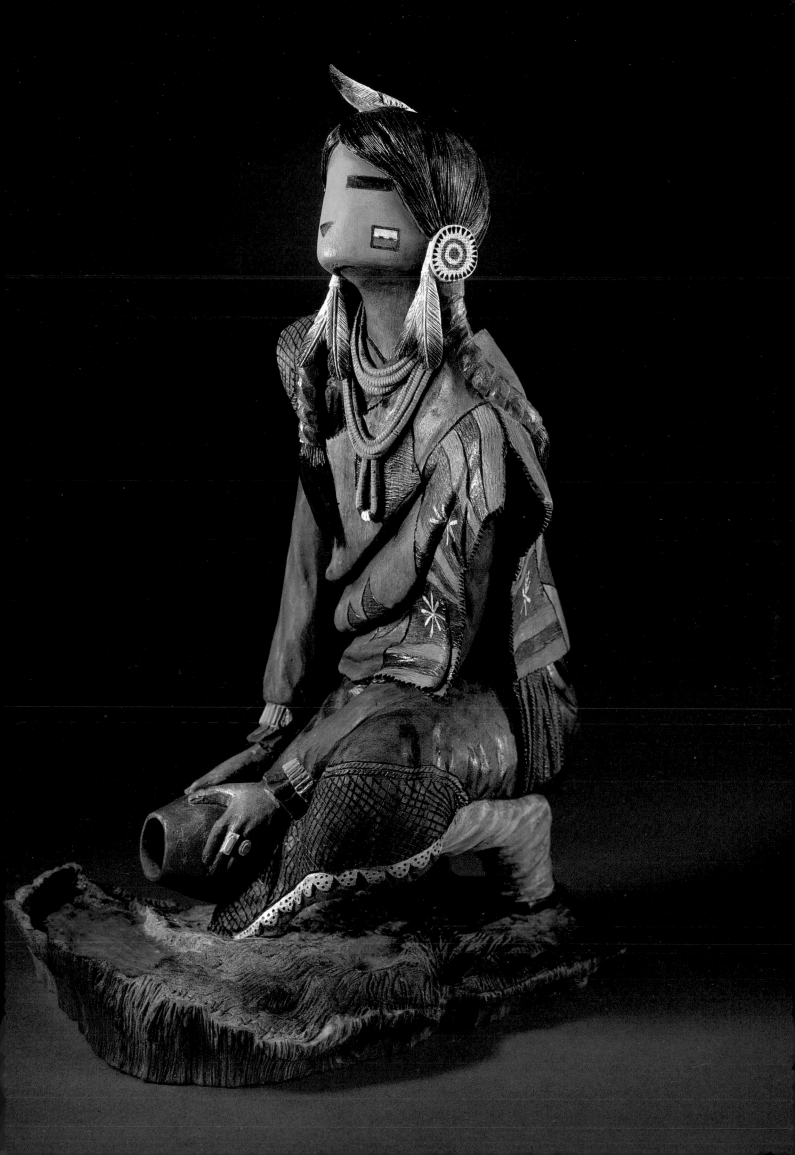

LEFT: Karita Coffey (Comanche) sculpted these 14½" tall moccasins of clay.

OPPOSITE: Acoma potters Wilfred and Sandra Garcia made this elegant 15" tall pottery jar. Beautifully executed bear paws appear on opposite sides of the shoulder.

BELOW: *Sleeping Grandmother,* 23" long by 14" high, English porcelain by Tex Wounded Face (Mandan/Hidatsa). The creative process involves hand-pressing the porcelain into a mold made from the original stone sculpture; two firings were then required: a bisque firing at 1900° Fahrenheit and a glaze firing at 2200° Fahrenheit.

ABOVE: Using the elegant shapes of her finely executed, thin-walled pottery as a canvas, Dorothy Torivio of Acoma Pueblo paints kaleidoscopic designs on her distinctive wares. The pottery shown here ranges in size from 1½″ to 8¾″ high.

OPPOSITE: Feather Woman, Helen Naha, was among the first Hopi potters to depart from tradition. Using designs from Anasazi black-on-white pottery shards, she produces a distinctive contemporary style of pottery.

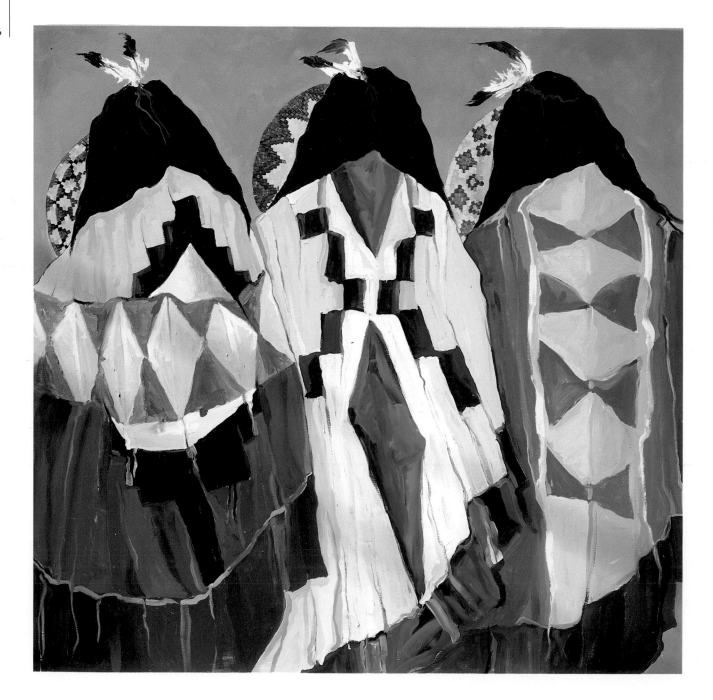

RIGHT: *Corn Spirit Conversations,* 42″ by 60″ acrylic on canvas by W. B. Franklin (Navajo) is highly complex. The vertical figures represent corn spirits with abstract faces, necklaces and shirts, corn bodies, small concha belts, kilts with designs, legs wrapped with buckskin leggings, and moccasins. The subtle human forms across the top represent the spirit world, the more distinct ones at the bottom, the people of today.

OPPOSITE: *At the Dance,* 58″ by 60″ acrylic on canvas by Dolona Roberts. The backs of the blanketed figures become the canvas for this Cherokee artist…all else is secondary.

PRECEDING PAGES: *Totality of the Day,*
42″ by 30″ oil on canvas by David Johns
(Navajo), is his interpretation of a
landscape at sundown. The terrace
symbols in the lower portion repre-
sent thunderclouds that flow across
the earth to demonstrate that rain
produces harmony between Mother
Earth and Father Sky. The sweeping
colors in the upper portion represent
a sunset during the rainstorm.

ABOVE: AND OPPOSITE: Hopi weaver
Ramona Sakiestewa creates a mar-
velous array of color by making her
own dyes from plants and insects. She
then incorporates these colors into
her hand-dyed wool yarns to create
beautifully unusual tapestries.

Contemporary color schemes and cross-cultural use of design are among the new trends in modern basketry.

ABOVE: This basket by Mary Black (Navajo/Ute) displays a design more typical of Pima basketry.

OPPOSITE: Mavis Doering (Cherokee) gathers thirteen different natural substances, including nuts, berries, roots and leaves to make dyes for her double-walled wicker baskets.

LEFT: This Burnt Water-style rug was woven by Marie Watson using the raised outline technique. Made of vegetal-dyed, hand-spun wool, it is exemplary of the innovative Navajo rugs being woven today.

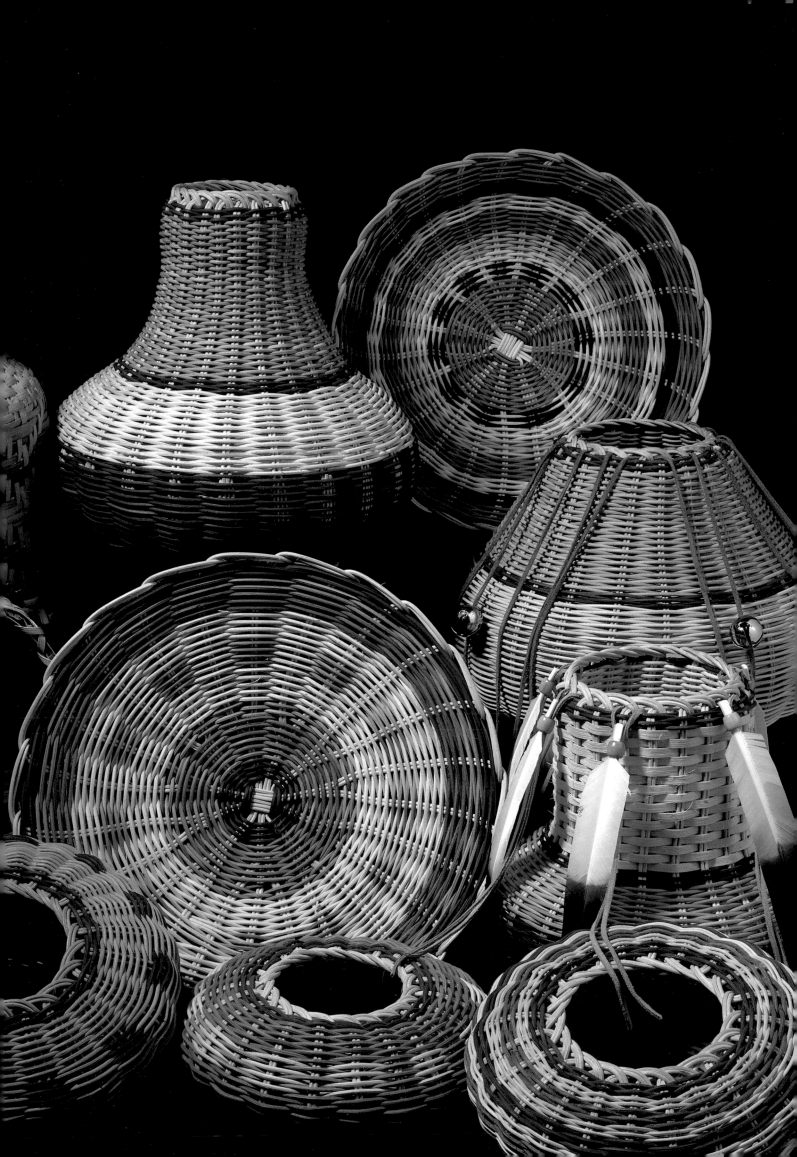

4

An outstanding example of the sculptural qualities and life-like animation that embody the finer kachina dolls carved today. Loren Phillips (Hopi) carved this incredibly detailed eagle (*Kwahu*) from one piece of cottonwood root.

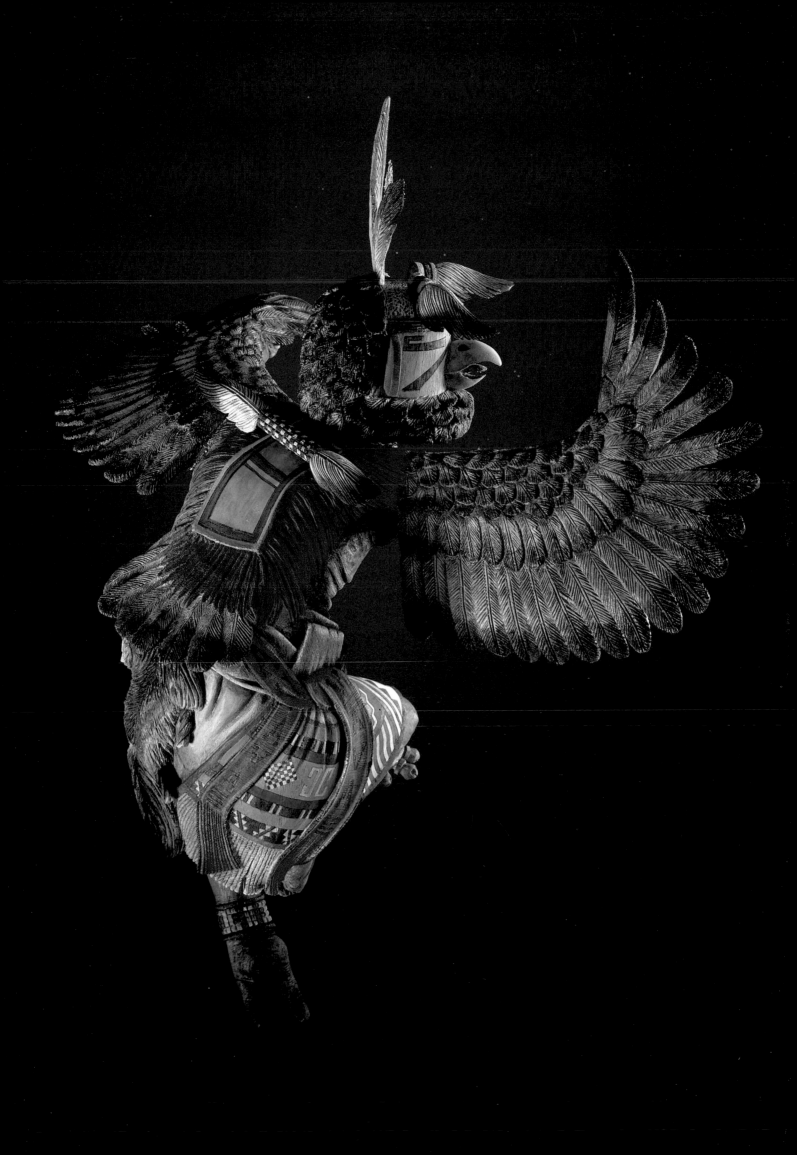

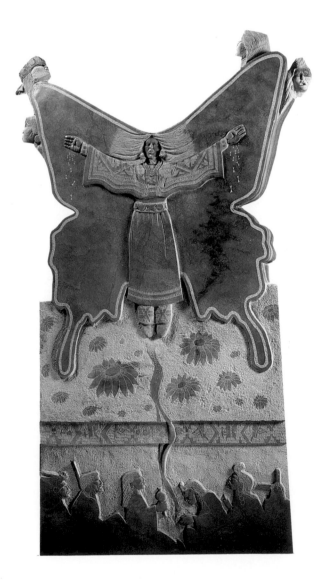

4 In Harmony with Nature

OPPOSITE: *Journey to the Butterfly World*, sculpted of alabaster and 62″ tall, is by Navajo artist Alvin Marshall. The piece makes a statement about the way man must live in harmony with the rest of the natural world and what he can learn from it. One of the men at the bottom of the sculpture is putting pollen into the fire to serve as a message of sister- and brotherhood and to tell the butterflies that people are coming. The smoke, flowing upward in front of the ceremonial belt, signifies that the ceremony is being done in the proper way. The Butterfly Lady (with outstretched arms) is beginning to travel, and sprinkles blessings and knowledge from her hands. The men on her wingtips are singing to the four directions.

AMONG NATIVE AMERICANS, REGARDLESS OF tribal affiliation, the idea that mankind should attempt to live in harmony with nature is universal. Underlying every native religion is respect for the earth and the Power that governs it. Prayers were offered, and are now, wherever the faith and practice of the ancient ones are observed: for needed rain, for flourishing crops, for success in the hunt. An offering was made for anything taken from the earth, whether it be clay for pottery, an animal for food, or plants for food and shelter. There was reverence for all nature, for life in any form.

And there was awe—for the beauty and bounty of the earth, the majesty of the sky, the seasons. The awe exists today, as it did then, as demonstrated by Harold Littlebird, Santo Domingo/ Laguna poet and potter.

> Our Father the Sun,
> has given to all people his radiant light
> to remind mankind of their humility
> His is the path we follow throughout our lifetimes
> to know when it is proper for all our earthly doing
> planting, hunting, bearing children
> to know where there is the sustenance
> of water, roots and animals
> look carefully at how we love this life
> and how our Mother Earth remembers her children.*

This suggests why motifs from nature—lightning, clouds,

On Mountain's Breath, © 1982, Harold Littlebird.

the forms of birds and animals—decorated ancient pottery, were carved into fetishes and body adornments, and were pecked in petroglyphs on stone. The primitive artist no doubt responded to both the aesthetics and the significance of natural forms, as did his more sophisticated descendents in the time of traditional tribal art. So do the Native American artists of today who use such motifs with perhaps more abandon and enthusiasm than ever before as they borrow freely from themes of nature.

Almost every element of nature—animals, the sun, plant life and more—is represented by a kachina spirit. As kachina dancers (who represent those spirits) perform, prayers are sent forth—perhaps for good health, abundant crops, or the well-being of all mankind. The kachina carvings, in turn, depict both spirit and dancer. The spiritual symbolism of the kachina is displayed as mountain sheep, deer, crow, prickly pear cactus, the sun, eagles, and others manifest Hopi ceremonial life. Realistically carved and full of emotion, each figure tells a story as the dancer becomes as one with the animal or spirit he represents.

A mountain sheep, head held proudly, appears poised to leap from cliff to cliff, and an eagle is so powerful and realistic that one almost expects to hear its cries. As the prayers, blessings, and well-being of the Hopi are dependent upon the kachina spirits, these lifelike kachina carvings embody the ceremonial tie with nature.

Nature's world offers three elements that are of special significance to artists: light, color, and design. Ramona Sakiestewa, who lives in Santa Fe, says light and color are two of the most important things in her life. "I think that comes from living out here," she explained, "watching countless sunsets, being able to look out across the land for miles and miles."

The scenic wonders of the Southwest do provide endless inspiration: red canyon walls and tall sculptural spires, the iridescence of summer rainbows, the many shades of Indian corn, windswept sand dunes, the brilliant hot pink of cactus blossoms, the subtle desert shades of green and sand, and an ever-changing panorama of sunrises and sunsets.

Color is all-important to artist Virginia Stroud, a student of tribal history who was raised by a Kiowa family after the death of

The human figures on these baskets made by Mary Thomas (Tohono O'Odham) represent the enactment of a traditional ceremony, which includes prayers for rain and good crops. Often referred to as the "friendship design," this circle of people surrounds a man-in-the-maze and a rattlesnake on the trays. Materials include: yucca (white), banana yucca root (red), and devil's claw (black).

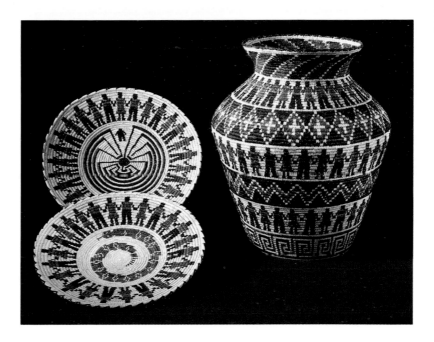

her Cherokee-Creek parents. She paints vivid "happenings" from everyday Indian life and describes herself as a "visual orator." Climbing the hill behind her Colorado home on a crisp day in autumn, Virginia confessed her adverse reaction to the season. "Autumn really bothers me. I'm not an earth-tone person. I go out looking for a thistle or something, *anything,* magenta." She laughs about her color "fetish": "I was told once that purple meant I was in a growing period, so I put all the purple paints away. Then I discovered I was mixing pinks and blues to make purple. So I quit fighting it."

Turtle Sounds, a painting by David Dawangyumptewa (Hopi), a member of the Water Clan, is filled with abstract natural forms and symbolism. A study in design and color, it is enhanced by the fanciful touch of turtle shells formed of turquoise clusters. These symbolize the turtle shell rattles that, when worn by kachina dancers, represent the sound of water.

In sculptural art, symbols of nature also abound. The eagle and buffalo appear in all types of stone, bronze and even silver. Elk Woman (Mandan/Hidatsa/Arikara) reflected on the significance of the two in her sculptures. "The eagle carries the prayers

of the Great Spirit and watches over us, seeing all and carrying our spirits to the Creator. The sacred buffalo gives us strength and stability. We are happy knowing we walk the Sacred Road."

Journey to the Butterfly World, an incomparable alabaster sculpture by Alvin Marshall, exemplifies a perfect joining of artistry and design. It teems with tradition, spiritual legends, naturalistic symbols, and emotion in the artist's attempt to communicate his feelings. "Everything is here for a reason," he explained. "We must walk in sacredness with the Great Spirit; he gives us everything on earth. I'm thankful for the talent he has given me and grateful that the stone, the animal, and I can touch your heart. If people can see what I mean, I'm satisfied."

When symbols of nature are portrayed, the artist's goal is to capture the essence of their power. "The feathers of birds are so important," explained Dan Namingha (Tewa/Hopi) as he talked about his painting *Red Tailed Hawk.* "They're all used in ceremonies. But the hawk and eagle are very powerful birds. I wanted the painting to have lots of energy to signify power and spirituality." He was successful. Power is manifest in the bold splashes of color emblazoned across the canvas, and the eye is compelled to travel upward to the essence of the masked kachina.

A silver vase created by White Buffalo became an exercise in perseverance as well as a work of art. The vase, which began as a silver disc eight inches in diameter and one inch thick, was perfected over a thirty-two month period. After the vase was formed, the painstaking task of developing the complex motif began. Intricate designs of nature—animals, birds, mountains, trees—and American Indian symbolism were chiseled and engraved into the vase and accented with silver overlay and turquoise-and-coral inlay. Inside of this highly unusual piece is one small, gold kernel of corn, symbolizing its importance in the lives of Native Americans. Although requiring an inordinate amount of time and energy, White Buffalo's creation is a triumphant tribute to the natural world.

Another such tribute is a rug created by Linda Nez (Navajo). Although she learned to weave by watching her mother and aunt, Linda is primarily self-taught. The unusual rounded forms that characterize her work, rather than the "blocked" figures tradi-

OPPOSITE: Hopi artist David Dawang-yumptewa entitled this 23″ by 30″ watercolor *Turtle Sounds.* The artist, a member of the Water Clan, frequently uses water as a theme in his paintings. Turtle shell rattles used during kachina ceremonies represent the sounds of water, and this painting incorporates an array of mystical elements that stand for water and its environment. The blanketed figure in the center is a water carrier.

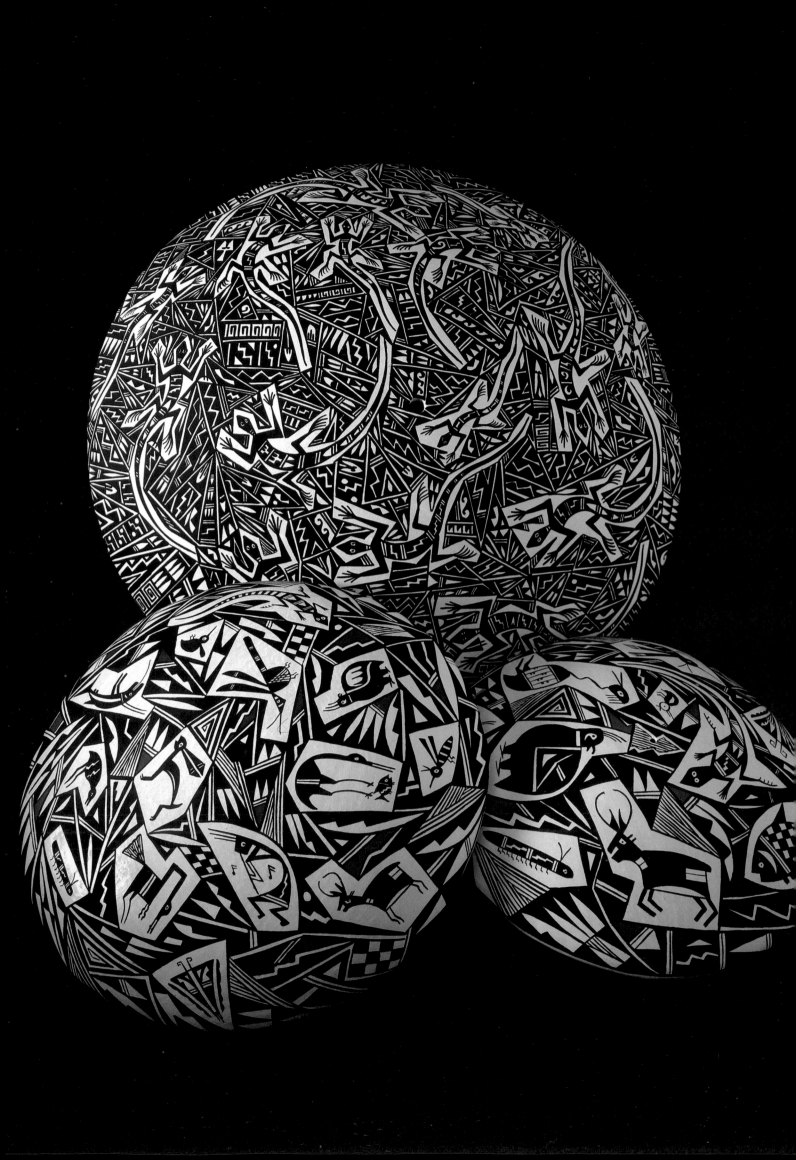

OPPOSITE: Complex geometric and life forms patterned after Mimbres pottery designs cover these highly unusual pottery pieces by sisters Rebecca Lewis Lucario (*top*) and Carolyn Lewis Concho (*front two*) (Acoma). Although the pottery shapes echo those of ancient seed jars, the only opening is a tiny vent hole at the top of each piece. They range in size from 5″ to 7¼″ in diameter, and 1½″ to 2¾″ tall.

tionally woven, add a most realistic appearance. Besides the mountain scene, fifty-nine animals, birds, fish, and butterflies, and twenty-four figures of plant life fill this incredible tapestry.

The sandpaintings of Joe Ben Jr. are a unique contemporary art form. He began creating sandpaintings when he discovered that he didn't like what was happening in his life. "In a University of New Mexico philosophy class, I found that I was being transformed into something I was not," Joe declared. So he turned to sandpainting as a way to earn a living and preserve his culture at the same time. "And because," he quietly explained, "sandpaintings made me feel good inside." Joe feels very strongly about both his culture and his sandpaintings. "I was born and raised a Navajo," he continued. "People in my family have been cured by sandpaintings; this is my way of life. All ceremonies involve keeping in harmony with nature—the Sun, Mother Earth, and their children, which includes *us.* Somewhere along the road we have put ourselves apart from nature. This has caused an imbalance. I am trying to bring this back. All my colors are natural, nothing is dyed; they are all from Mother Earth. I work with nature's art and put it together." The "dust" from gold, diamonds, sugilite, lapis lazuli, and other stones is obtained from Joe's jeweler friends. Sulphur, gypsum, copper, low-grade coal, and sandstone are also used in blending materials to make various shades.

Inspired by the colors and life forms of nature, today's basketweavers experiment with new combinations of these elements in their basketry. A recent trend among Navajo and Paiute weavers is the use of butterflies, animals, and human forms, some in colors not previously found in basketry. Though the baskets retain many traditional characteristics, the artistry of design and color earn them a place in the contemporary art world.

Many types of pottery teem with natural themes, beginning with Grace Medicine Flower and Joseph Lonewolf's incised and carved birds, flowers, and wild animals. Yet another aspect of nature is presented in the perfection of the incised pottery of Rosemary "Apple Blossom" Lonewolf, Joseph's daughter. One such piece, entitled *The Cat's Meow,* is inscribed with the moon, stars, and more traditional designs, yet both realistic and stylized cats whimsically scamper over the entire piece, while mice frolic among them.

Pueblo life and legend, animals, and symbols of nature permeate the pottery vessels of some Santa Clara artists, but there any likeness often ends. Intricate, incised designs of great complexity boldly intermingle on the pottery of Paul and Ana Naranjo, while the motifs of Lois Gutierrez-De La Cruz's gracefully shaped vessels are delicately painted in a simple, yet detailed, style.

Jody Folwell's unusual pottery exemplifies nature's emotional appeal as well as the visual. Her *Sun Country* pot, which she describes as "earthy, with an 'Indian' feeling," is rough-textured, with two lizards lying languidly along the irregular rim. "Indians are from the sun country," Jody explains, "the lizard country. And the Indians are like lizards, always sunning themselves against a wall. I do that myself; as Polly [Jody's daughter, an up-and-coming contemporary potter] and I work, we find ourselves moving from window to window in order to stay in the sun. And the sun is baked into every grain of this piece." The sun country, Indian country, nature, all are intertwined in the ingenious mind of this artist and many others.

Jewelry by Jake Livingston (Zuni/Navajo) comes from another such imaginative mind. Though highly contemporary, many of his bird and flower designs have a distinct Zuni flavor, while other aspects of his work strongly reflect his Navajo culture. With a grin, Jake claims, "It depends on which eye I am looking out of at the time; when I open one eye, I see Zuni, open the other and see Navajo." Fortunately, both eyes see very well, and the combination results in exquisite jewelry. One of seven children, Jake is from an all-artist family. His parents and all of his siblings are jewelers or painters, as is most of his extended family. His uncle, Dennis Edaakie, was a leader in the refinement of the Zuni inlay technique, and among the first to use delicate flowers and birds in his intricate designs. Although Jake may come naturally by his talent for making jewelry, his skills don't stop there. He is also a master saddle-maker who designs and handcrafts western saddles, complete with silver conchas and engraved silver trim.

Other jewelers also embellish their work with symbolic designs of nature: mountains, lightning, rainbows, clouds, the sun, and shooting stars. One of the favorite motifs, because of its

Corn is a popular motif among Native American artists. The one on this bracelet by Charles Supplee (Hopi) is cast in 14-karat gold. The corn on the necklace, carved from coral and set with sugilite, pink coral, turquoise, and gold, is accented on each end with a diamond.

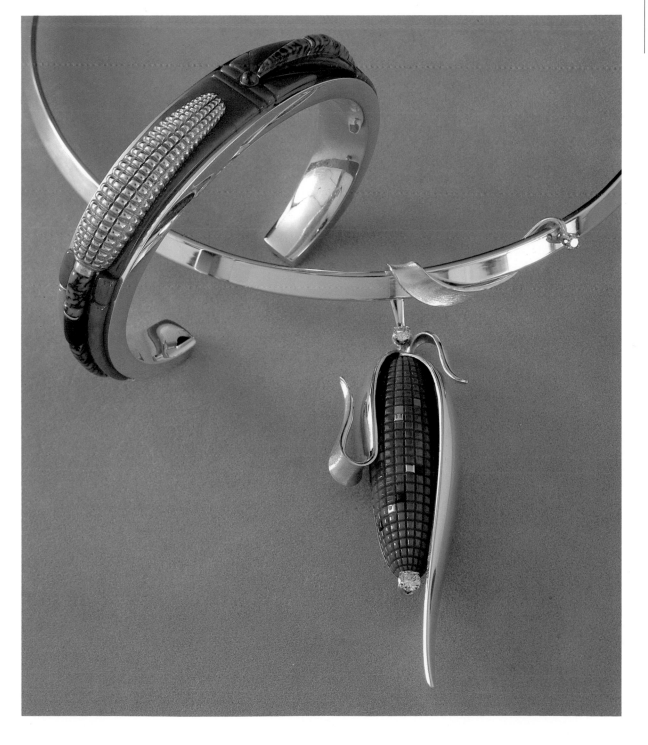

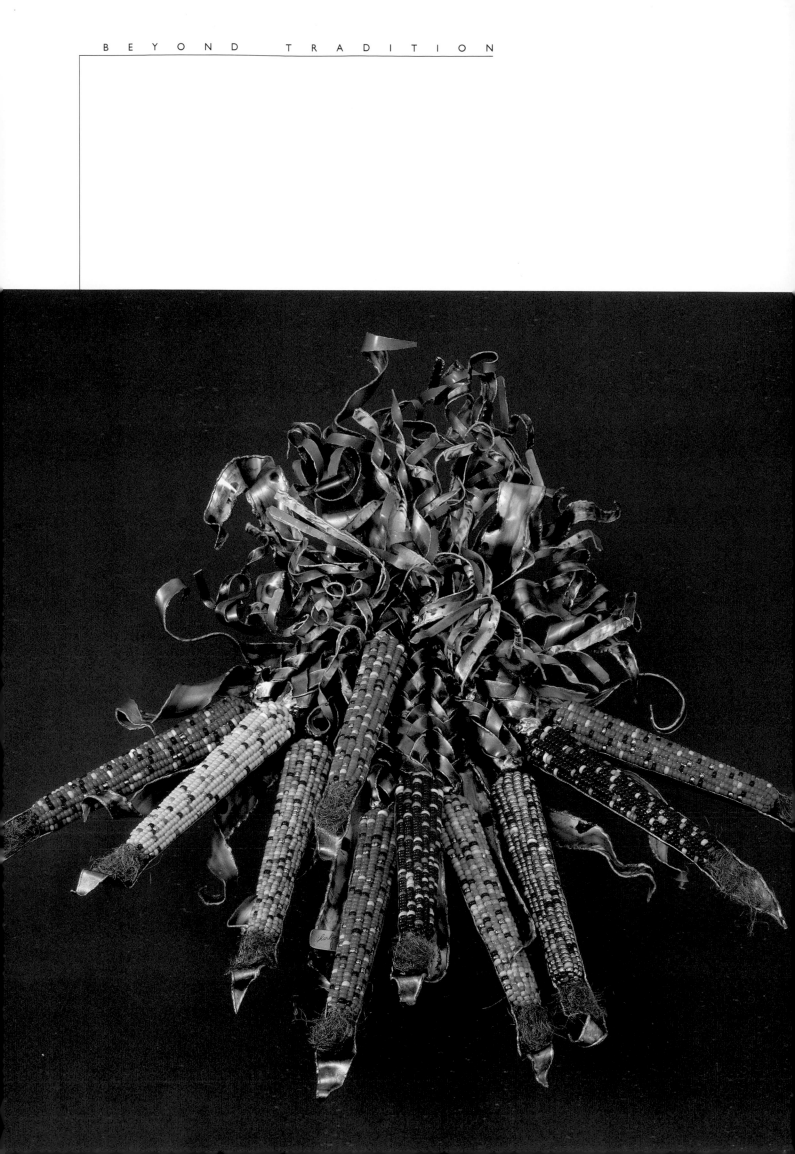

OPPOSITE: This life-sized cluster of Indian corn by Cheyenne/Arapahoe artist Charles Pratt, entitled *Gift of the Gods,* was fashioned of brass and set with nearly 3,000 kernels made of lapis lazuli (dark blue), coral (red), blue and green turquoise, reconstituted serpentine (yellow), and polished brass (gold).

ceremonial significance among many tribes, is corn.

Fashioned by Charles Supplee, a pendant in the shape of a delicate ear of corn with gold husks has kernels of coral, turquoise, sugilite, and gold, representing in miniature the multi-hued kernels of Indian corn. A James Little pendant is accented with sugilite, four diamonds, and a 14-karat-gold ear of Indian corn (cast using the lost wax process). Navajo jeweler Lee Yazzie is the creator of an award-winning bracelet made to resemble an ear of blue corn. Rows of Royal Web Gemstone kernels, interspersed with a few kernels made of opal, coral, and Bisbee turquoise, cover the entire piece. Lee explained why he often uses a corn motif: "I appreciate the Indian corn; it's the staff of life. I want to show appreciation, so I put corn on a pedestal."

Sculptor Charles Pratt (Cheyenne/Arapahoe), noted for his life-sized brass sculptures of corn and kachina figures, recently completed the "ultimate"—a unique wall-hanging sculpture of ten ears of corn. Some of the polished brass husks are braided together, others intertwine in artistic disarray. The corn silk is made of small copper wires; kernels are of highly polished brass and various stones: lapis lazuli, coral, reconstituted serpentine, and both blue and green turquoise. Most appropriately entitled *Gift of the Gods,* it is a remarkable piece.

The original inspiration for Charlie's corn sculptures came about in a most unusual way. At the Concho, Oklahoma, boarding school of his youth, each child took turns doing various chores—on the farm, in the dairy, in the kitchen. Though Charlie hated rising early to feed the livestock, he remembers well the large wooden bin where corn was kept, and he remembers running his hand through the corn, letting the kernels pour through his fingers. Years later, examining some turquoise stones that were for sale, Charlie unthinkingly ran his hands through the stones, allowing them to flow through his fingers just as he once had the corn kernels, and was instantly reminded of those early days. He promptly bought some of the stones to create his first corn sculpture.

Imagination, talent, motivation...the artists possess an abundance of all three. Equally important, they have the desire and ability to merge the past and the present while retaining the Native American view of harmony and balance with nature.

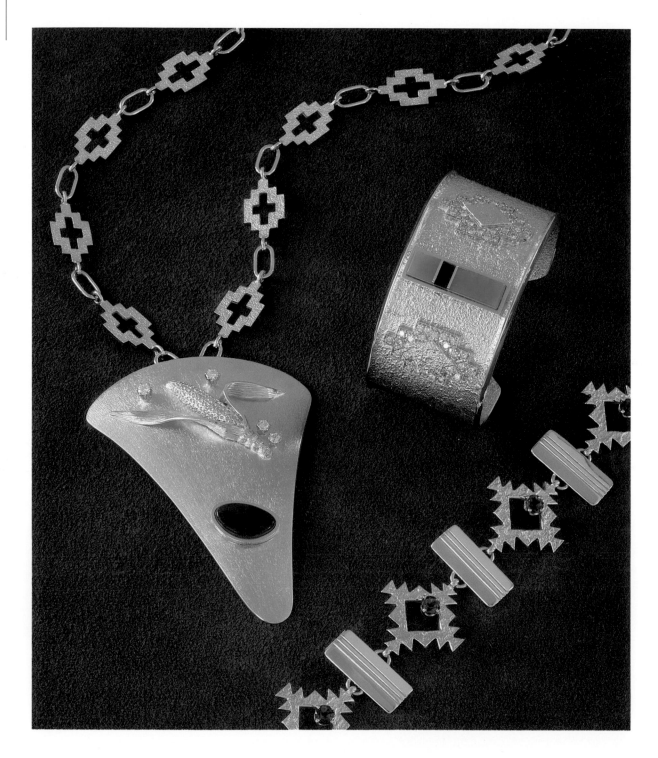

RIGHT, *top:* Watson Honanie's gold and silver jewelry portrays traditional Hopi life. The buckle (*top*) depicts a Hopi corn field; the necklace shows a village bustling with activity. Eagles on the roof-tops imply that this scene takes place just prior to the Niman ceremony. The bracelet includes gold deer and eagle kachinas. *Bottom:* This bracelet by Lee Yazzie, entitled *Blue Corn,* is accented with 14-karat gold and set with 365 pieces of Royal Web gemstones as well as Bisbee turquoise, opal, and coral, all within a meticulously constructed framework.

OPPOSITE: Although very modern in appearance, the jewelry of James Little contains traditional Navajo designs. Tufa-cast of 14-karat gold, the bracelet is adorned with rug designs, the pendant with a lost-wax cast ear of corn. Stone settings include diamonds, purple sugilite, blue topaz, and chrysoprase, a green gemstone from Australia.

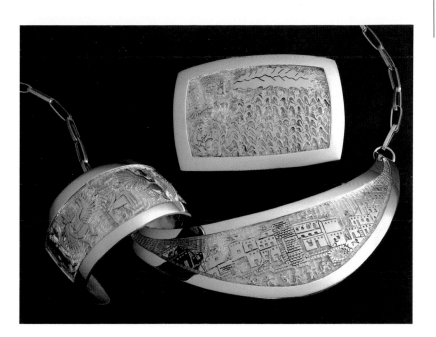

Cherokee/Creek artist Virginia Stroud's 36″ by 36″ acrylic, entitled *Dreamer's Holiday,* incorporates nature motifs in a very unique way. Pastoral in style, the unusual sheep-lined border adds a novel touch.

PRECEDING PAGES: *Red-Tailed Hawk,* 80″ by 120″ acrylic on canvas by Dan Namingha (Tewa/Hopi). In describing this painting, the Hopi artist noted that "the hawk is a powerful bird. That's why I used this particular style. I put a lot of energy into it because I wanted it to signify power and spirituality."

OPPOSITE: Traditional sandpainting motifs are reproduced in exceptional detail by Navajo artist Joe Ben Jr. Filings, or "sawdust" of gold, lapis lazuli, and sugilite, plus sulphur and copper ore, are among the materials used. Feathers, birds, buffalo horns, the four sacred plants (*clockwise, from top right:* corn, beans, squash, and tobacco), and a rainbow border enliven this 7″ by 7″ work, entitled *Four Houses of the Sun.*

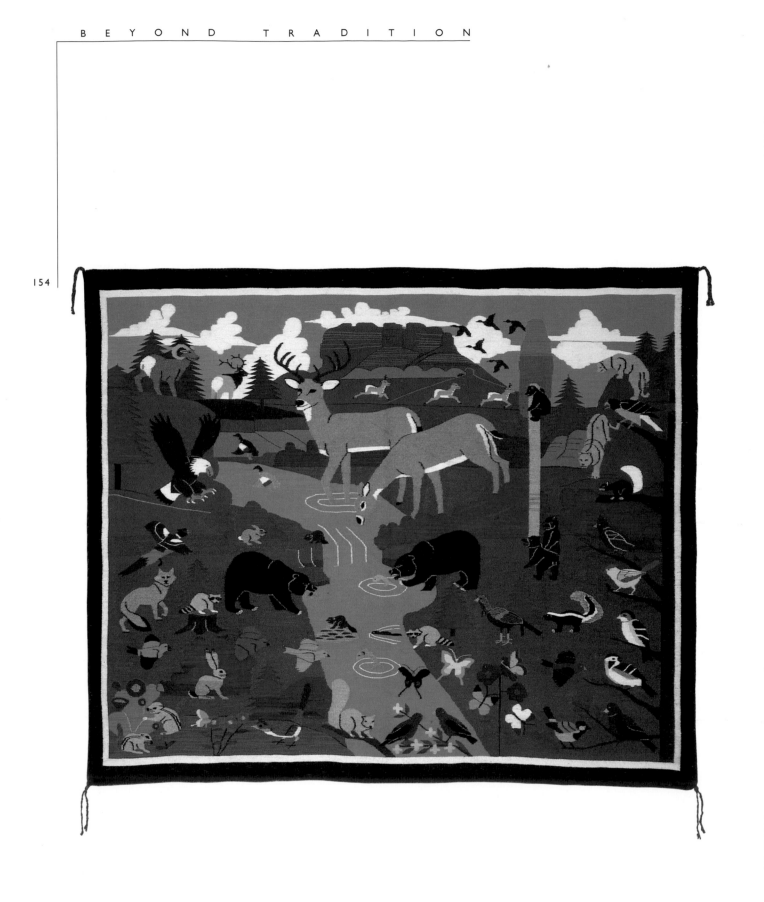

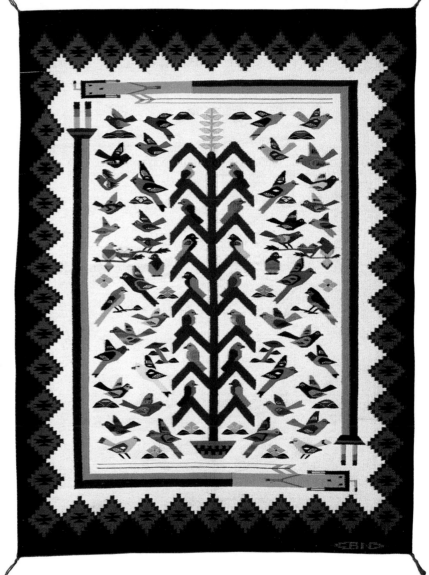

This exceptional pictorial rug (48″ by 65″) woven by Bruce T. Nez and designed by his wife Nadine (both Navajo), contains 82 birds (with round forms) and flowers, as well as a corn stalk in a ceremonial basket. Two *yei* figures form the inner borders, while 46 diamond patterns flank the outer black border. The artist, in his late twenties, wove his initials into the lower right corner.

OPPOSITE: Perhaps the most realistic pictorial rug to date, this 54″ by 64″ weaving by Linda Nez contains over 100 individual life and earth forms. A masterful weaver, she incorporates rounded forms in her work rather than the squared corners and rectilinear design elements commonly found in Navajo weaving.

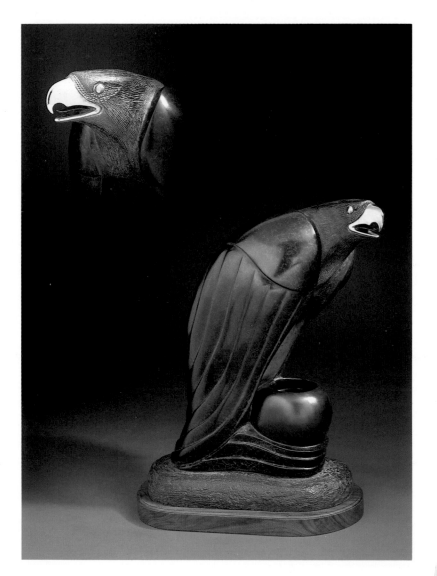

LEFT: *Guardian of the Ancestors,* a 27″ tall bronze by Rollie Grandbois (Turtle Mountain Chippewa) was cast from an original stone sculpture.

BELOW: *The Sacred Eagle Soars Us to the Great Spirit,* an alabaster sculpture by Elk Woman (Mandan/Hidatsa/ Arikara) portrays an eagle in flight with a face representing the human spirit being carried to the Creator; a buffalo appears on the reverse side.

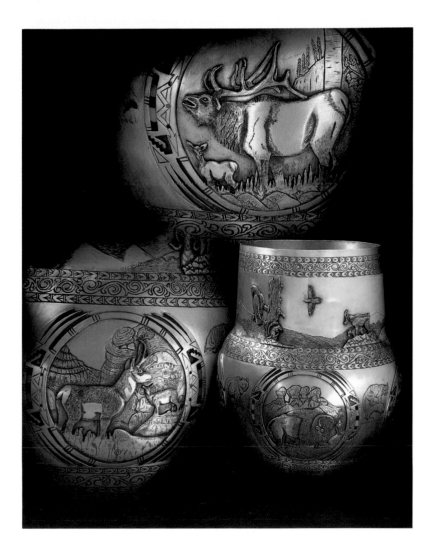

ABOVE: *White Buffalo*, a 20″ tall alabaster sculpture by Victor Vigil of Jemez Pueblo.

RIGHT: Sculpted silver vase by White Buffalo (Comanche) that began as a disc of silver 8″ in diameter and 1″ thick. It was hand-wrought into its final form and embellished with chiseled and engraved designs from nature and Native American symbolism.

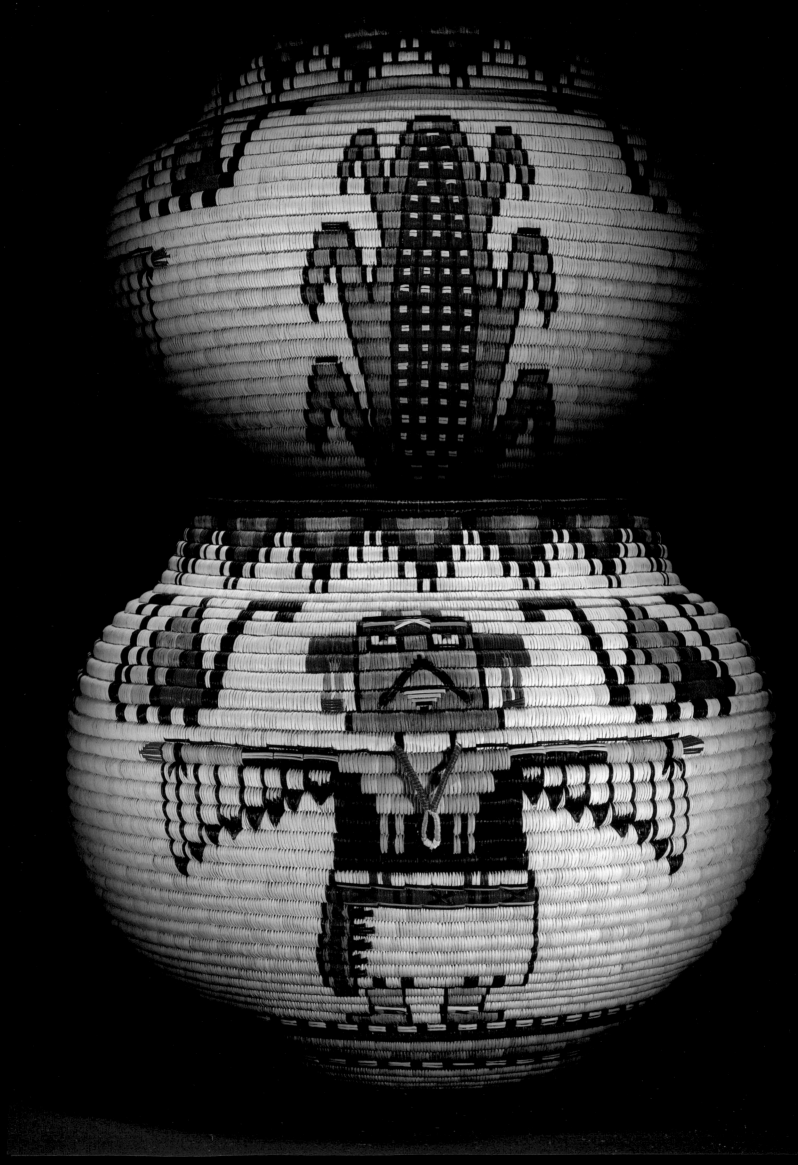

Butterflies and other life forms, as well as bright colors and the frequent use of commercial dyes, typify dramatic departures from traditional Navajo and Paiute basketry.

RIGHT: Deer, butterflies, and human forms dominate these coiled trays by Navajo basketmakers Lorraine Black (*top,* 19½" in diameter) and Agnes Black (*foreground,* 21" in diameter).

OPPOSITE: This basket, 15½" deep and 18½" in diameter by Hopi Madeline Lamson, was awarded Best of Show at the 1986 Annual Museum of Northern Arizona Hopi Artist's Exhibition. The double exposure shows its two major design elements.

BELOW: Aniline dyes were used to create the bright array of butterflies on this basket by Grace Lehi (San Juan Paiute). Patterned after the Navajo wedding basket, it retains the traditional border and center design elements common to that basket style.

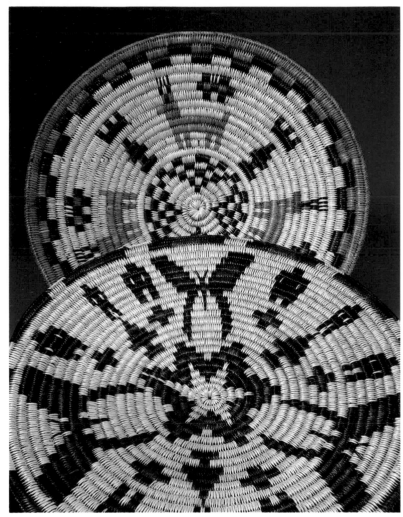

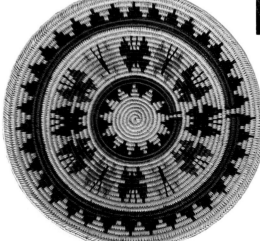

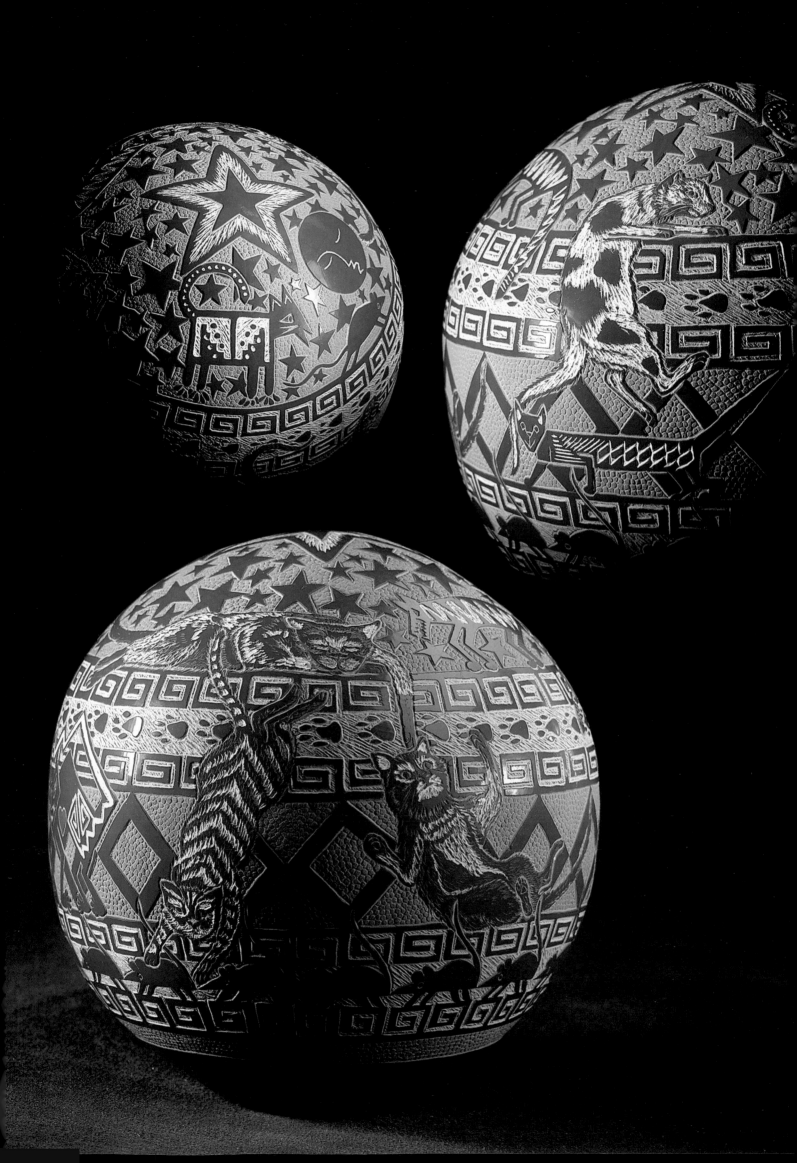

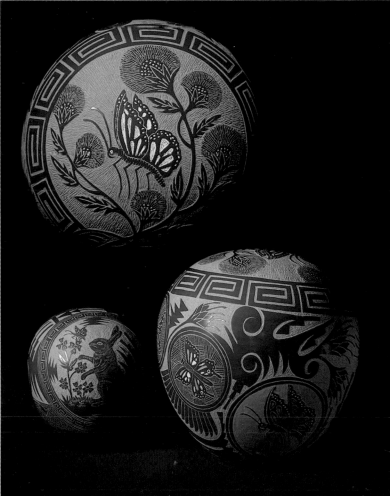

Joseph Lonewolf, his sister, Grace Medicine Flower, and other members of this creative family are among the leading innovators in contemporary American Indian pottery. Noted for their finely detailed pieces, they draw upon their Santa Clara Pueblo heritage and nature as subject matter.

OPPOSITE: Incised figures of cats and mice scamper around this whimsical piece entitled *The Cat's Meow* by Rosemary "Apple Blossom" Lonewolf, daughter of Joseph.

LEFT: Pottery bowls by Grace Medicine Flower display incised butterflies, rabbits, flowers, and geometric designs. The bowl on the left is 2½" tall and the one on the right is 4" tall; a double exposure reveals the latter's top surface.

BELOW: Joseph Lonewolf combines carving and incising with traditional pottery-making techniques to create masterpieces of sculptured pottery.

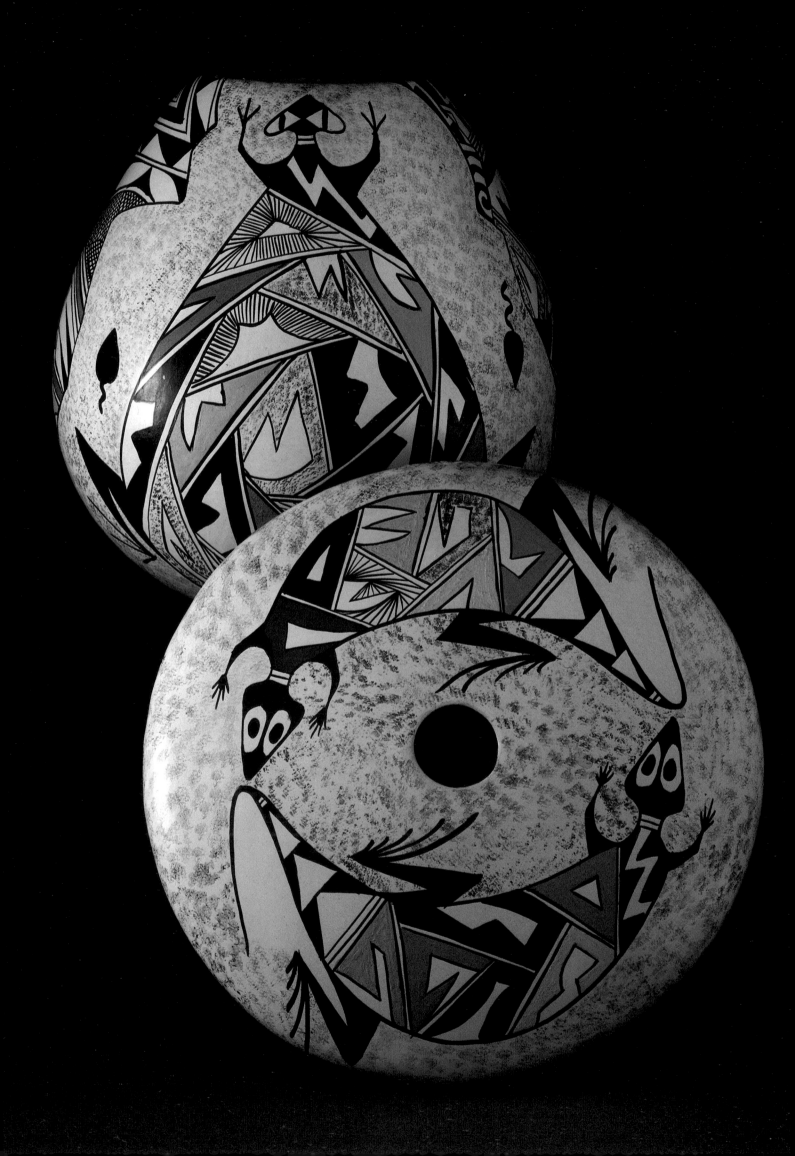

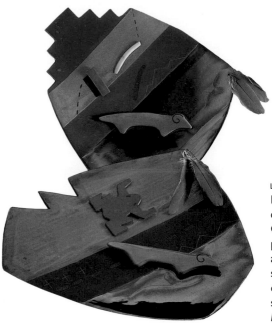

LEFT: Unlike any traditional American Indian art form, these 12″ by 14″ ceramic plates were made by Navajo/Oneida artist Conrad House. The piece in the back, *Layered Nights*, uses a variety of color and glaze to represent different levels of the night, and is decorated with images of mountain sheep, mountains, and parrot feathers. *Road of Separation (front)* represents the confining of nature by dividing lines, such as roads, that hinder the movement of animals and other living things.

OPPOSITE: Sylvia Naha, daughter of Helen Naha, "Feather Woman," incorporates colorful adaptations of Mimbres designs into her Hopi pottery. The jar (*top*) is 5½″ tall; the seed jar (*front*) is 3″ tall and 5½″ in diameter.

BELOW: Santa Clara potter Jody Folwell portrayed lizards sunning themselves against pueblo walls in this 15″ in diameter pottery bowl (*left*). The ancient ruins at Chaco Canyon, New Mexico, provided the inspiration for her 6″ tall pottery jar (*right*).

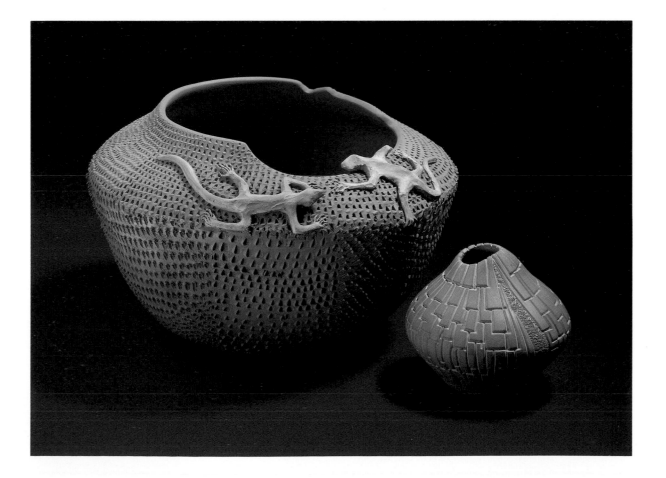

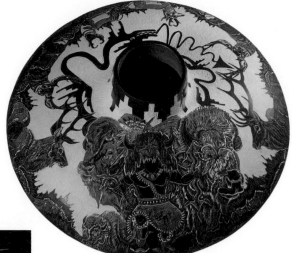

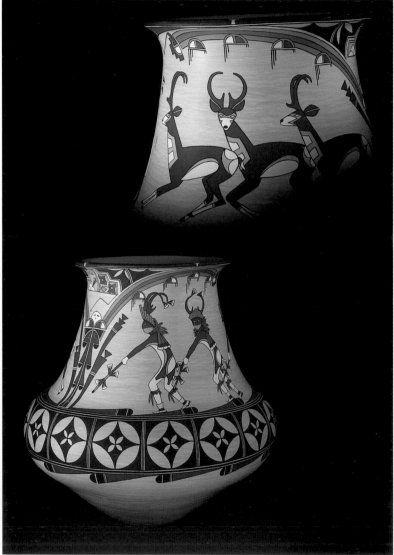

ABOVE: Antelope, deer, elk, and buffalo are accompanied by a Buffalo dancer (*center*) and the plumed serpent, or *avanyu*, on this incised pottery jar by Santa Clara potters Paul and Ana Naranjo.

LEFT: Antelope and antelope dancers are framed by symbols of rainbows, clouds, rain, and flowers on this 16″ tall pottery jar by Santa Clara potter Lois Gutierrez-De La Cruz.

RIGHT: Carved by Hopi Loren Phillips. The Sun (*Tawa*) Kachina (*left*) is 18½″ tall with stand, and the Ram (*Pang*) (*right*), is 17″ tall.

BELOW: This *Sakwap-Mana*, carrying a basket of blue corn, was carved by Ronald Honyouti (Hopi).

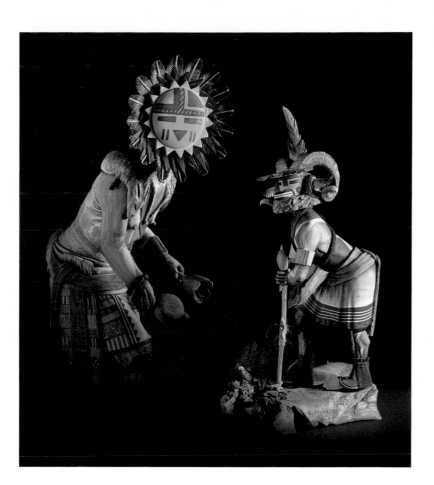

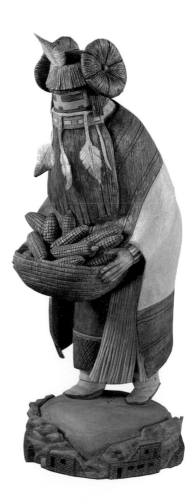

5

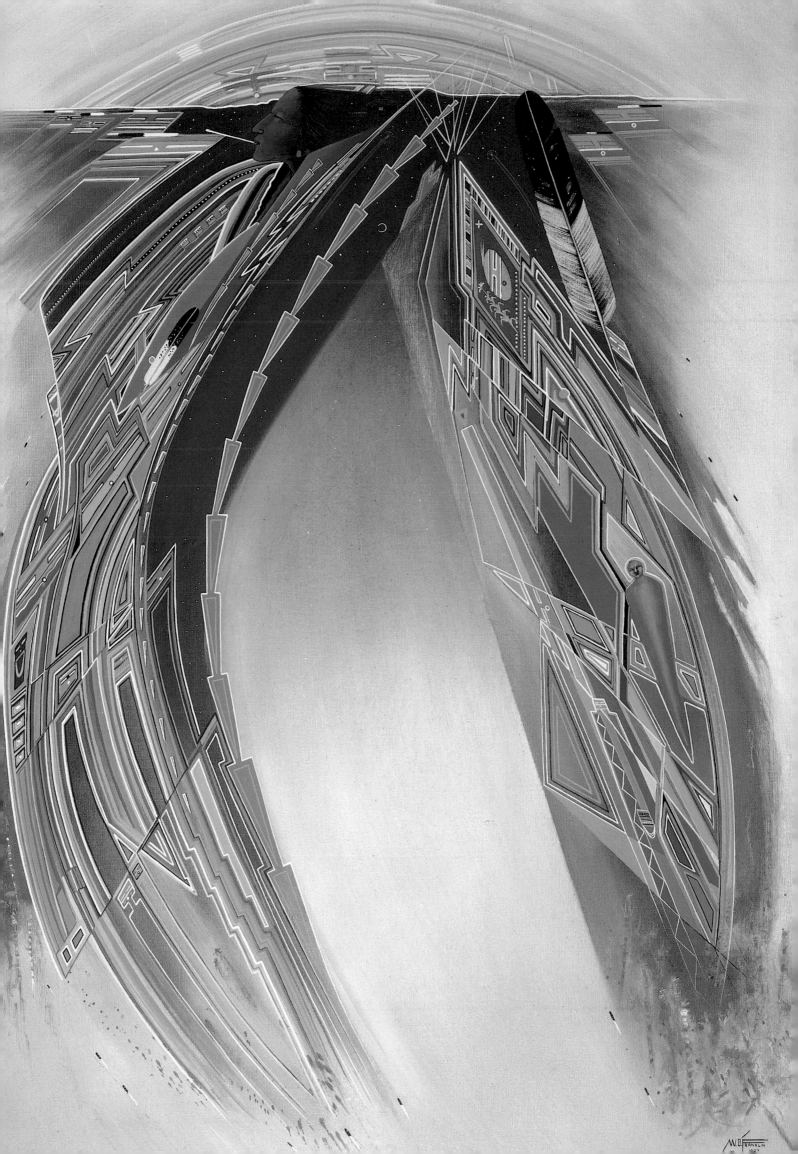

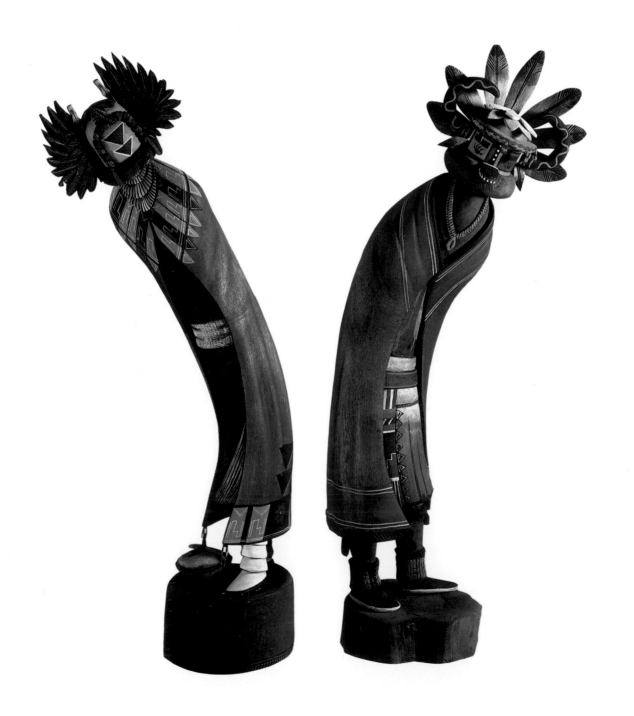

5 Dreams and Visions

OPPOSITE: Born of Hopi ceremonies and carved according to tradition from the root of the cottonwood tree, these stylistic sculptures surpass the realm of kachina dolls and enter a new arena of aesthetic spirituality. This pair was carved by John Fredericks and are representations of Crow Mother, *Angwusnasomtaka* (*left*) and *Hototo* (*right*), both 22½" tall.

As THOSE FIRST AMERICAN INDIANS FORGED A pathway into the unknown with their primitive art, they left a faint trail that others would follow. Today, as life and legends are given new eloquence through contemporary art, Native Americans gaze back down that pathway, clearly envisioning the ancient ones. Linked to the past by their heritage and ancient rituals, many artists say they feel the presence of their ancestors, and believe they are guided and directed through dreams and visions.

"Oh, yes, I do believe that," asserts Joseph Lonewolf. "I believe that the old ones are my guides and mentors still, showing me in my dreams and visions how to use the old Mimbres designs in new ways, just as they direct my hands and heart when I work those envisioned symbols into my pots."

"Dreams" was the reply from artist after artist when asked about their inspiration. Jesse Monongye was taught to make jewelry by his father, Preston, who was noted for his distinctive style of tufa-cast jewelry and was one of the first to use gold. However, Jesse admits that he was "slightly bored and only 'playing' at silver work" until his mother appeared in a dream. From her graveside she spoke to him, saying he would be "a famous Indian" if he would take the files and jewelry tools she offered. From that time on, Jesse pursued his work in earnest.

"I do what I do because I'm an architect, an artist, a Hopi...and a dreamer," remarked the successful Dennis Numkena. His dreams have led him far—from a small Hopi village in northern Arizona to international recognition of his art and architecture. Dreams will lead still further, for they enable the artist to both capture the past and envision the future. Sculp-

tor Larry Yazzie is yet another dreamer. "I grew up in a contemporary world," he explained, "a dreamer of the past. Today I would like to stand still and let time pass without disrupting me. With the year 2000 upon us, I feel a strong need to retain any tradition and culture left with us. The single best way I know of preserving culture and tradition is art. That is my inspiration."

Several artists mentioned songs—the chants of the *yei bi chai* or the kachina—and the feelings they evoke as their inspiration. Many of Michael Kabotie's paintings are his interpretations of the Hopi kachina songs, and Danny Randeau Tsosie's painting *October Song* expresses his feelings about the *yei bi chai* ceremonies. "October is the time the *yei bi chai*s start their dances; I was thinking of that and the feeling I get at that season. The *yei* songs are almost like a prayer without words, just feelings. My painting represents that feeling and the sacredness the *yei bi chai*s possess."

Potter Jody Folwell says that her imagination is stimulated by personal experiences: "names, dreams, things I feel about family and politics"; Al Qöyawayma's motivation comes from "anything pleasing and aesthetic, even philosophy and history." Still others identified a variety of things that spark the imagination: legends, an exotic sports car, the colors that Mother Nature provides, mother's rug designs, romanticizing the past, architecture, looking into the skies at night, seashells on the beach, and looking out at nature, the people, how we feel about ourselves...it's all around and "I just see it."

Michael Naranjo captured his inspiration in verse.

> I sculpt
> what comes into my mind's eye
> from dreams
> from hearing talk, from music
> from books I once read
> what I remember seeing.
> I wait sometimes a week
> sometimes a month
> sometimes a year
> then suddenly one morning
> He is there.

October Song, 16″ by 20″, prisma on paper, by Danny Randeau Tsosie (Navajo). "This painting represents the feeling I get when I hear the *yei bi chai* songs and the sacredness they possess," the artist commented. The *yei bi chai* is shown at right; the eagle (*top*) represents the spirit of the entire piece; clouds, the sun, and stars appear; and a white abstract representation of a rainbow leads to the face of the *yei bi chai*.

Although artists are motivated by many external manifestations, much inspiration comes from emotions or memory. Many of their earliest memories are ones of encouragement and example (parents, take note!). Allowed to paint on bedroom walls or given a ball of clay and encouraged to "make something" as parents shaped their own pottery, the artists remember those events as the true beginning of their interest in art. Sculptor Alvin Marshall began to draw when he was three or four years old. "My father drew on paper sacks, matchbooks, anything; so I did the same."

Weaver Ramona Sakiestewa has always been fascinated by fabric. She began sewing doll clothes when she was only four years old and by second grade, was making her own. Her Anglo step-father, a collector of Hopi and Navajo artifacts, filled her life with Native American art. "And what's more," explained Ramona, "it was my job to count the warp and weft of his weavings for documentation." She laughed as she added, "That was my excitement!"

Jaune Quick-to-See Smith's love affair with art also began very early. "My father split shingles for the roof of our cabin and gave me the ones he didn't use. I drew a picture for him on a shingle and he kept it hanging by his bed. It was a girl with a basket of flowers and she had 'hooped' arms. I remember that so well because many of the petroglyphs I paint today have that same characteristic. When I began first grade, painting *consumed* me. We were too poor to buy paints, but school was wonderful...there were easels with little paint cans. I did my first abstract, Mount Rainier with children dancing in the sky. I find it very interesting that I'm still doing what I did then...breaking up space in a 'crazy quilt' kind of way."

At age five, Jacquie Stevens formed her first pottery piece, a small horse, with the encouragement of her grandfather. However, once it had dried in the sun, she ate it, which undoubtedly was not part of the plan. This early encouragement was important, however, and Jacquie has since learned that there are better things to do with clay.

The seed planted by early artistic influences and encouragement is never wasted, even though it may appear to bear no fruit at the time. In high school, Harvey Begay worked part-time as a silversmith in his father's jewelry shop but had no desire to make

Sculptures by Gordon Van Wert (Red Lake Chippewa). *Star Warrior's Medicine*, 22″ tall by 34″ wide. This sculpture represents the Night Hunter Society, which is made up of the tribe's best hunters. Flanked by younger warrior/hunters, the old man in the center symbolizes knowledge. The cross within the circle represents the four directions; the translucent alabaster star represents power.

OPPOSITE: This 57″ tall sculpture, entitled *Buffalo Spirit Dancers*, has a formless body and no feet to convey a sense of floating and supernatural power. The face and base are alabaster, the rest is made of copper-coated welding rod.

that his life work. He admits that his first thought upon leaving high school was "good, I don't have to make silver any more." However, after serving in the Navy (one of only five American Indian flyers in Vietnam, and the only Navajo) and then participating in test flights for McDonnell-Douglas, his views changed. He returned home, not just to take up where he left off, but to develop and expand his talents. He is now one of the country's top jewelry artists, who also creates magnificent silver goblets and trays. His teenage son, Kyle, also follows family tradition as he creates award-winning jewelry of his own.

On the other hand, when Charles Pratt finished high school he wanted to be a sculptor but couldn't afford to have bronze castings made. Upon seeing some of Allan Houser's welded pieces in the early sixties, Charlie's first reaction was, "I think I can do that." He made it all seem quite effortless as he told the story. "I got a torch and tried it…and it worked! I think one reason my 'look' is so different is because I'm completely self-taught, I didn't pick up anyone else's style." He also taught himself to do lapidary work and began to incorporate turquoise into his welded brass sculptures. Although he soon earned enough from

those sculptures to afford bronze castings, he discovered that he actually preferred welded metal work.

Dorothy Torivio credits both her mother and mother-in-law with helping achieve her success. Her mother first taught her to make pottery and now helps with firing; her mother-in-law taught her to make large vessels, discouraged her from ever using greenware (commercially made, unfired pottery), and encouraged her to try new designs. Sitting under the portal on the Santa Fe plaza to sell her traditional wares, Dorothy began to sketch. "I admired the way Marie Z. Chino's designs came out, but there was too much competition in traditional pottery. I decided to stick to just one pattern and get progressively larger." When questioned further about the inspiration for the unusual motif, Dorothy replied without hesitation, "God gave me a thought and that became an idea." She receives further encouragement from her teenage daughter, Audry, who assists with clays and paints and makes her paintbrushes, peeling and chewing the yucca stem that Dorothy later shapes.

At times, artists have developed some unique aspect or innovative design in their work by coincidence or perhaps some Greater Design. Sculptor Gordon Van Wert (Red Lake Chippewa) recalled a rather remarkable experience. While working on a sculpture with an air hammer, he accidentally broke a hole completely through the stone. Setting the piece aside in dismay, he began work on another. When a ray of sunlight suddenly struck his face, he looked up to find that it was shining directly through the hole he had accidentally cut through the stone. He tried setting a piece of translucent alabaster in the hole, and the light shining through caused it to glow as if the sculpture were filled with an inner radiance. Now Gordon often sets translucent alabaster in strategic spots in his sculptures.

Presley La Fountain (Chippewa) demonstrated how the natural stone patterns so often fit precisely with a design. "See the way the stone is around the eyes?" He pointed out the way in which the matrix in the stone formed natural lines in the face. "It really makes me wonder.... I don't actually plan it that way, and yet it happens so often."

White Buffalo recently moved to Sedona, Arizona. While

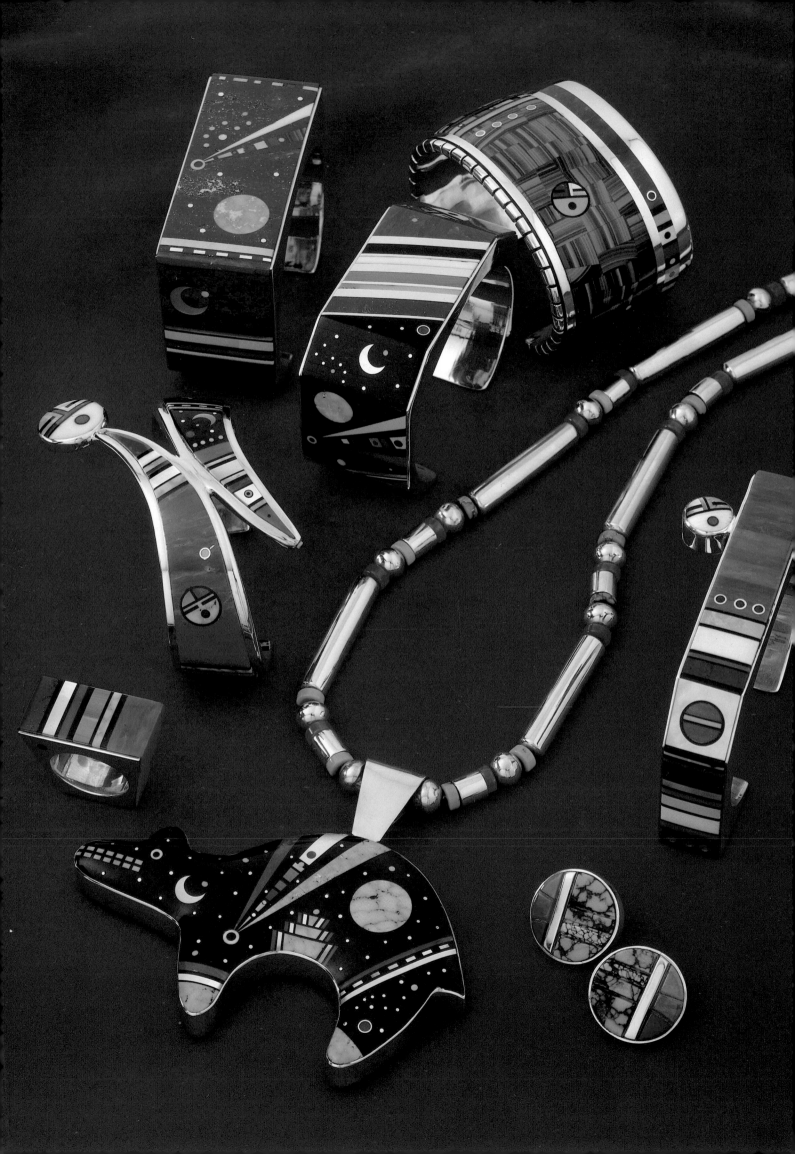

OPPOSITE: The masterfully executed inlay jewelry of Navajo/Hopi Jesse Monongye. Incorporating a myriad of stones set in silver and gold, Monongye draws upon the galaxies as well as his Navajo and Hopi cultures for inspiration. The pendant is reversible (above).

looking for a home, he discovered that his Realtor was a transplanted European silversmith, a master craftsman, who was longing to share his knowledge and skills with a worthy protegé. "We felt an instant relationship," exclaimed White Buffalo. "I've been looking for him all my life."

Coincidence? Most of the artists can't quite believe in coincidence to that degree, but feel that some greater power directs their lives. Al Qöyawayma explained, "The gift of creativity is one of our Father's great gifts. The force and energy in the creative process is both awe-inspiring and humbling. My challenge now is to walk in the knowledge of His light. Do I pray when forming my pots? Certainly!"

Charles Supplee says he believes that "whatever happens is a gift. If something doesn't work out the way I want, I know it wasn't meant to be."

Navajo sculptor Larry Yazzie goes even further. "I believe that everything works out. It's all meant to be...everything falls into place. Not just in my art, but in providing for my family, making ends meet. There's Someone watching over me and I have a lot of gratitude."

Artists! People with belief in a Higher Power and in themselves. People who care not only about their art, but their people. Many artists who are doing well today spend time "putting something back" into their culture. Speaking at schools around the country, they offer encouragement and advice to Native American youth and practical assistance to talented young people. Others give or assist in raising money for tribal projects and, with long-range vision for the future, speculate on ways to procure museums, libraries, care for the elderly, and other refinements to make reservation life richer for their people.

Sculptor Oreland Joe has been an encouragement and more to several fledgling artists. Forming a group in Shiprock, Arizona, which he called "Eagles in Flight," he chose seven of the best students just out of high school, taught them the basics of art, and encouraged them to go from there. "There was no program or source of inspiration in Shiprock," explained Oreland. "Talent was going to waste. If you have talent, why waste it pumping gas?" Oreland's talent has certainly not been wasted.

176 He is not only an exceptional artist himself, but with his help and encouragement, two of his seven students have placed in major galleries. Alvin Marshall, another artist whose work is included in this book, was also introduced to sculpture by Oreland Joe.

Native American sculpture today is filled with emotion, for the intensity of the artists' feelings seem to permeate their work. From deep within Michael Naranjo comes a gentle force that flows smoothly into each graceful, fluid line. Michael, who became a sculptor only after he returned from Vietnam blinded and deprived of most of the use of his right arm, becomes as one with a sculpture as he works. Reluctant to talk about himself, he did give his short, but thought-provoking, *Recipe for a Bronze:*

> A thought,
> A stirring of emotion,
> A strong, yet gentle touch.

He also quietly shared the story behind his emotional sculpture of an old man with a crow riding on his shoulder. "I first made him with a smooth skin, but then textured it to give the appearance of age," explained Michael. "It is early morning or late evening; it's cold, so he needs a blanket. The crow lives in a tree about twenty yards from the house. The old man raised the crow and now when he goes for a walk, it comes to ride on his shoulder and whisper secrets in his ear. At a point in his life where he isn't worried about whether the crop is in or if anything will be killed at the hunt, the old man is just grateful for each day." Although Michael worked on the piece with a title in mind, he knew at the end that the sculpture had "spoken"; the title must be changed to *The Secret.*

The sweeping, curving lines of Cliff Fragua's (Jemez) *Vision Quest* lead the eye on a journey of beauty, but the quest is an inner, spiritual one. The essence of Larry Yazzie's black soapstone *yei* figures transcend cultural belief, giving them universal appeal. The spiritual quality of this stone must have been deeply embedded, for Larry says his ideas come directly from the stone. "I start in an area and follow through." He advises that the best thing to do is to begin work. "I used to take about a week, now I just go. The more I think about it, the worse it gets. At first, I feel

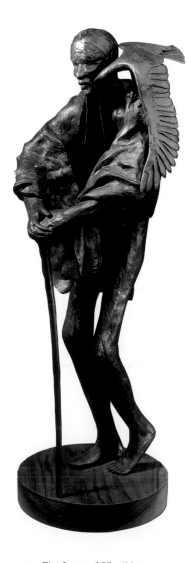

ABOVE: *The Secret,* 28″ tall bronze by Michael Naranjo (Santa Clara). The sculpture of an old man with a crow riding on his shoulder speaks of the secrets shared between the two.

terrible, because I'm not sure where I'm headed. But an hour later, I'm so excited. I call my wife to come and look, because something is beginning to happen—now I can see it."

Alvin Marshall also approaches a piece with no set of pre-planned drawings. He just carves, but says that he "can actually see the sculpture in its completed stage." Apparently, the stone evokes the same feelings from the Native American artists as it once did from an earlier master, Michelangelo, who spoke of "liberating the figure from the marble that imprisons it."

Meanwhile, kachina carvings have evolved ever further into the realm of fine art. Born of the religious ceremonies of the Hopi, today's sculptural carvings often resemble kachinas in mask, features, and coloration, but otherwise diverge remarkably. The bodies tend to be more abstract, elongated, curvilinear, flowing in simple, sculptural lines. Embodied with an ethereal quality, these stylized carvings suggest unrevealed mysteries.

Pottery also takes on a spiritual feeling in the hands of some contemporary artists. The strong, dynamic pottery of Tom Polacca displays deeply carved and painted designs from Hopi religion and symbolism against unusual textured backgrounds. His feelings about the mysteries of the Hopi spirit world are emblazoned across each piece.

In direct contrast are the ceramics of Peter B. Jones (Onondaga-Seneca-Iroquois Confederacy). Simple figures in both stoneware and clay are calmly mystical. The emergence from the sipapu in *Creation Myth* leads to quiet contemplation of the piece, as if one is indeed viewing a secret rite. Where Tom Polacca's pieces shout their spiritualism, Peter's quietly murmur their message.

Other potters mold variations of an ancient theme. *The Anasazi Pot,* a creation of Dawn'a D (Navajo), is a large irregularly shaped vessel with the textured appearance of leather. Tiny cliff dwellings are tucked inside "caves" formed of overlaps of clay. Ladders leading to the cliff dwellings, *yei* figures, and other cultural symbols are etched into the pottery. The vessel is a blend of subtle design, earth tones, and texture that aesthetically recounts the past.

Adorned with cloud symbols, petroglyphs, geomet-

ric designs, and appliqued facial features, Harold Littlebird's unusual stoneware vessels are integrated with masks and effigy pieces reminiscent of pre-Columbian pottery. However, Harold uses pastel shades of blue, pink, tan, gray, and yellow, rather than the earth tones favored by most potters, and refers to his ceramics as "skyscapes."

Just as all artists to some degree reflect their own cultures, environments, and experiences, so Native American painters today tend to show the influence of Indian life and memory. Now, however, as they increasingly assert the freedom to innovate, their work is becoming more individualistic. A variety of styles are used, from the mystical figures of Danny Randeau Tsosie to Conrad House's (Navajo/Oneida) complex abstracts teeming with images.

The same cultural subjects often appear, but with totally different interpretations. For example, representations of the sacred Navajo *yei bi chai* are created by numerous artists in a wide variety of styles that range from Clifford Brycelea's dream-like visions rising from mesatops to Emmi Whitehorse's (Navajo) emotional abstracts.

Dan Namingha easily explained how the same subjects can be done repeatedly and yet remain fresh. "Everyone is an individual, and each has his own vision of what he hears. If you told twenty children a story, each would have a different vision in mind." Though Dan is influenced primarily by European artists, his ideas come from Hopi. "It's what I grew up with and what I know best. My ideas come from some deep inner place. I take my feelings about tradition and extend them with my art background and my own visions."

Native American jewelry, enhanced by exotic stones, becomes ever more innovative as masterpieces of gold and silver are created, some in simple, classic styles, others of incredible complexity. Jewelry by Jesse Monongye is inlaid with minute stones of various colors in intricate stellar designs, while a singular sweeping gold bracelet and ring by Ted Charveze are each adorned by a ribbon of diamonds in *pavé*. Pavé means, quite literally, to pave, for the finished product was thought to resemble cobblestone streets. An old European technique, it is relatively

OPPOSITE: *Yei's Collection of Mountains, Hills, and Plant Life*, 38″ by 48½″, mixed media on paper and canvas by Emmi Whitehorse (Navajo). According to Navajo tradition, the *yei* live on top of Mount Taylor in New Mexico. This abstract focuses on the natural elements of that mountain, which is near the artist's family home.

new to Native American jewelers. Perfectly matched gems are "bead set" so closely together that little or no metal shows and so level that, though each gem shows up individually, the whole forms a pathway of diamonds leading across a piece of jewelry. Only a few American Indian jewelers are sufficiently experienced to master this special technique. Others are learning and obtain assistance in setting diamonds and other gemstones, for most are drawn to the beauty of these precious jewels.

Believing that beauty is the most important element in jewelry designing, Charles Loloma spoke fervently on the subject. "Things with beauty will always survive," he declared. "I want to make pieces so beautiful that someone can't resist them. There's no end to where art can go. The public is the stimulation point, but beauty goes beyond. Many new things can be done as long as beauty is the ultimate goal in our minds. Things come from inside; we can do all things with imagination."

Contemporary Navajo weavers also seek an enduring beauty and create intricate patterns while introducing rather startling new colors. As weavers experiment, often using only vegetal dyes, pastel shades of purple, green, blue, pink, yellow, and others are created, as are more vibrant colors. Designs have become more and more complex, until they are now labyrinths of intricate geometrics and iconographies. With an innate sense of style, weavers maintain harmony and balance in their work while, with design and color, they create kaleidoscopic tapestries that become abstract works of art.

As there are limitless directions to art, contemporary Indian artists will continue to seek new ways to express their dreams and visions. Inspired by voices from the past, they are challenged by a spirit of adventure, driven by a desire to succeed, and haunted by a vision that leads them ever onward. Though they share their Native American heritage and some common goals, each is an individualist with his own thoughts and ideas, which he expresses in his own particular way. Each has his own unique talent and his own special dreams.

They are indeed people with dreams, ones who take those dreams and give them life as they sculpt, paint, carve, hammer,

An outstanding example of Burnt
Water-style weaving, 54″ by 36″, by
Betty Van Winkle (Navajo).

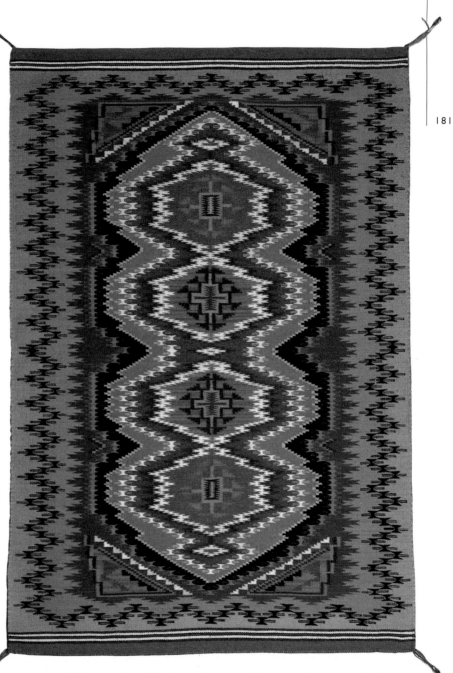

weave, solder, and mold them into art. Fantasy becomes design
in their creative minds, and illusion becomes reality in their tal-
ented hands. They will continue to dream. Seeking, striving,
reaching, searching, they know only that they are lured on by the
promise of the future. And so the quest continues. With the rich-
ness of yesterday to draw upon, their art perpetuates itself for
tomorrow. There can be no ending; it will go on and on and on.

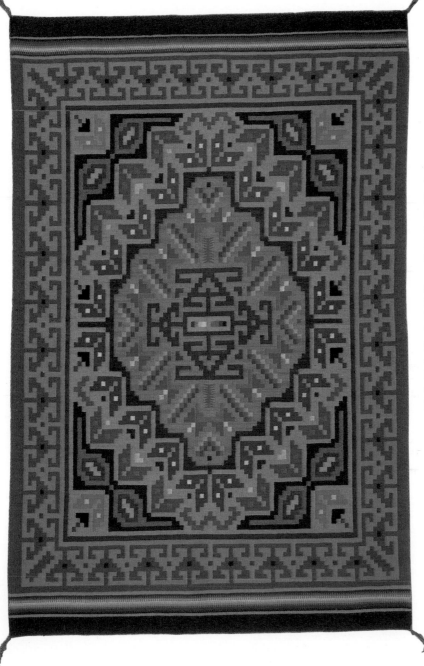

This 36″ by 54″ Burnt Water-style rug by Wanda Tracy (Navajo) was awarded the Best of Division prize at the 1987 Scottsdale Native American Indian Cultural Foundation Arts & Crafts Competition.

OPPOSITE, *top*: Annabelle Teller (Navajo) wove this eye-dazzling 36″ by 48″ Burnt Water rug. *Bottom*: Weaver Kathy Lee (Navajo), in her twenties when she wove this 36″ by 48″ rug, included twenty-two subtlely blended colors. She used vegetal-dyed wool produced by several other Navajo dye artists.

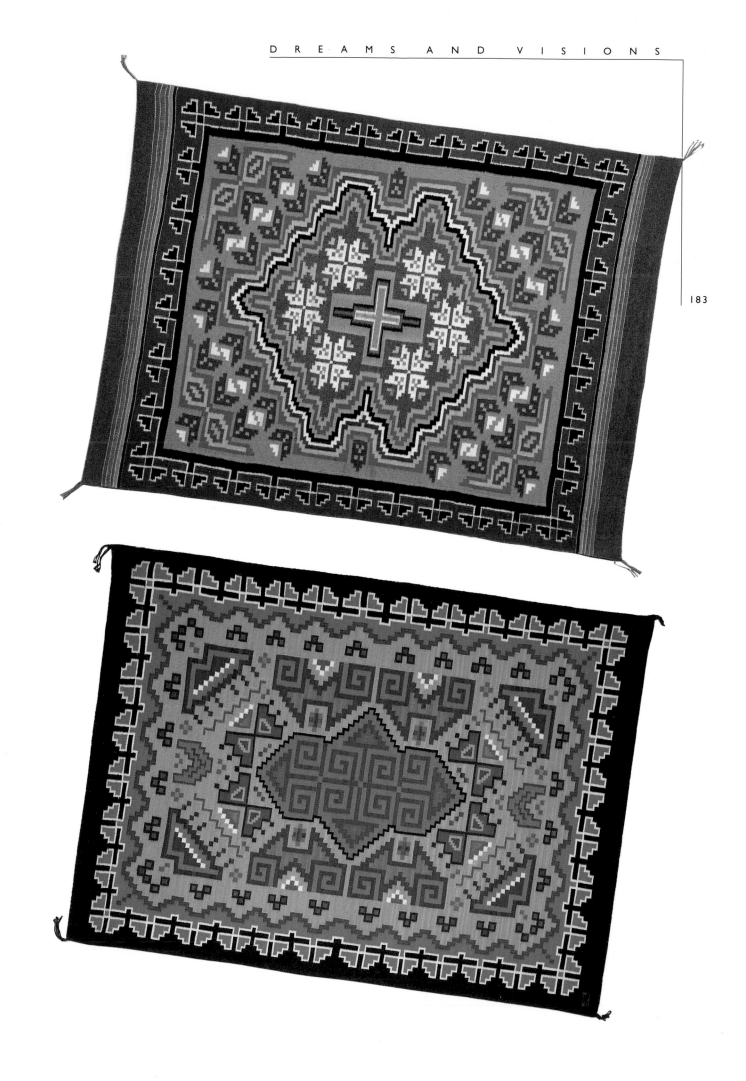

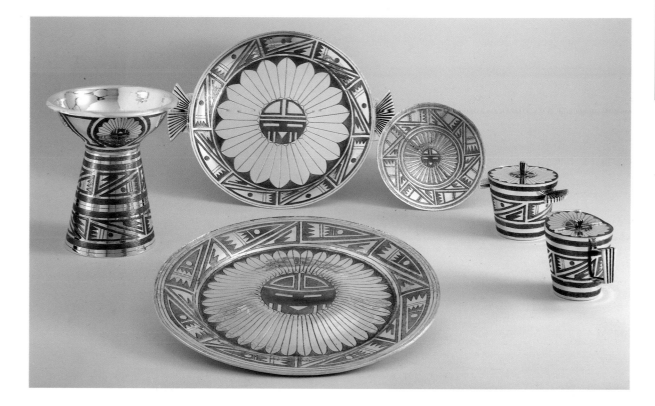

Seeking new ways to express their creativity, Native American artists accept difficult challenges, such as that of producing hand-made flatware and hollowware.

ABOVE: Comanche artist White Buffalo made this serving set of sterling silver meticulously engraved with sun faces and other traditional designs.

RIGHT: Harvey Begay (Navajo) created this stunning eight-piece sterling silver goblet set which appears European in style. However, tradition is subtlely retained; the vase of each displays stars and cloud terrace symbols. Begay also made the gold necklace set with coral and turquoise.

OPPOSITE: Hopi weaver Bessie Monongye wove a vortex of design when creating this deep bowl wicker basket. It was awarded First Prize in the 1987 Museum of Northern Arizona Annual Hopi Artist's Exhibition.

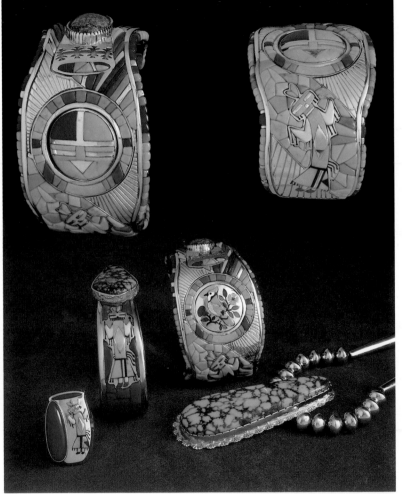

ABOVE: *The Star Blower*, 14-karat gold bracelet set with diamonds by Victor Coochwytewa (Hopi). The central design, a personification of a Hopi legend, is framed by symbols of clouds, rain, and lightning.

LEFT: Jake Livingston (Navajo/Zuni) made this striking array of gold and inlay jewelry (two views of the bracelet are shown above). The reversible pendant in the center of the bracelet rotates; one side has a sun face design, the other, a blue jay. Settings are of turquoise, lapis lazuli, sugilite, coral, and shell.

OPPOSITE, *top*: This necklace and earring set represents the first major work of Elizabeth Charveze-Caplinger, 28-year-old daughter and apprentice of jeweler Ted Charveze (Isleta). Fashioning jewelry since she was 14, she has been exhibiting in major galleries since 1985. This ensemble of 14-karat gold set with 2.52 carats of diamonds (pavé set by her father) and a 12-carat fancy-cut topaz, has beads of gold with diamonds and frosted black onyx. *Bottom*: Fourteen-karat gold, frosted black onyx, amethyst, citrine (yellow), and pavé-set diamonds were used in this elegant jewelry by Ted Charveze. Ted's daughter, Elizabeth, cut, drilled, and rolled the amethyst and onyx beads.

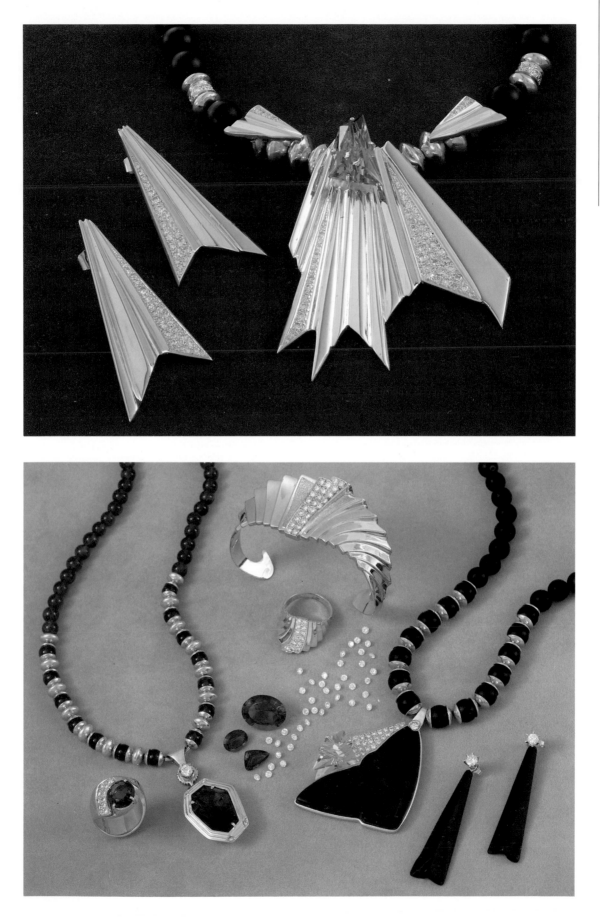

Rainbow Song, 17½″ by 18½″, prisma color pencil and pastel by Joe Maktima (Laguna/Hopi) who says his goal is to create harmony and rhythm in his abstract designs.

OPPOSITE, *top*: *Kachina Poetry*, 20″ by 31″, acrylic on canvas by Michael Kabotie (Hopi). This visual interpretation of the Long Hair Kachina song portrays the rain (the kachina's beard and hair) that blesses the land. This results in an abundance of crops, flowers, hummingbirds, and butter-flies, all represented in abstract. The human pictographs represent the ancient spirits that reside in and around the area. *Bottom*: *Yeis in Seattle*, 30″ by 45″, crayon and prisma color on black Arches paper, by Conrad House (Navajo/Oneida). The artist described the backdrop of his painting as his studio in Seattle, with the city-scape in the foreground. Abstract images of Navajos, night-chant singers, sheep, rainbows, clouds, and a myriad of other subjects fill the painting.

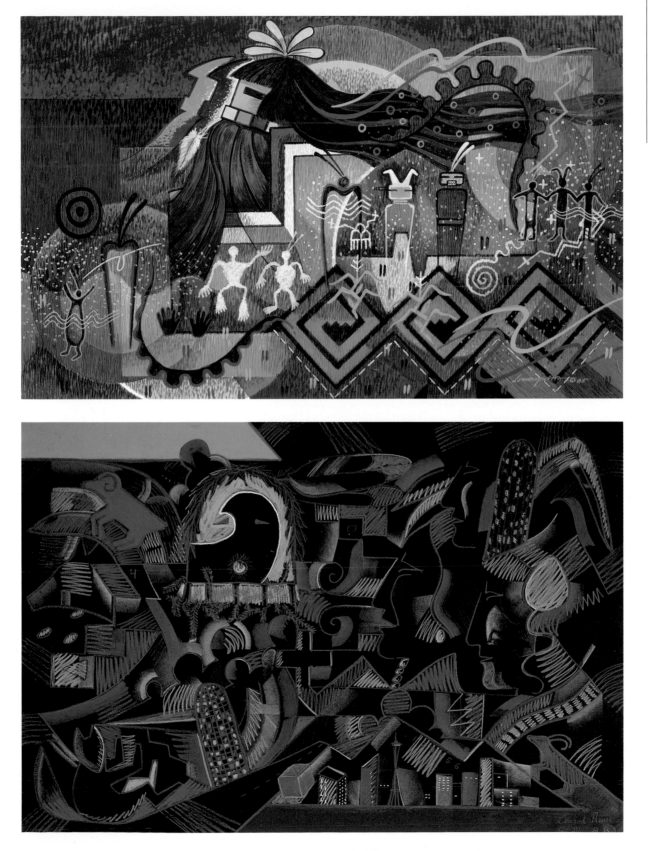

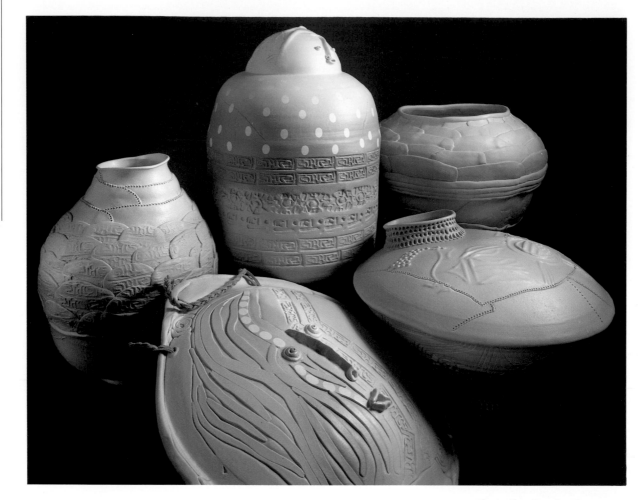

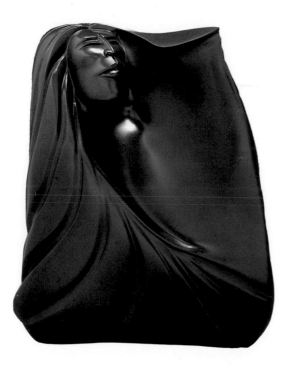

ABOVE: Santo Domingo/Laguna poet and potter Harold Littlebird uses the sealed earth (or *terrasigilatta*) process to create his unusual ceramic wares. Referring to his work as "skyscapes," he incorporates colors of the sky rather than the earth in his work. The three pieces in the back range in size from 9″ to 17″ tall. The center piece is called *Rain Cloud Effigy;* the 14″ in diameter mask *(front)* is from his *Moon Face Series;* while the 12″ in diameter canteen *(right front)* is from the *Petroglyph Series.*

LEFT: Using black African wonderstone, Presley LaFountain (Turtle Mountain Chippewa) captured a feeling of the wind's force in this sculpture, *Night Wind.*

OPPOSITE: Peter Jones (Onondago-Seneca-Iroquois Confederacy) makes a variety of sculpted ceramic figures and vessels. *Taos Man*, stoneware with Bristol glaze and red iron oxide, 11″ tall *(top); Creation Myth-Sipapu*, stoneware, 20″ tall *(right);* untitled figure, 10″ tall *(left).*

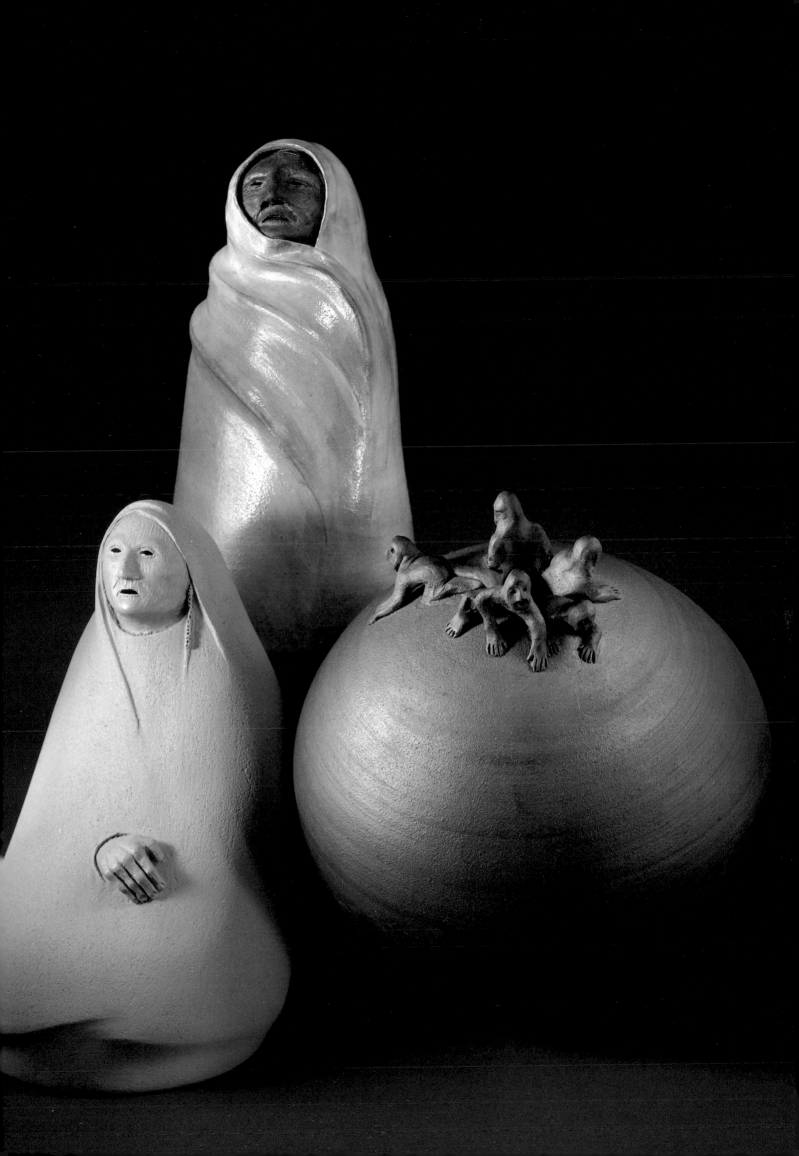

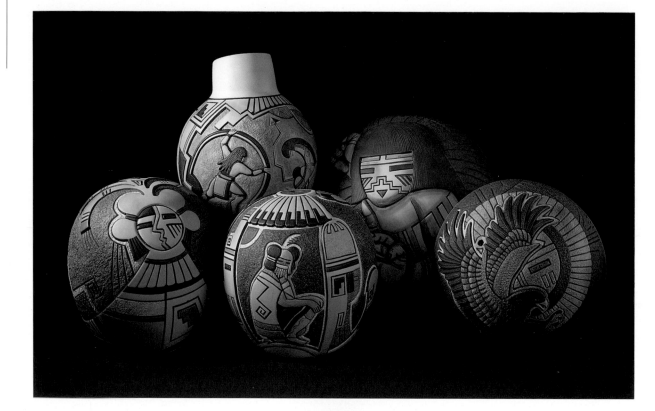

ABOVE: Thomas Polacca has added his own innovations to Hopi pottery by carving and painting "murals" that depict scenes from Hopi religion and ceremony. His work could be considered a pictorial textbook on Hopi legends.

RIGHT: *Eagle Medicine*, 19½", Utah alabaster by Oreland Joe (Ute/Navajo). The eagle claw hanging from this warrior's neck is special medicine that gives strength, keen senses, and sight.

OPPOSITE: Teeming with symbols of supernatural spirits, wedding baskets, and rug designs, the pottery of Lucy Leuppe McKelvey represents a broad departure from traditional Navajo pottery. *Buffalo People*, 15" tall (*left*); *Whirling Rainbow Goddesses*, 12" in diameter, 6¾" tall (*top right*); *Cloud People of the Wind Way*, 8" tall (*right*).

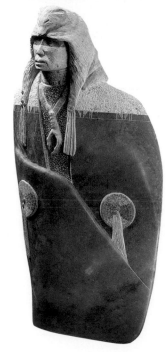

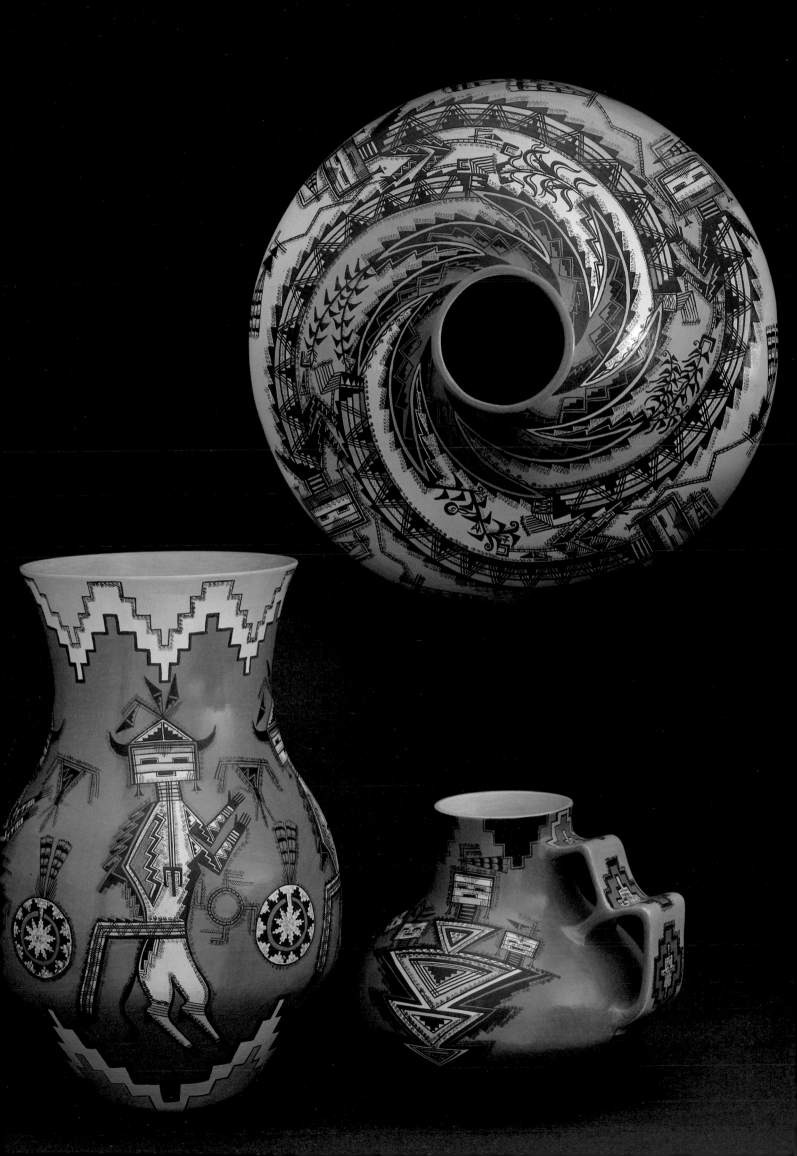

194

OPPOSITE: This highly unusual pottery vessel by Dawn'a D (Navajo), entitled *The Anasazi Pot*, has the appearance of leather and received First Prize in the Fine Arts, Contemporary Ceramics category, at the 1987 Museum of Northern Arizona Annual Navajo Artists Exhibition.

BELOW: Navajo sculptor Elizabeth Abeyta creates fanciful figures of clay. Blending natural mineral pigments and acrylics to produce these unusual colors, she then uses an airbrush to achieve sandstone effects.

RIGHT: The pottery innovations of Richard Zane Smith (of Wyandot descent) are architectural in nature, with painted designs that have three-dimensional qualities.

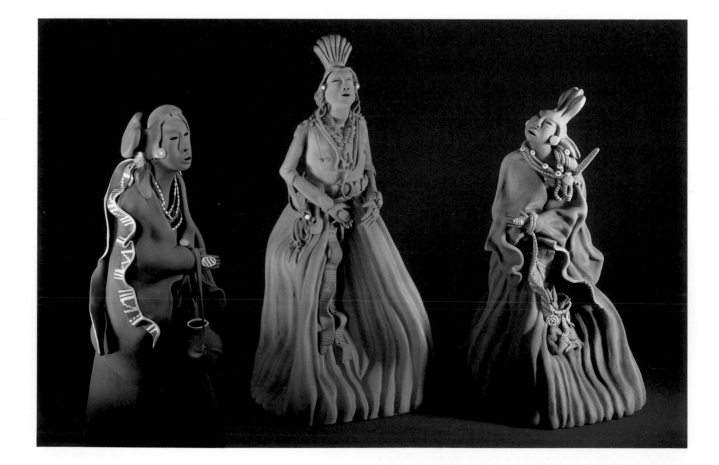

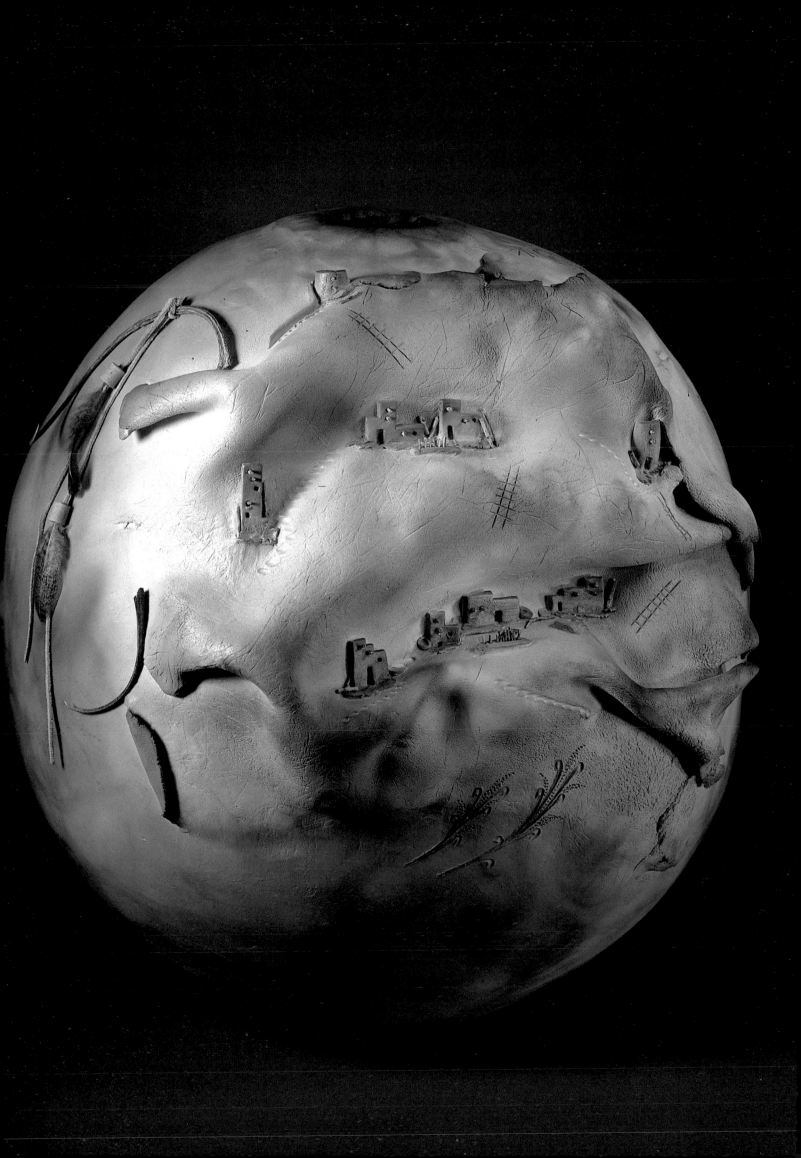

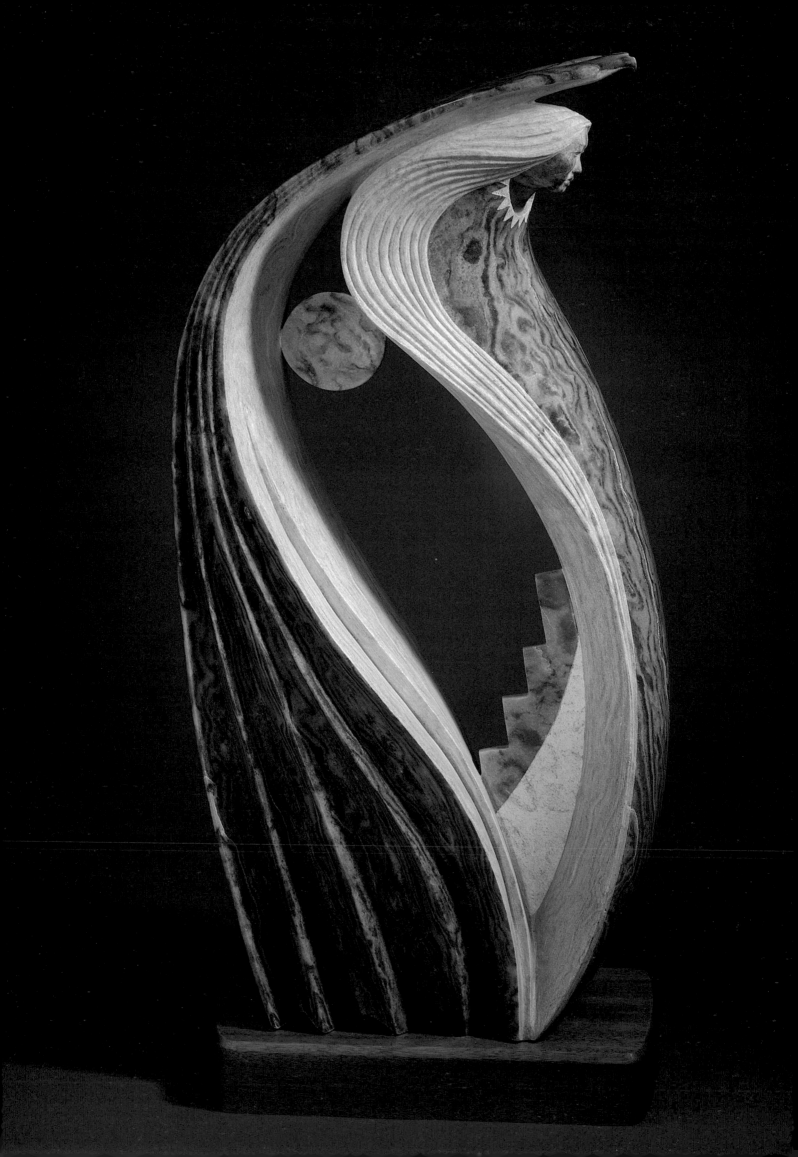

RIGHT, *top and bottom*: Two views of *Holy People's Journey*, a 44" long, 31½" tall piece sculpted from golden alabaster by Alvin Marshall (Navajo). The artist has interpreted this piece as follows: The four Navajo people want to travel on the rainbow to the equivalent of the white man's heaven; at the end of the rainbow is the female *yei* (round face); the four sacred mountains are below. The baskets on either side represent the four directions. The back of the sculpture (*bottom view*), the male side, contains a storm with lightning and cloud symbols. A sacred hogan, made of materials from Mother Earth, is where the people withdraw to be reborn…there they sing, pray, and fast until the storm is over. Then they begin to travel toward the rainbow.

OPPOSITE: *The Vision Quest*, 39" tall, Utah alabaster by Cliff Fragua (Jemez Pueblo). Sweeping abstract life forms of eagle and man are symbolic of how man and all others on earth should live in harmony…all are a part of the earth, which is represented by the step designs within the sculpture. The circle near the top symbolizes the universe.

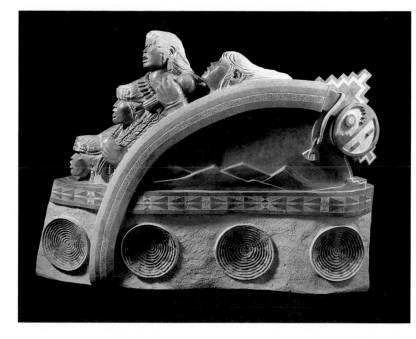

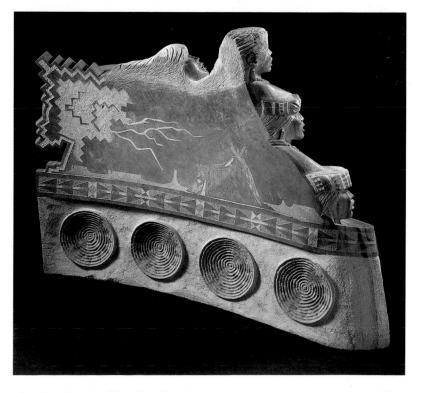

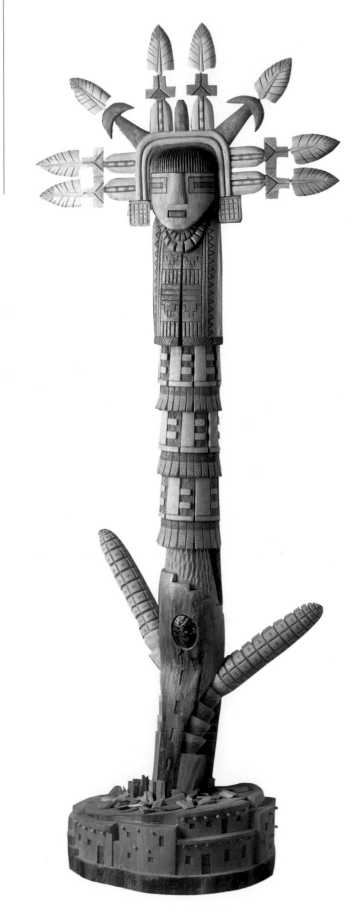

Sculptural carvings often bear little resemblance to their forerunner, the kachina doll. Elongated, curvilinear forms flowing into simple, sculptural lines are embellished with villages, corn, and other symbolism which adds to the ethereal quality of this Hopi art form.

LEFT: *Butterfly Maiden,* 38″ tall, by Delbridge Honanie, *Coochsiwukioma.*

OPPOSITE, *left: Salako mana,* 15½″ tall, by Bryson Nequatewa. *Right: Nuvak' Chin Mana* (Snow Maiden), 12¼″ tall (*left of photo*) and *Kau-a-Kachin Mana,* 19¼″ tall (*right of photo*), both by Wilmer Kaye.

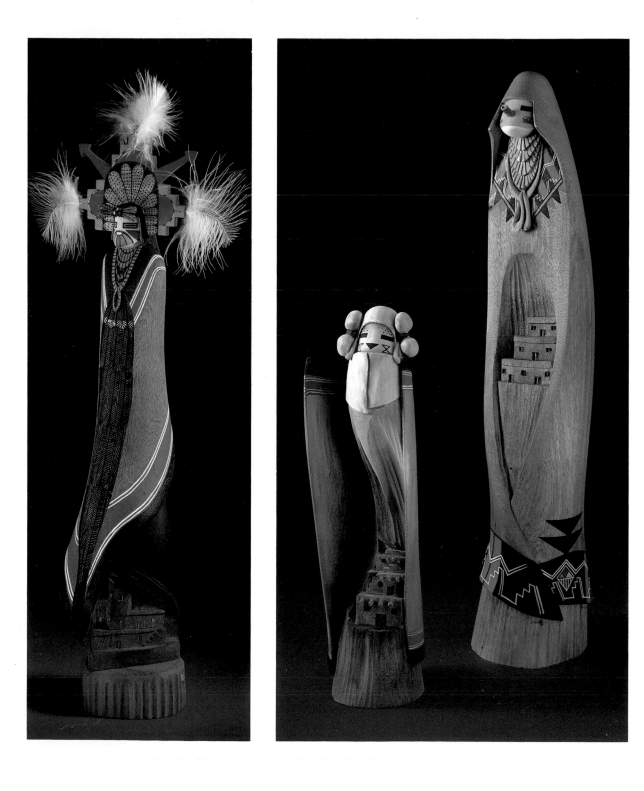

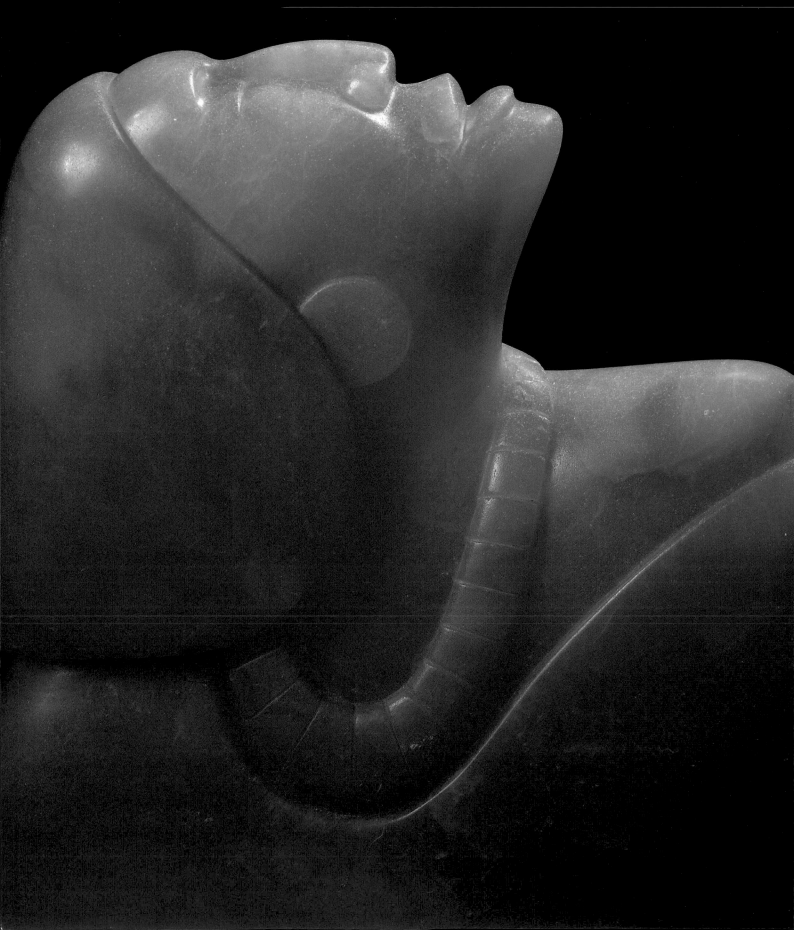

Acknowledgments

WITH THE ABUNDANCE OF WORDS AT ONE'S COMMAND, IT IS strange to find that they have all become very inadequate. Yet that is exactly what happens when attempting to thank everyone involved in a project of this scope. All those words, no matter how sincerely expressed, suddenly seem rather trite and meaningless. Therefore, all we can offer in return for invaluable assistance is a simple "thank you," but we are genuinely grateful, especially to those who allowed photography of their art: artists, galleries, museums, traders, and private collectors. Work was shipped to us from all over the Southwest and occasionally, artists appeared unexpectedly at our doorway, art in hand. Others welcomed us into their homes on little more than a moment's notice upon receiving our phone call. Art worth literally millions of dollars has passed through our hands in the last four years, all with no promise that any particular piece would appear in this, or any other, publication.

Museum directors and special events chairmen gave their full support, as did the staff at The Coconino Center for the Arts in Flagstaff. At Santa Fe Indian Market, we were allowed to photograph art entries throughout most of the night—behind locked doors with armed guards outside. At the Arizona State Museum, University of Arizona, in Tucson, Mike Jacobs provided assistance in the selection of artifacts to be photographed. Linda Robertson and Mishael Magarin-Smith gave their full cooperation at the Museum of Northern Arizona as award-winning art was photographed prior to several major exhibitions. Special thanks are due to Michael Fox, Ann Marshall, and the rest of the staff at The Heard Museum for providing art, information, and support for this project in countless ways.

The cooperation of galleries was incredible, and several— The Heard Museum Gift Shop, Gallery 10, Lovena Ohl Gallery, Artistic Gallery, and Margaret Kilgore Gallery—went far beyond the call of duty in fulfilling our every request.

During Indian Market, Peter and Linda Waidler allowed us to set up a temporary studio at their home in Santa Fe and, on several occasions, Forrest Fenn's guest house became our home-away-from-home.

OPPOSITE: Navajo sculptor Tomas Dougi Jr. works with a variety of stone, using their natural colors to enhance the beauty of each piece. *The Long Wait*, a 21½" tall sculpture of translucent red alabaster, portrays a woman waiting for her mate—a warrior who has died in battle.

Steve and Gail Getzwiller in Benson, and Gerry and Glenda Collings in Sedona, graciously furnished "bed and breakfast" while pieces from their collections were photographed. Bruce McGee shipped work from Keams Canyon Arts & Crafts to our Phoenix studio time and again…and again, and Danny Medina allowed us to excerpt quotes from his book, *The Pottery Jewels of Joseph Lonewolf.*

There are still more—those who delivered art, provided information, read manuscript, or performed any one of a dozen other necessary tasks: ATLATL, Elijah Blair, Bruce and Virginia Burnham, Jackson Clark, Lee Cohen, Bill Faust, Malcolm (Mac) Grimmer, Mary Hamilton, Dick Howard, Byron Hunter, Kelly Kilgore, Margaret Kilgore, Marquetta Kilgore, Peggy Lanning, Dian Magie, Sheri Maktima, Bill Malone, Tony Moná, Lovena Ohl, Don Owen, Steve Pickle, Randy Polk, Ellen Reisland, Jay and Carol Rosenblat, Gene Waddell, Bill Ward, Merrill Windsor, Barton Wright, Erin Younger and others who may have unintentionally been omitted. Mike and Kathy Jacka (our son and daughter-in-law) were our right-hands as they served as computer programmers, assisted with data input, and acted as all-around trouble shooters.

And last, but not least, is Clara Lee Tanner—Indian art expert, writer, anthropologist, and university professor. When the decision was made to include examples of prehistoric and historic art, her name was the first that came to mind. She graciously consented to become part of our team, and we are deeply indebted to her for sharing her experience and expertise.

To say we are grateful is a preposterous understatement; quite simply, without these people there would be no book. In addition to the many artists who made their work available, art was furnished by the following:

ARIZONA STATE MUSEUM, University of Arizona, Tucson
ARTISTIC GALLERY, Scottsdale, Arizona
BURNHAM TRADING POST, Sanders, Arizona
C.G. REIN GALLERIES, Santa Fe, New Mexico/
 Scottsdale, Arizona
CHRISTOF'S GALLERY, Santa Fe, New Mexico
GEROLD & GLENDA COLLINGS, Sedona, Arizona
COCONINO CENTER FOR THE ARTS, Flagstaff, Arizona
ANITA DA, San Ildefonso Pueblo, New Mexico
TERRY DeWALD, Tucson, Arizona
EL TALLER GALLERY, Santa Fe, New Mexico
FENN GALLERIES, Santa Fe, New Mexico
GALERIA CAPISTRANO, Santa Fe, New Mexico/
 San Juan Capistrano, California

GALLERY 10, Santa Fe, New Mexico/Scottsdale, Arizona
GALLERY WALL, Santa Fe, New Mexico/Scottsdale, Arizona
STEVE & GAIL GETZWILLER, Benson, Arizona
ALLIE MAE GODBER, Scottsdale, Arizona
WILL GRAVEN, Flagstaff, Arizona
THE HEARD MUSEUM, Phoenix, Arizona
THE HEARD MUSEUM GIFT SHOP, Phoenix, Arizona
WILLIAM & BARBARA HINKLEY, Paradise Valley, Arizona
HOGAN IN THE HILTON, Santa Fe, New Mexico
DICK HOWARD, Santa Fe, New Mexico
INDIAN ARTS & CRAFTS ASSOCIATION, Albuquerque,
 New Mexico
INSTITUTE OF AMERICAN INDIAN ART, Santa Fe, New Mexico
KEAMS CANYON ARTS & CRAFTS, Keams Canyon, Arizona
KENNEDY KRAFTS, Albuquerque, New Mexico
KOPAVI, Sedona, Arizona
LOVENA OHL GALLERY, Scottsdale, Arizona
DENNIS & JANIS LYON, Paradise Valley, Arizona
MARGARET KILGORE GALLERY, Scottsdale, Arizona
MARILYN BUTLER FINE ART, Scottsdale, Arizona/Santa Fe,
 New Mexico
MITTIE COOPER GALLERY, Oklahoma City, Oklahoma
MORNING STAR GALLERY, Santa Fe, New Mexico
MUSEUM OF NORTHERN ARIZONA, Flagstaff, Arizona
MUSEUM OF NORTHERN ARIZONA GIFT SHOP,
 Flagstaff, Arizona
STEVE NELSON, California
OLD TOWN GALLERY, Flagstaff, Arizona
SANTA FE EAST, Santa Fe, New Mexico
SANTA FE INDIAN MARKET, Santa Fe, New Mexico
JOE SIMMONS, Phoenix, Arizona
BOB & TONI SKOUSEN, Scottsdale, Arizona
SOUTHWEST ASSOCIATION ON INDIAN AFFAIRS, Santa Fe,
 New Mexico
SQUASH BLOSSOM GALLERY, Palm Springs, California
SUZANNE BROWN GALLERY, Scottsdale, Arizona
JOE TANNER, Gallup, New Mexico
TOH-ATIN GALLERY, Durango, Colorado
TROY'S GALLERY, Scottsdale Arizona
TUBA CITY CULTURAL CENTER, Tuba City, Arizona
TURQUOISE TORTOISE of Sedona, Arizona
GEORGIA VOISSARD, Phoenix, Arizona
GENE WADDELL, Tempe, Arizona
WADLE GALLERIES, Santa Fe, New Mexico
LOTTIE WOFFORD, Santa Fe, New Mexico

Index: The Art